The 15-Minute
ARTIST

T0154114

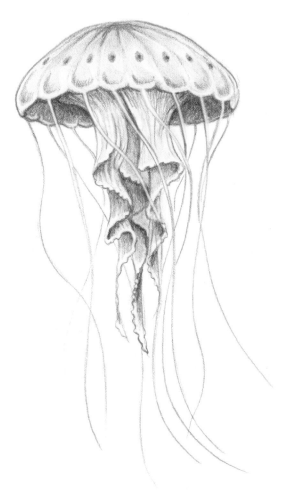

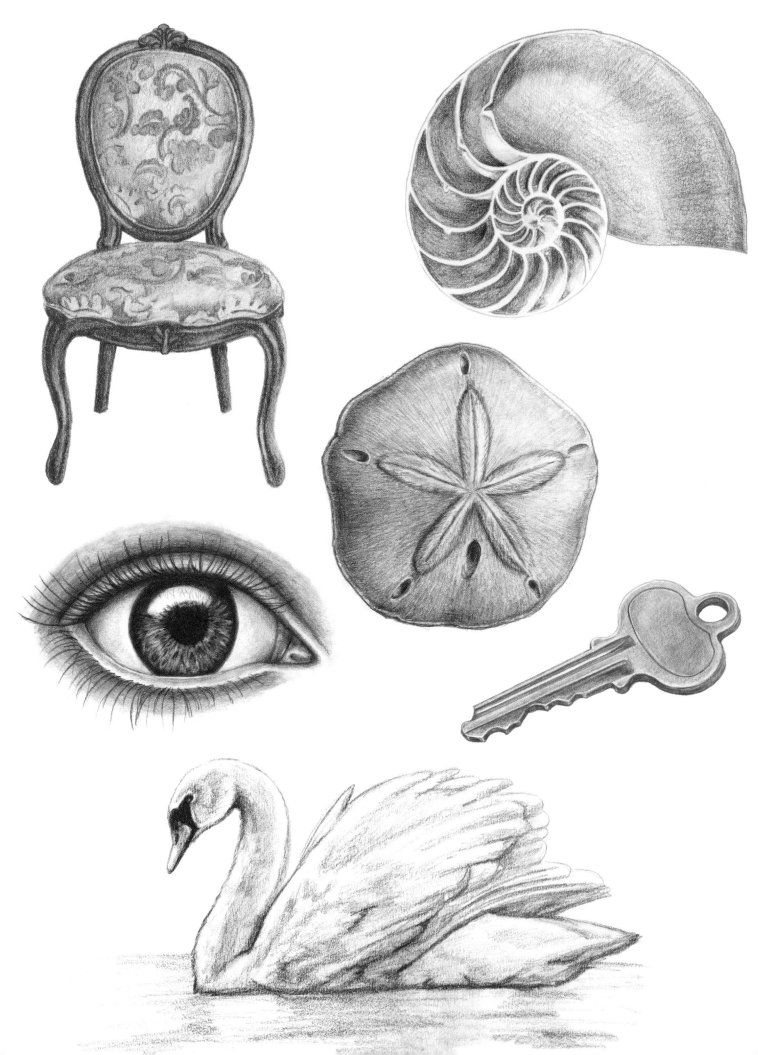

The 15-Minute ARTIST

The Quick and Easy Way to Draw Almost Anything

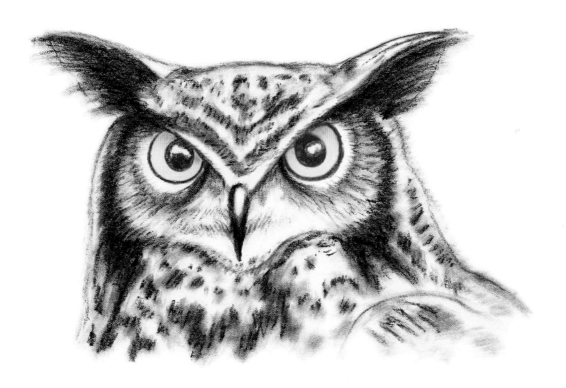

Catherine V. Holmes

Get Creative 6

Get Creative 6
An imprint of Mixed Media Resources
104 West 27th Street
New York, NY 10001

Connect with us on Facebook at
facebook.com/getcreative6

Senior Editor
MICHELLE BREDESON

Art Director
IRENE LEDWITH

Chief Executive Officer
CAROLINE KILMER

President
ART JOINNIDES

Chairman
JAY STEIN

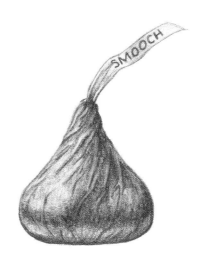

Everyone is born with the ability and desire to create. Charlotte and Taya Cate, I can't wait to see what you will make next. I love you both to the moon and back and so much more.

Library of Congress Cataloging-in-Publication Data

Names: Holmes, Catherine V. author.
Title: The 15-minute artist : the quick and easy way to draw almost anything
 / by Catherine V. Holmes.
Description: First edition. | New York : Get Creative 6, [2019] | Includes
 index.
Identifiers: LCCN 2019005493 | ISBN 9781640210431 (pbk.)
Subjects: LCSH: Drawing--Technique.
Classification: LCC NC730 .H558 2019 | DDC 741.2--dc23
LC record available at https://lccn.loc.gov/2019005493

Manufactured in China

5 7 9 10 8 6 4

First Edition

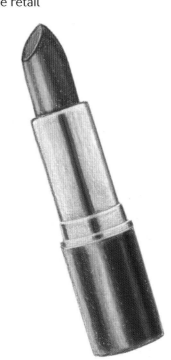

Acknowledgments

Thank you to Mom, Dad, Dave, Kathy, Jeff, and Marcia. Through your love, company, support, and/or babysitting, I have been able to be productive in the arts beyond crayons and slime.

Thank you to Usher Morgan, who helped me share my vision with the world.

To my friends at the Holbrook Public Library (and Kat), thank you for being a part of my routine and bringing joy to my girls through the adventure, color, and wonder of books (and movies and programs, too).

To my colleagues at Vinal and Dennett Elementary Schools, your kindness, positive modeling, and patience have taught me to be a better teacher. You help me learn something new every day.

Finally, I want to acknowledge all the folks at Mixed Media Resources who reached out to me to make this book a reality. Thank you for understanding the reasons why I do what I do and the choices I make, as well as helping me understand that collaborating can be challenging yet rewarding.

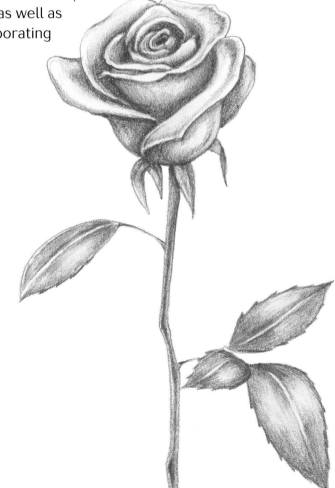

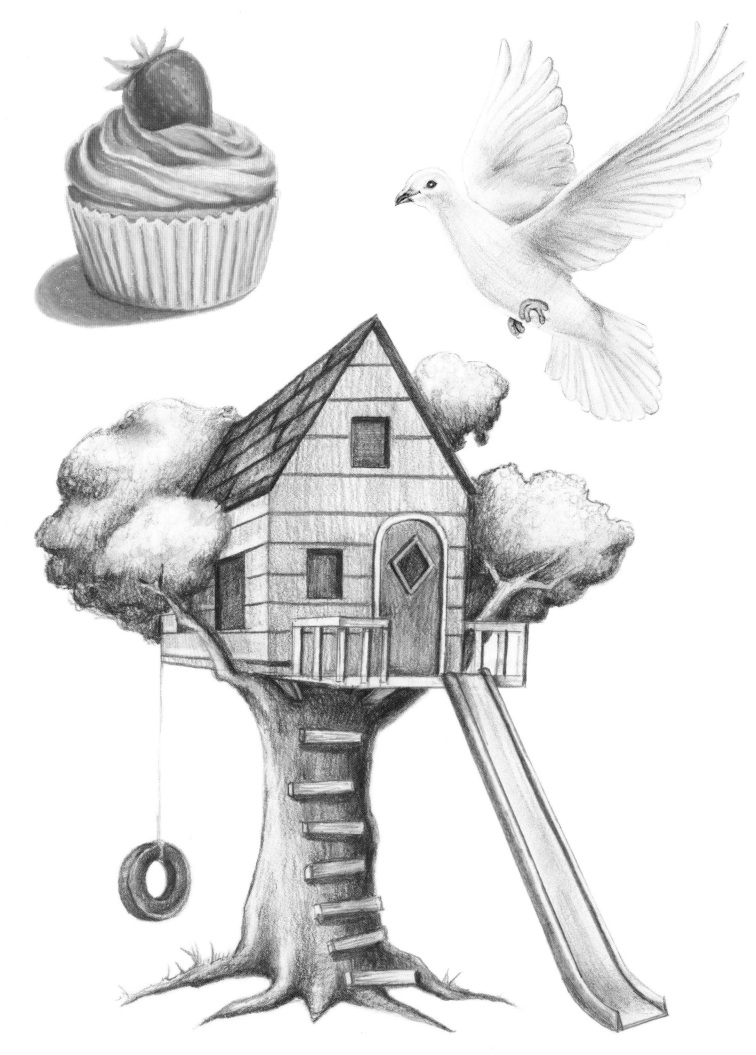

Contents

INTRODUCTION
Learn to See Like an Artist . . . in 15 Minutes!

Drawing realistically can be intimidating. Aspiring artists often begin with a final product in mind before even beginning to create. Unfortunately, many artists find that halfway through the drawing process they are unhappy with their results and throw away their paper and start over again—or worse, they don't try again at all.

One reason for this frustration is that in this age of technology we are constantly looking for instant gratification. Our society is breeding a culture of impatience and unrealistic expectations. We forget that we need to put time and effort into learning a new skill or creating satisfying work.

At the same time, people are finding themselves with less and less free time. How do you make time to learn to draw and create art when you have so many other commitments? As a full-time teacher and mother of twins, I understand! There are days when I barely have time to brush my hair, let alone sit down to draw. I believe that the key is to try to carve out just a small amount of time on a regular basis.

In *The 15-Minute Artist* I offer a step-by-step guide to drawing specific creatures, plants, household objects, and other items in 15 minutes or less. Why 15 minutes? I believe that is a good amount of time to immerse yourself in learning how to see like an artist. Less than that may not allow you to focus long enough. And even the busiest people can usually find 15 minutes every day or so.

Experienced artists develop a special way of seeing drawing subjects. We break them down into simple shapes and lines and connect them to create a whole object. We also (whether we are conscious of this or not) break the creative process down into manageable steps

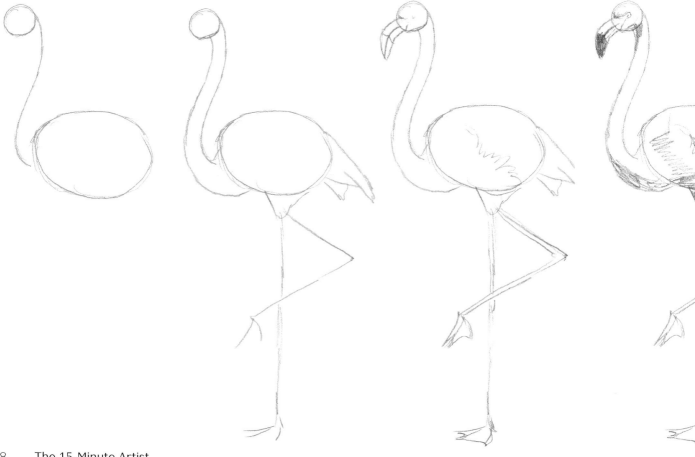

that make drawings less daunting. If you allow yourself a small chunk of time to train your brain to see like an artist, you will be able to draw anything, not just the items in this book.

Each project you complete in this book will teach you how to draw that subject, but it will also teach you new skills and techniques you can apply to other drawings. The result is the learned skill of seeing differently that automatically takes over when an artist creates a piece of art. You will truly learn to draw almost anything!

It isn't necessary to buy a lot of specialized drawing supplies to start drawing. For most of the drawings in this book, you just need a pencil and some basic drawing paper. Some of the projects showcase other fun materials, such as charcoal and colored pencil. While this book is not meant to be a thorough overview of those mediums, I do include some general information and pointers on how to use them (see page 14).

Basic Steps

This is the typical process I use with most drawings, including those I demonstrate in this book.
1. Break it down into simple shapes.
2. Connect the shapes.
3. Add details.
4. Erase the initial guidelines.
5. Shade the entire object with a medium tone.
6. Darken the darkest areas.
7. Erase areas to create highlights.

The projects are grouped by subject—food, animals, plants, household objects, and more— and are presented in no particular order. Got 15 minutes? Start at the beginning and work your way through the exercises or pick something that catches your eye and jump right in!

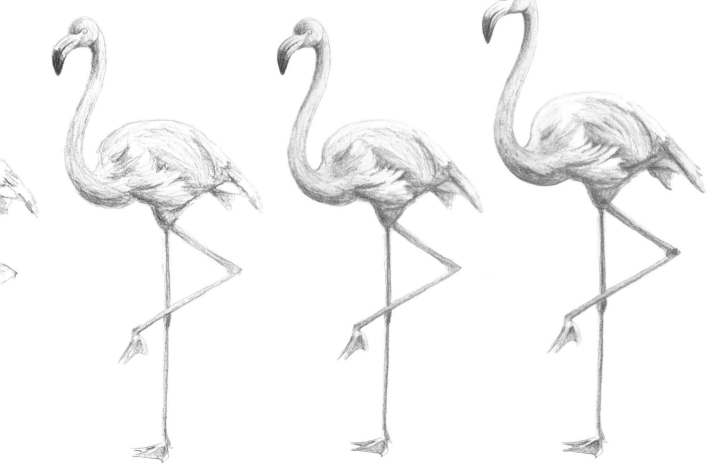

Quick-Start Drawing Tips

I'll walk you step by step through each drawing in this book, but here are some pointers that will help you with these drawings and any drawing you attempt.

Step back. Look at your work from a distance from time to time. Standing or sitting too close while drawing can distort the perception of how the artwork is working as a whole. The longer you go without viewing your art from a distance, the easier it becomes to obsess over details.

Squint. This can clarify shapes and values and provide a simplified version of your reference image.

Bigger is better. If you work large (at least as large as the steps shown in the projects if not larger), you will have more room to add details, shading, and highlights.

Keep it loose. The initial lines you draw are just guides for placing details and don't need to be perfect. The general shape of the outline may be changed slightly or added to later on. Holding your drawing tool closer to the end will help you stay loose.

Lighten up. Some of the lines you start with will eventually be erased, so don't press too hard. Keep the lines soft and wispy.

Keep it simple. The simpler you make your drawing, the more powerful it will be. A successful image is one that quickly reads well.

Stand up. When working large, try standing up to draw and tacking your paper to an easel or the wall. Standing up when creating larger artwork will allow for more movement and looser lines. It will encourage you to step back more frequently. Standing up will also prevent

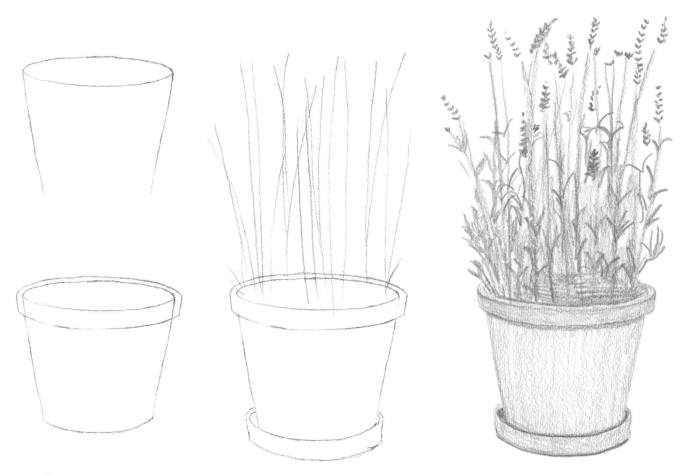

you from resting the side of your hand on an artwork and smudging it.

Use drawing paper. While you can use copy paper or other nondrawing paper, using a paper that is meant for drawing and has a bit of *tooth* (texture) will help with shading and blending.

Measure up. Notice the distance from one part of the image to another in your reference image and use that as a guide for your drawing. No need for a ruler, just eyeball it.

Line it up. Pay attention to the direction of lines and angles in your reference images. Replicating them in your drawings will help with creating a likeness.

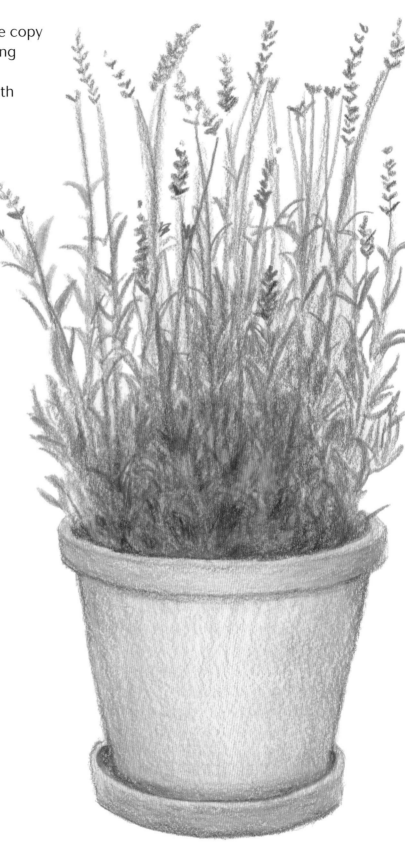

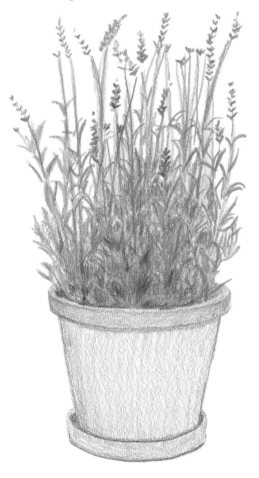

A Few Drawing Basics

These drawing concepts are used throughout the book—and for most drawings you'll create.

Understanding Value

In drawing, the word *value* refers to the lightness or darkness of a tone.

A *value scale* is a chart consisting of blocks of tone that starts with the lightest tone, or white, on the left and gradually changes from block to block into the darkest tone, or black, on the right. *Midtone* is halfway between the highlight and the shadow. The midtones show the real color and value of an object, because the highlights are brighter than the "true" color and shadows are darker.

Using a range of tones helps create the illusion of depth, highlight, and shadow in an artwork. Creating the scale in itself helps an artist determine how much pressure to use or what type of pencil to use when trying to recreate a specific tone.

Be careful not to make your darkest areas as dark as they can be right away. Start with a lighter value and increase gradually. You can always make areas darker, but it is not so easy to lighten them.

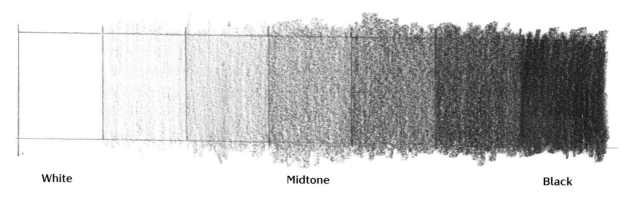

White **Midtone** **Black**

Working with Guidelines

As you can guess from the name, *guidelines* are intended to "guide," or help, you with your drawing by creating a framework to build on. They are used to lay down the initial shapes of an object or to plan out its form. They also assist with creating realistic proportions and perspective. Guidelines also help an artist focus on what is seen, not what they believe an object looks like.

Guidelines are not meant to be perfectly placed but offer a rough idea or reference for an initial sketch. They will not be apparent in the finished artwork.

Not everyone's guidelines will look the same. Some artists use simple lines that follow the center of a form,

while others use a series of geometric shapes laid out to generically mimic an object. Others may block out the *contour* (outline) of an object while leaving the inside temporarily blank.

With practice, some artists may visualize the guidelines on the page and use minimal actual lines. Every artist is different and there is no right or wrong way to use guidelines. If they help, use them!

Guides should be drawn using loose, light lines so they can be easily erased or changed later. With an initial guide to follow, you will create fewer mistakes and ultimately have less erasing to do.

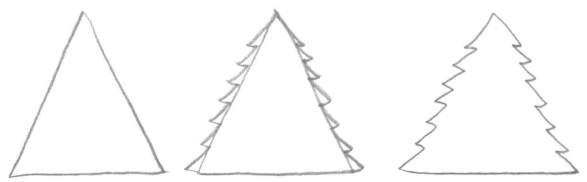

This very simplified example shows how a triangle is used as a guideline for an evergreen tree.

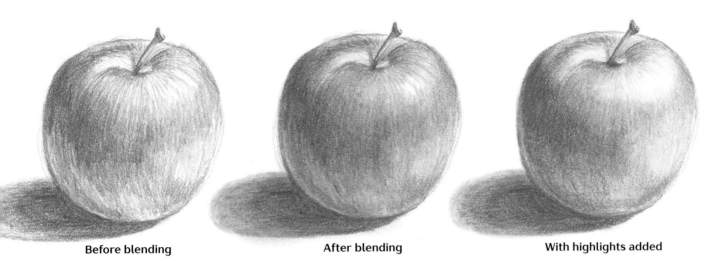

Before blending　　　**After blending**　　　**With highlights added**

Blending Basics

Blending is the technique of creating a gradual transition from one value or color to another. Blending adds to the depth and believability of a work and can give the art a realistic appearance.

You can use specialized tools and household supplies for blending. These include tissues, blending stumps, tortillons, cotton swabs, fingers, chamois cloths, kneaded erasers, dry paintbrushes, and more. Each individual will form a preference of which tools they find the most useful. I like to use what is handy and inexpensive.

Blend your graphite once the initial values are placed on an artwork. Move the tool of your choice over the tones in need of blending a few times to smooth them together. Try to avoid going back and forth too many times as this can flatten tones into one shade of gray, taking away the contrasting, beautiful darks and lights.

If areas of contrast do become too weak or flattened after blending, add another layer of graphite.

You can also blend with a variety of art pencils or pressure. Softer graphite pencils (I prefer 4B–8B) can be used to create darker tones while overlapping them with harder (such as 3B) pencils to transition into a lighter tone. Pressing harder with a pencil will create a darker tone, while pressing lighter will result in a lighter tone. This method can also be used to create blended tones.

Whichever method you use, notice the direction in which the lines and angles are drawn. Be sure to blend following the same direction as these lines.

Shading a Sphere

Careful shading will ensure that your spheres appear three-dimensonal and convincing. There are several areas of shading and highlight shown in every sphere.

Light source: Where the light is coming from. This could be the sun or a lamp. It's helpful to mark the light source on your page to keep it in mind.

Highlight: The lightest area on the sphere is where the light source shines on it directly.

Midtone: The actual color or value of the sphere.

Core shadow: The darkest area on the sphere.

Reflected light: A lighter area on the sphere that is created by light reflecting back from the surface the sphere is sitting on.

Cast shadow: The shadow on the surface on which the sphere is sitting that is cast by the sphere. The length of the cast shadow depends on the direction of the light source. The cast shadow is shortest when the light is directly overhead and gets longer as the light source gets lower.

Occlusion shadow: The darkest area of the cast shadow. It is close to the sphere.

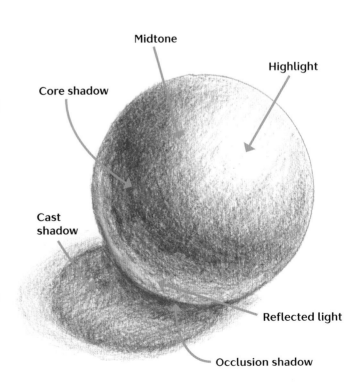

Midtone

Highlight

Core shadow

Cast shadow

Reflected light

Occlusion shadow

What to Use

Here are a few drawing tools I use in the projects.

Pencil Types

For most of the projects in this book I use graphite pencil. While you can certainly use your standard #2 graphite writing pencil for your drawings, specialized artist pencils will give you more variety of marks and enable you to create more satisfying drawings.

Artist pencils come in two major graphite categories based on the hardness of the graphite and are labeled as "H" or "B." Hard (H) pencils leave lighter, thinner marks and can be sharpened to a very fine tip. Soft (B) pencils leave darker, thicker, smudgy marks.

Along with the H or B letter grade, a pencil will also have a number grade. For H pencils, the higher the number, the lighter and thinner the marks will be. For B pencils, the higher the number the softer and darker the marks will be.

You can change the pencil or change the pressure to get a different effect.

My go-to pencil for most drawings is a 6B. You can see the wonderful range that is possible with just one pencil.

Drawing with Charcoal

Charcoal is a classic drawing medium that can provide a rich black color, but it is quite different from pencil. Here are some tips for successful charcoal drawings. These tips apply to vine charcoal and compressed charcoal.

• Draw large! Charcoal sticks are thicker than pencil and therefore more suitable to making larger drawings. It's difficult to create small details with charcoal, especially at a smaller size.

• If you're uncomfortable using charcoal for the initial sketch, feel free to draw lightly in pencil first.

• Hold the drawing tool near the far end (not the drawing end) with a loose grip for a lighter mark.

• Charcoal is messy. Wrap your charcoal stick in a tissue or wear gloves to keep your hands clean and not transfer any oils from your skin onto the paper.

• To blend I use tissue that is wadded up or wrapped around my finger. You can also use cotton balls, chamois cloths, kneaded erasers, foam pads, blending stumps, hog-bristle brushes, and your fingers.

• The direction of the blend should follow the same direction as the initial laydown of charcoal.

• Charcoal is very soft and can smear easily. Spray your drawing with a workable fixative to avoid smudging and smearing.

• Do not wipe away any stray charcoal dust! It will smudge your artwork. Instead, gently shake your paper over a trash can, or if no one else is around, carefully blow the dust away.

• Use a kneaded eraser to remove light marks and to add highlights.

Using Oil Pastel

Oil pastels are sticks of pigment combined with oil and wax binder. Here are a few tips to help when working with this fun medium.

• Try to keep the individual sticks clean as you work. They can pick up other pigments. Wipe them off with a paper towel or draw the soiled parts off on a scrap piece of paper.

• Block in the major colors first and add details after.

• Oil pastels are usually applied using a back-and-forth motion. Other methods include crosshatching, adding small dots to make up an object or create a shading effect (stippling), or scumbling a blend of colors over one another.

• You can blend with your finger, but it's messy! Try using a paper stump, a tortillon, another pastel, or a cloth instead.

• Oil pastels never dry completely. Protect your drawing with glassine (a paper similar to wax paper that is made for storing fine art) or frame it under glass.

Working with Colored Pencils

Colored pencil is a great way to easily (and neatly) add pigment (color) to an artwork. Colored pencils require zero setup time (unlike most painting procedures), are easy to use, and leave no mess behind.

While you can use ordinary drawing paper, paper that is designed especially for colored pencil may provide a better result as it has a slightly rough surface, or "tooth," necessary for a clean laydown of color.

It's a good idea to begin a colored pencil drawing with a light graphite pencil sketch. Once you're happy with your drawing, apply a layer of color to the areas that will be the darkest. Next, add a lighter layer of color to all but the lightest areas of the composition. This helps fill in the main shapes and tones. Then add another layer of color as needed, experimenting by layering similar colors to the one underneath or even contrasting colors. Continue layering colors as desired.

When creating highlights and shadows, avoid the temptation to use only black for shadows or white for highlights, which can make the drawing look flat. Cool colors such as purples or blues can work for shading, while warmer colors like yellow or pink can be used for highlights.

During the coloring process, the tones need to be burnished. Burnishing involves layering and blending until no paper tooth shows through the colored pencil layers. It works the pigment into the grooves of the paper, smooths out colors, and minimizes the appearance of pencil strokes.

The first way to do this is to use the colored pencils and burnish while you're layering. Every time you place a color over another, use pressure to mesh these layers of colors until no paper shows through. Any color can be used to burnish; a lighter color should be used for highlights, and a darker color should be used for shadow areas.

You can also use tools, such as stumps, tortillons, and tissues, to blend and burnish. Rub the tool/tissue gently over the surface of the color to smooth it out.

The third option for blending is the use of solvents. Rubbing alcohol and mineral spirits are two choices. Solvents offer the most dramatic effects and create a painterly style. Paintbrushes, cotton balls, or swabs can be used to apply them.

Each blending option offers a different outcome, and different pencil brands react differently with each type of blending. It is best to test each one out before using them on an important artwork.

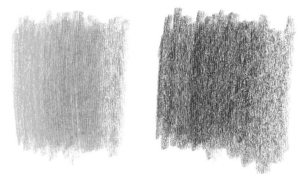

In each example, the colors on each side are layered in the center.

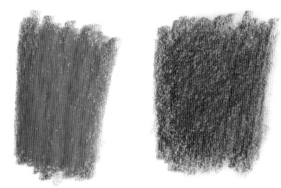

Blending or burnishing with a white colored pencil (left) or the same color pencil (right).

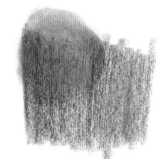

Blending with a solvent creates a painterly effect.

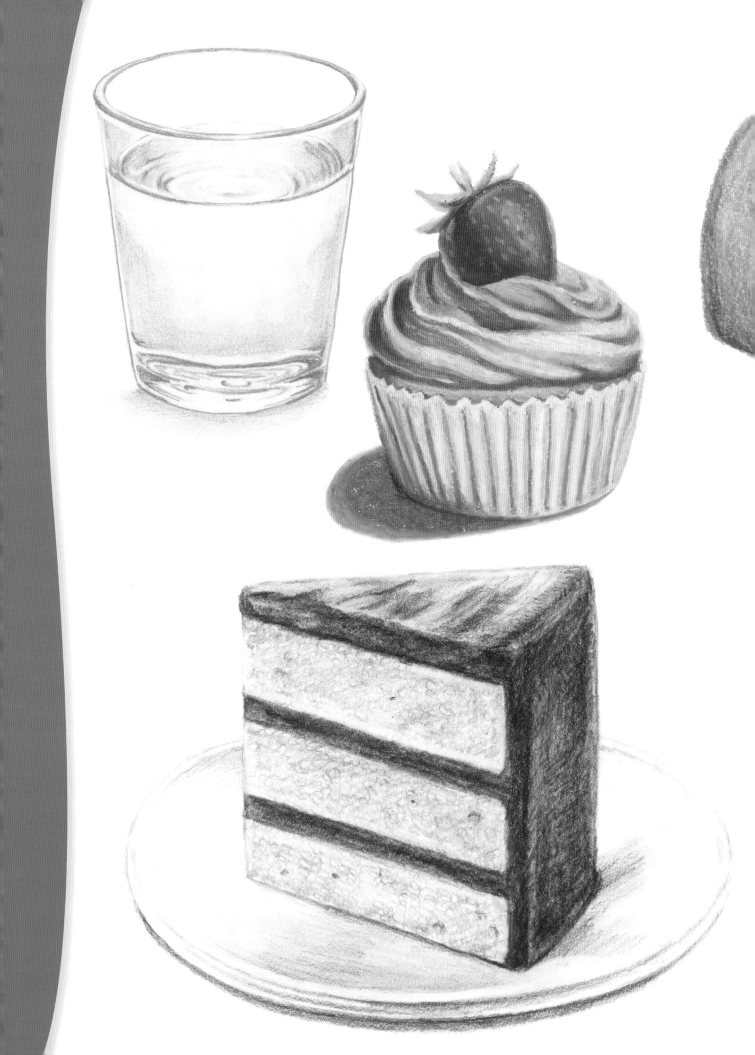

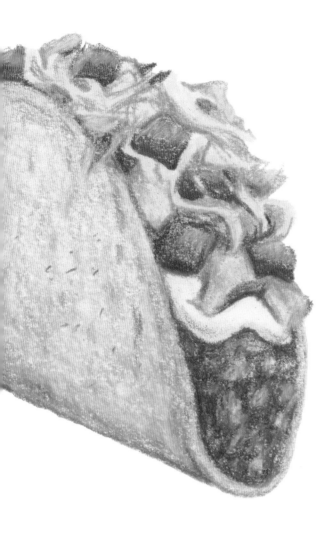

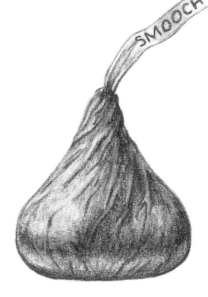

Fun with Food

In this chapter, we'll use drawings of food to learn a variety of drawing techniques and concepts, such as scumbling, working with colored pencil, value, and more. Most edibles are organic in shape, meaning that your lines don't have to be precise to be accurate, and they feature lots of interesting textures. By following the simple steps, your drawings will look good enough to eat!

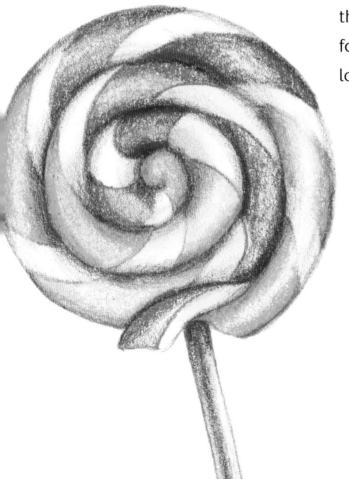

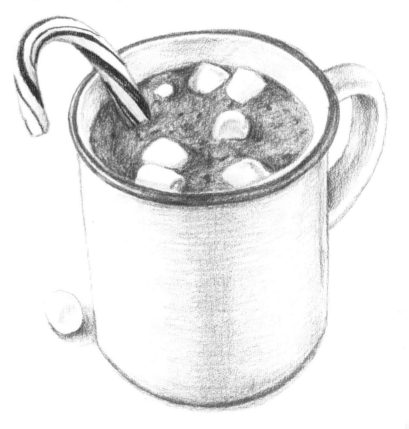

Chocolate Kiss

Based on a very simple shape, this drawing is perfect for practicing creating volume and texture. Draw this for a friend and write their name on the tag.

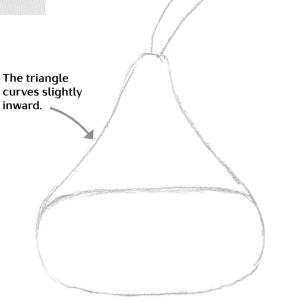

The triangle curves slightly inward.

THE BASIC SHAPE

1 Start with a rectangular oval.

2 Draw a triangular shape on top of the oval. Add a thin banner, or flag, at the top.

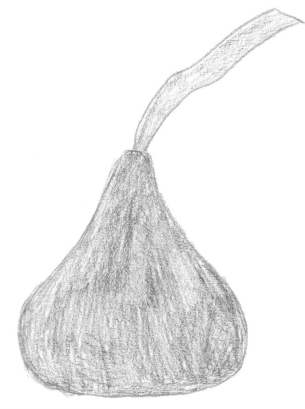

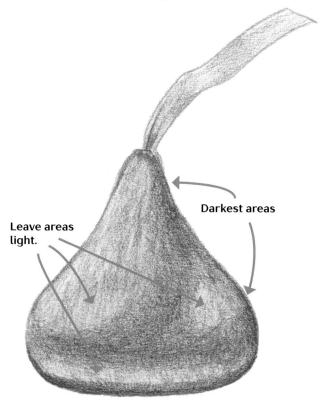

Leave areas light.

Darkest areas

START SHADING

3 Add a light layer of tone over the whole image.

4 Add the darkest tones using heavier pressure at the base, the bottom third, and the center at a slight diagonal.

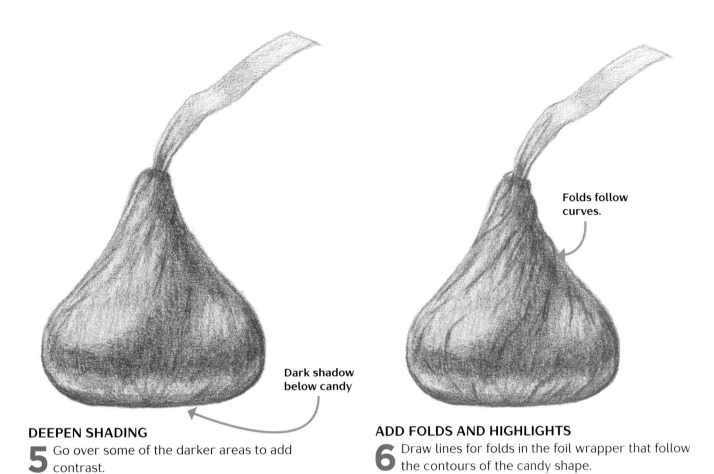

Dark shadow below candy

Folds follow curves.

DEEPEN SHADING

5 Go over some of the darker areas to add contrast.

ADD FOLDS AND HIGHLIGHTS

6 Draw lines for folds in the foil wrapper that follow the contours of the candy shape.

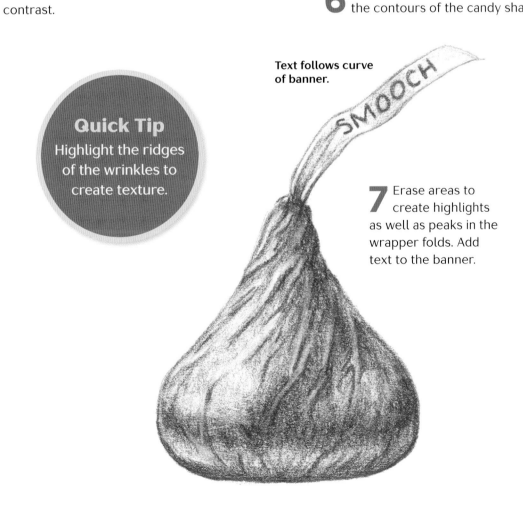

Quick Tip
Highlight the ridges of the wrinkles to create texture.

Text follows curve of banner.

SMOOCH

7 Erase areas to create highlights as well as peaks in the wrapper folds. Add text to the banner.

Piece of Cake

The texture in this image is created with *scumbling*—a fun technique in which you use little circles to achieve an allover pattern.

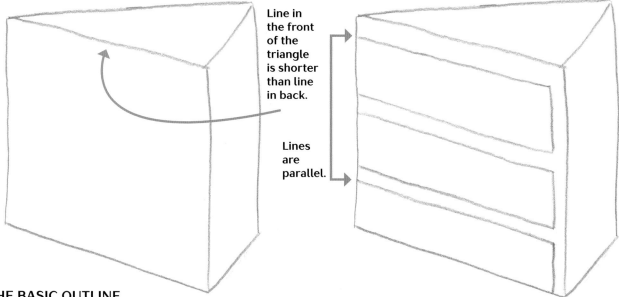

Line in the front of the triangle is shorter than line in back.

Lines are parallel.

THE BASIC OUTLINE

1 Start with an angled triangle shape for the top of the cake (think of a pizza slice). Add vertical lines to each end of the triangle. Close the bottom with a line that follows the same direction as the bottom of the triangle.

2 Add equally spaced layers on the cake using parallel lines.

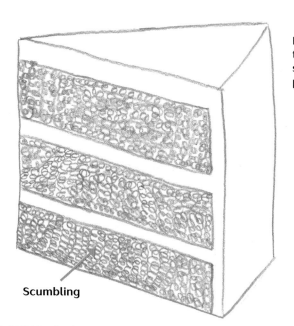

Scumbling

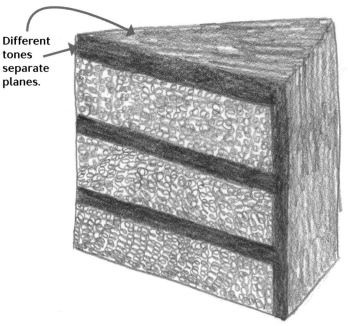

Different tones separate planes.

SCUMBLING

3 Add the first layer of shading to the cake layers using light scumbling. Don't shade the frosting.

BASIC SHADING

4 Use the edge of the pencil to block in the frosting. Use more pressure or a darker pencil on the frosted layers on the rectangular portion of the cake. This will separate the planes of the cake more realistically than lines.

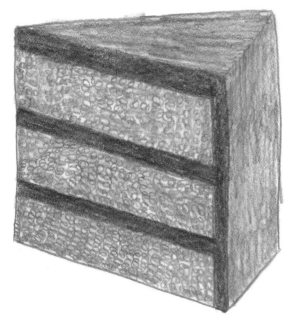

Darken and lighten to create peaks and valleys.

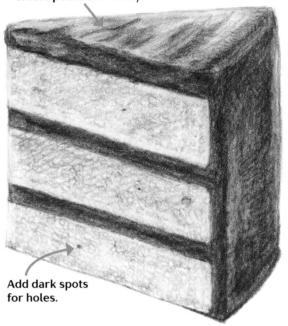

Add dark spots for holes.

BLENDING

5 Use a light touch with your favorite blending tool and smooth the tones just a bit so the scumbling circles are not as obvious.

FINAL SHADING AND HIGHLIGHTS

6 Dab at the scumbled area with a kneaded eraser to lighten. Add another layer of allover shading. Darken some areas while using a kneaded eraser to create areas of highlight.

Quick Tip
Be careful not to overblend, which will create a single flat, gray tone.

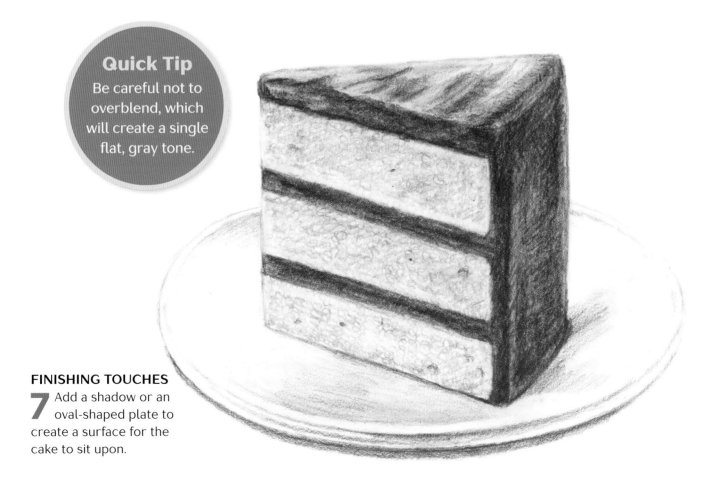

FINISHING TOUCHES

7 Add a shadow or an oval-shaped plate to create a surface for the cake to sit upon.

Make-Your-Own Taco

What do you like on your tacos? You can use colored pencils to customize your taco with your favorite toppings.

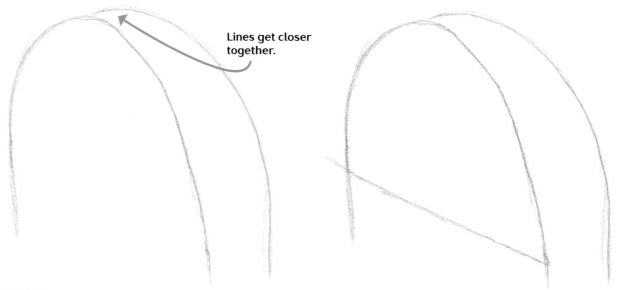

Lines get closer together.

PENCIL SKETCH

1 Start with a mound and add another curved line next to it.

2 Draw a diagonal as a guide for the bottom of the taco shell.

Quick Tip
Lighten the pencil lines before adding color by blotting them with a kneaded eraser so they don't mix with the colored pencil.

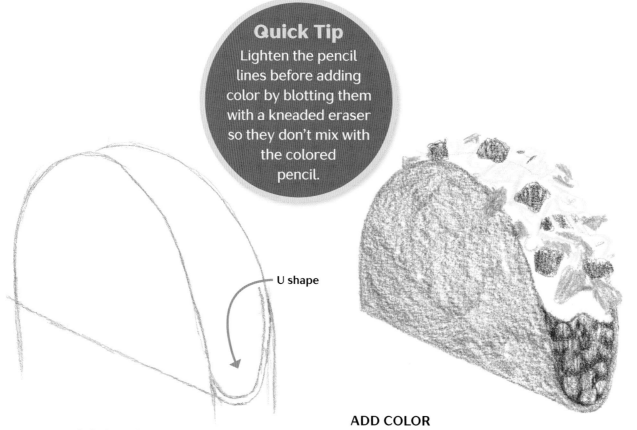

U shape

3 Draw a "U" shape between the base of the first mound and second curve.

ADD COLOR

4 Erase the guidelines. Use a warm yellow/ brown tone to fill in the shell. Decide on the toppings and add a light layer of colors.

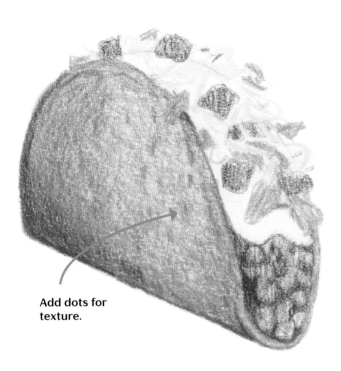

Add dots for texture.

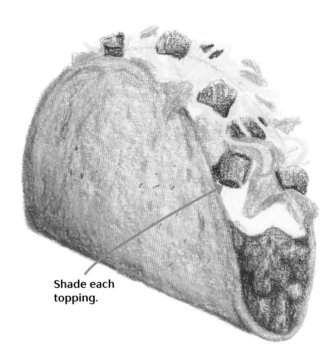

Shade each topping.

TEXTURE AND SHADING

5 Add a light layer of yellow, then a darker tone to the lower left of the shell as well as texture using random dots of brown and warm yellow.

MORE SHADING AND HIGHLIGHTS

6 Vary heavy and light pencil pressure on the lettuce, tomato, and cheese to indicate shading. Use drawing pencil or dark brown to add texture to the meat. Use white to blend and add highlights to the shell.

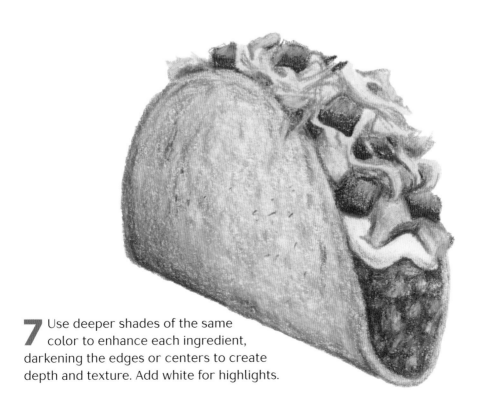

7 Use deeper shades of the same color to enhance each ingredient, darkening the edges or centers to create depth and texture. Add white for highlights.

Value Layer Cake

This clever cake is more than just a delicious-looking dessert. It's a fun way to look at *value*—the lightness or darkness of a color—as the cake layers go from light to dark.

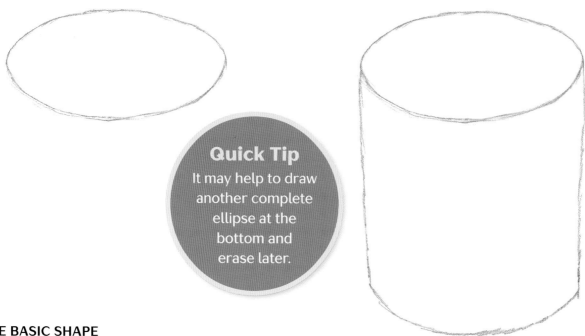

Quick Tip
It may help to draw another complete ellipse at the bottom and erase later.

THE BASIC SHAPE

1 Start with an ellipse shape near the top of the paper.

2 Draw two vertical lines coming from the ellipse. Close the base with a curve so the result looks like a stubby can.

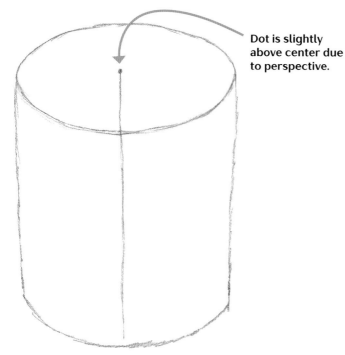

Dot is slightly above center due to perspective.

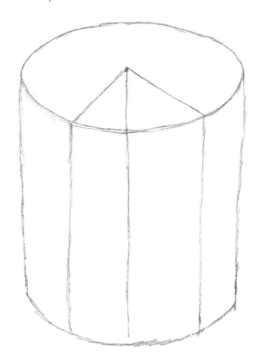

3 Find the center of the ellipse and place a dot slightly above it. Draw a vertical line coming from that dot that moves downward to the bottom curve.

4 Using the dot as the top, draw a triangle shape that stops when it touches the base of the ellipse. Draw vertical lines coming from the left and right bottom corners of the triangle.

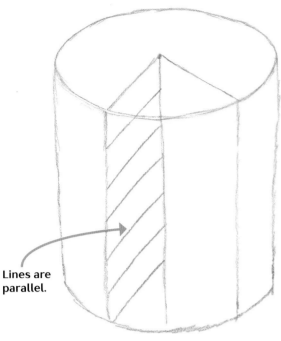

Lines are parallel.

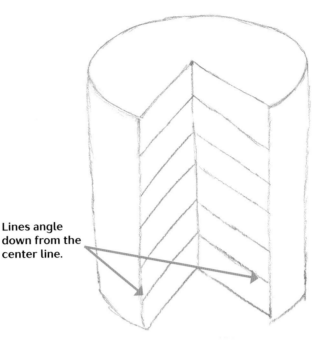

Lines angle down from the center line.

ADD THE LAYERS

5 Draw six equally spaced diagonal lines that follow the same direction as the left corner of the triangle.

6 Repeat Step 5 going in the opposite direction for the right side. Erase the parts of the ellipses that fall within the triangles.

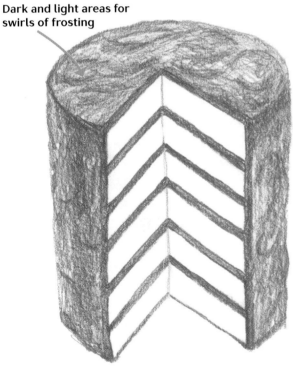

Dark and light areas for swirls of frosting

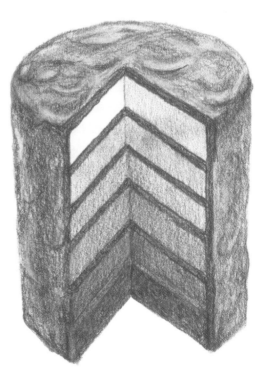

START SHADING

7 Thicken the diagonal lines to represent frosting between cake layers. Shade the outside of the cake using swirly motions to indicate frosting.

ADDING VALUES

8 Using heavy pencil pressure, fill the bottom layer. Repeat for the layer directly above, using a slightly lighter pressure. Continue this process of gradually shading each layer as you move up, leaving the top layer untouched. Blend the outer frosting and erase areas near the peaks.

Glass of Water

You can't have food without something to wash it down. A glass may be transparent, but that doesn't mean there isn't a lot going on. Adding shadows and highlights creates volume and makes your drawing believable.

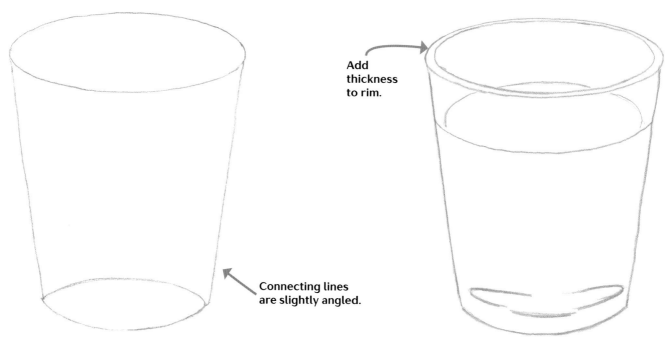

Add thickness to rim.

Connecting lines are slightly angled.

THE BASIC DRAWING

1 Start with a large ellipse for the rim of the glass and a smaller one for the base. Connect them with straight lines.

2 Add another ellipse inside the glass to be the top of the liquid. Thicken the rim on the inside. Erase the far side of the bottom ellipse and draw curves at the base as shown.

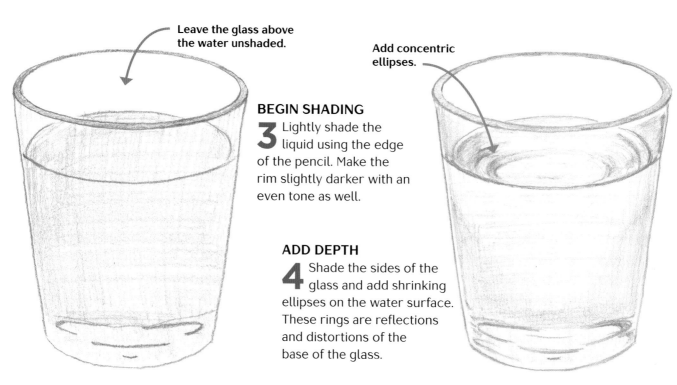

Leave the glass above the water unshaded.

Add concentric ellipses.

BEGIN SHADING

3 Lightly shade the liquid using the edge of the pencil. Make the rim slightly darker with an even tone as well.

ADD DEPTH

4 Shade the sides of the glass and add shrinking ellipses on the water surface. These rings are reflections and distortions of the base of the glass.

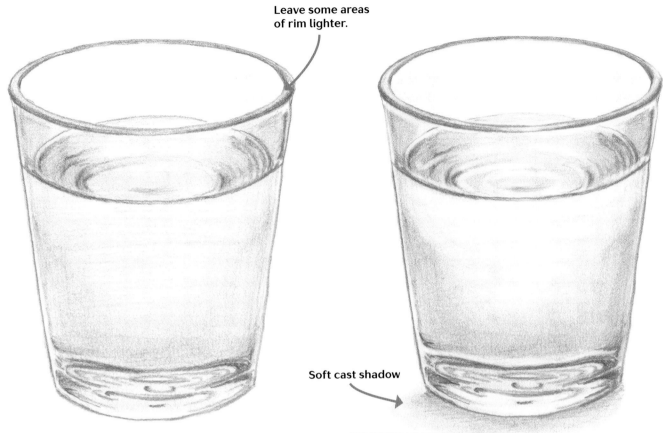

Leave some areas of rim lighter.

Soft cast shadow

BLENDING

5 Blend the tones into one another while adding more rings of ellipses at the base. Darken some areas of the rim and sides of the glass as shown.

FINISHING TOUCHES

6 Continue blending for a smooth finish. Darken some areas in the corners to indicate the cylindrical shape of the glass. Erase some areas near the top/center of the liquid for contrast.

Drawing Transparency

Drawing transparent items such as a wine glass may be daunting at first because we automatically recognize most glass as clear. But that doesn't mean they are blank surfaces. When drawing clear objects, it's important to observe the areas of light and dark within the glass as well as what is surrounding it.

Start by making a light sketch. It will have a two-dimensional look because it is just the preliminary sketch. Add a three-dimensional aspect to the object by drawing details such as edges and rims.

Start to add shading. Observe the inside of the transparent object and what you can see through it. Areas behind it may seem to distort, become darker, or even disappear. Be concerned less with any objects that are seen and more so with what shapes are formed. Make note of areas of shadow, highlight, and reflection. Replicate what you see working on the darkest areas first, comparing tones from one area to another for tonal accuracy.

Blend (see page 13) for a smooth finish and use a kneaded eraser to remove pigment and create reflective highlights.

Rainbow Lollipop

Subtle shading highlights the coils of this pretty lollipop and prevents it from looking flat. Use any colors, or flavors, you like!

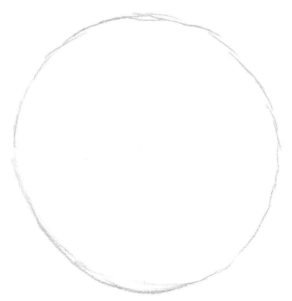

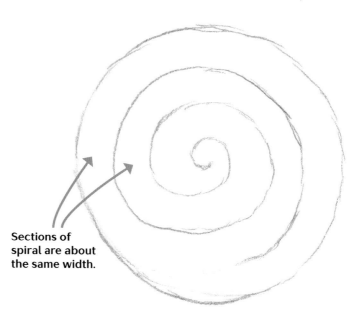

Sections of spiral are about the same width.

THE BASIC DRAWING

1 Start with a light circle.

2 Beginning in the center of the circle, draw a spiral.

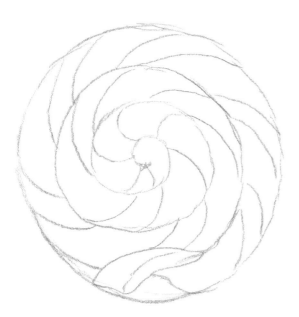

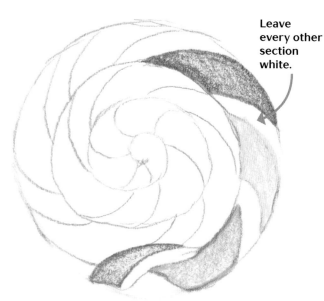

Leave every other section white.

3 Add lines that curve around each section of the spiral. Close the bottom.

ADD COLOR

4 Starting around the outside of the spiral, use colors of your choice to lightly fill in the curves. You may want to add a color, skip a section, add another color, skip a section, etc.

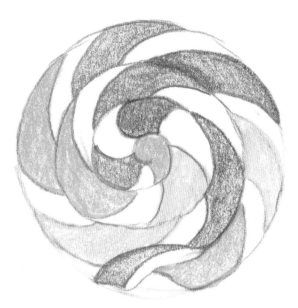

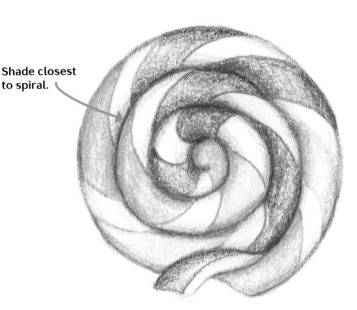

Shade closest to spiral.

COMPLETE COLORING

5 Repeat Step 4 until all of the colors have been added.

SHADE

6 With a darker shade of each color, darken only near the lines of the original spiral to add depth. Use a drawing pencil to do the same to the areas without color.

Quick Tip
You can use a drawing pencil to blend the pencil tone into the colored areas and to create shadows.

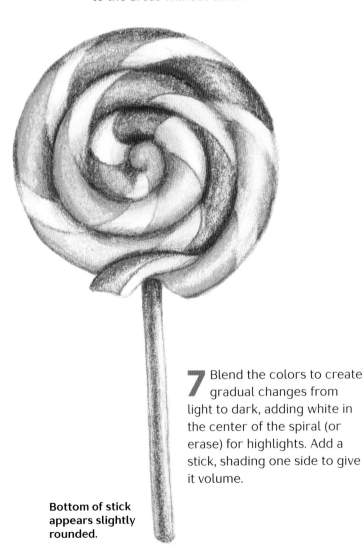

7 Blend the colors to create gradual changes from light to dark, adding white in the center of the spiral (or erase) for highlights. Add a stick, shading one side to give it volume.

Bottom of stick appears slightly rounded.

Cozy Cocoa

What could be better on a chilly afternoon than drawing a mug of steaming hot chocolate complete with mini marshmallows. Add a candy cane for a pop of color!

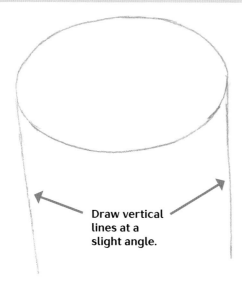

Draw vertical lines at a slight angle.

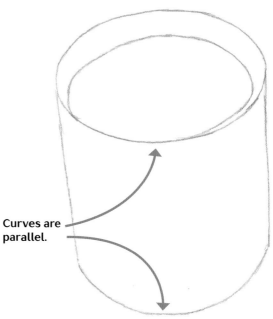

Curves are parallel.

PENCIL OUTLINE

1 Start with an ellipse shape with a line drawn downward on each side.

2 Close the two lines at the bottom with a curve. Add another ellipse inside the first to form the surface of the cocoa.

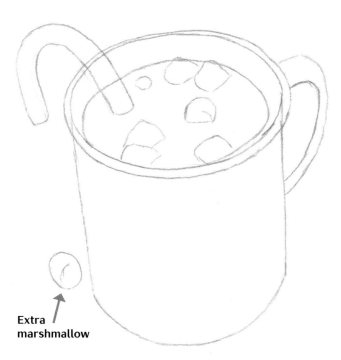

Extra marshmallow

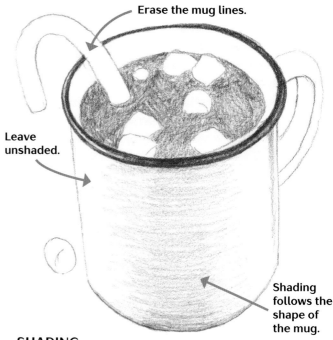

Erase the mug lines.

Leave unshaded.

Shading follows the shape of the mug.

3 Add a rim around the top of the mug. Place small rounded shapes inside the ellipse for "floating" mini marshmallows and two backward "C" shapes for the mug handle. Draw an upside-down "J" for the candy cane.

SHADING

4 Darken the rim, leaving a thin area untouched to indicate shine. Curve light lines around the front of the mug. Use the edge of the pencil to block in the cocoa. Add an inner line to the handle.

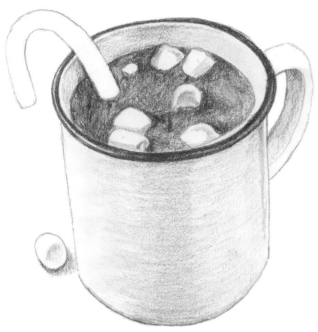

ADD DETAILS

5 Add more tone overall. Blend the tone on the mug following the curve of the shape. Add shadows to the lower right of each marshmallow and add a layer of light tone to the inner rim of the mug.

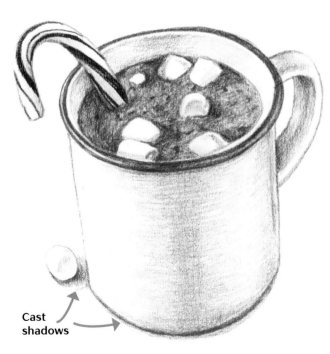

Cast shadows

6 Draw lines around the contours of the cane using colored pencil. Darken the shadows, leaving the cocoa somewhat rough. Add scribbles for texture. Add shadow to the cane. Erase areas to create highlights on the mug and marshmallows.

Circles in Perspective

If you look at a cylindrical object like a mug, the top (opening) and bottom are circles. But unless you are drawing the object as if looking straight down on it, the circles will become *ellipses* (ovals) because of perspective.

At the horizon line (eye level), the circle is a straight line. As you move above or below that line, it becomes an ellipse that gets taller until it becomes a circle.

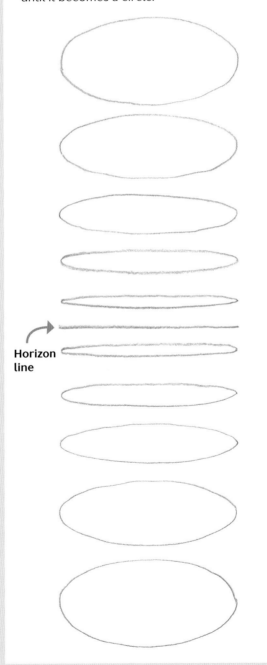

Horizon line

Yummy Cupcake

Oil pastel is a wonderful medium to use to draw in color and easily get a painterly look. There is no waiting for paint to dry and you can blend colors using just the pastel sticks for a smooth, creamy finish.

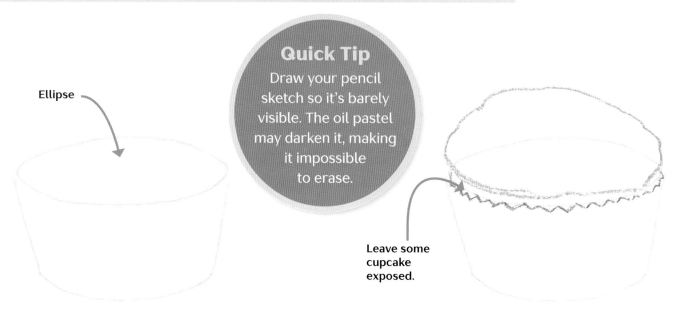

Ellipse

Quick Tip
Draw your pencil sketch so it's barely visible. The oil pastel may darken it, making it impossible to erase.

Leave some cupcake exposed.

PENCIL SKETCH

1 Draw an ellipse top with two slightly angled lines connected to each edge. Connect the lines with a curve to create the base.

START WITH OIL PASTEL

2 Add a zigzag line around the front of the ellipse with brown pastel. With the color of your choice, draw a mound for the frosting that extends beyond the original ellipse.

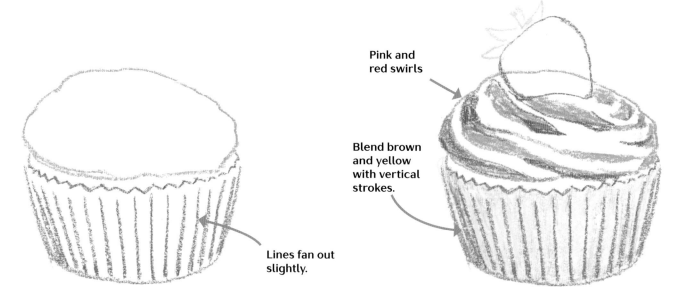

Pink and red swirls

Blend brown and yellow with vertical strokes.

Lines fan out slightly.

3 Go over the cupcake liner with brown. Add lines that are slightly fanned out.

ADD VALUE AND DETAILS

4 Color over the liner with yellow. Use your original frosting outline color and a darker shade of that same color to add swirls of color. Add a strawberry outline shape.

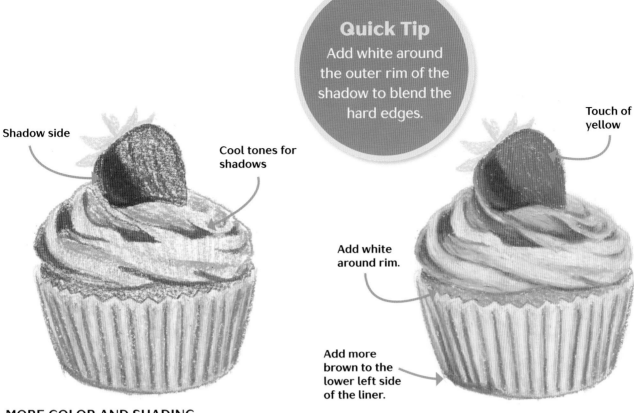

Shadow side

Cool tones for shadows

Quick Tip
Add white around the outer rim of the shadow to blend the hard edges.

Touch of yellow

Add white around rim.

Add more brown to the lower left side of the liner.

MORE COLOR AND SHADING

5 Fill in the strawberry, adding a darker tone to the shadow side. Fill in the rest of the frosting with light pink. Deepen the folds of frosting with purple or blue shades.

6 Add a light layer of brown to the space between liner and frosting. Smooth over the frosting colors with white pastel and the strawberry with pink. Using a blending tool and a vertical motion, blend the colors of the liner.

7 Darken the shadows of frosting and liner using cool blues or purples. Add dots of color to the berry for the seeds. Add a blue shadow rimmed with purple.

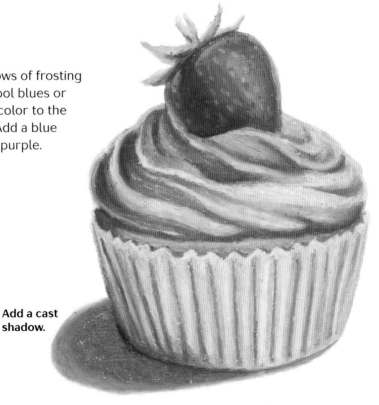

Add a cast shadow.

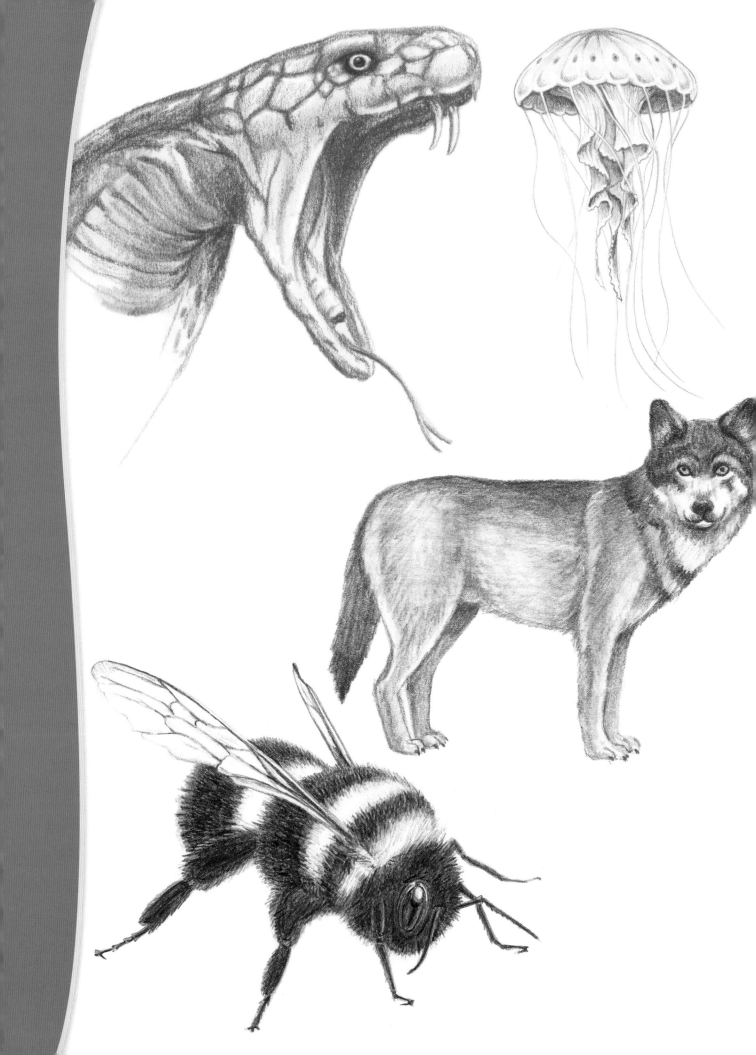

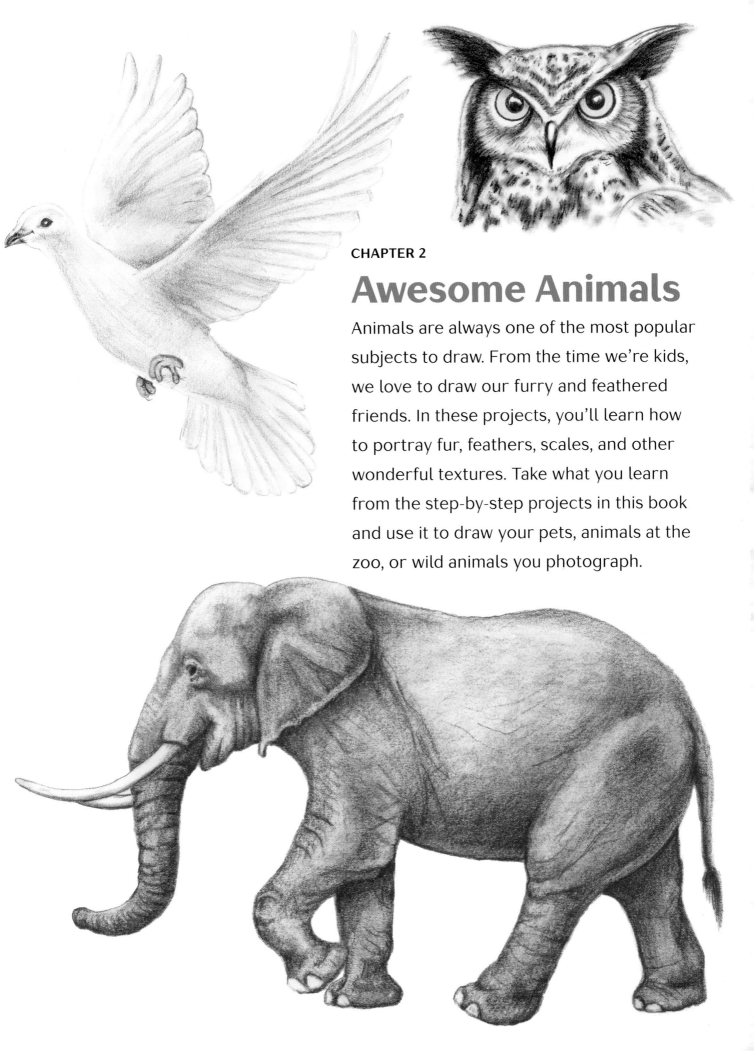

Awesome Animals

Animals are always one of the most popular subjects to draw. From the time we're kids, we love to draw our furry and feathered friends. In these projects, you'll learn how to portray fur, feathers, scales, and other wonderful textures. Take what you learn from the step-by-step projects in this book and use it to draw your pets, animals at the zoo, or wild animals you photograph.

Cat's Eyes

Focus on a feline's beautiful eyes in this drawing to capture all the subtle colors that make them so mesmerizing.

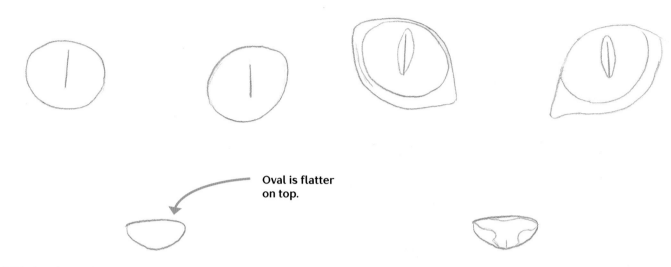

Oval is flatter on top.

PENCIL SKETCH

1 Start with two circle shapes for the eyes with short lines for pupils and an oval for the nose.

2 Draw a frame around each eye with a point in the inner corners to define them. Draw elongated ovals around the pupil lines and refine the nose.

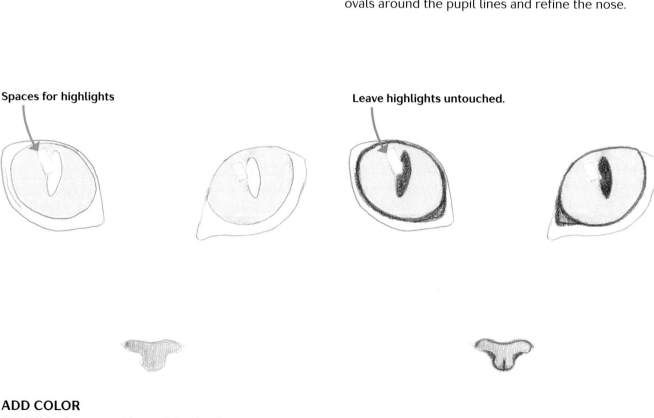

Spaces for highlights

Leave highlights untouched.

ADD COLOR

3 Fill in the eyes with a solid color, leaving a space near the pupil top white for a highlight. Color the nose a light pink.

4 Outline the eyes and nose with black. Fill in the pupil with black as well.

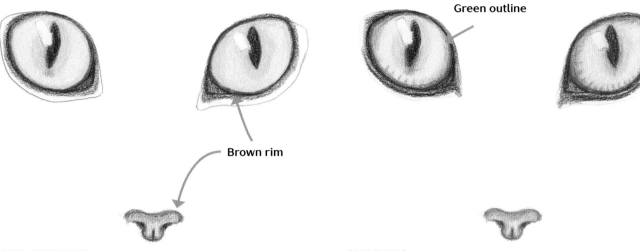

Green outline

Brown rim

ADD DETAILS

5 Add a rim of brown around the inside of the black outline of both the eyes and the nose. Add light green around the pupils and outer edges of the eye.

SHADING

6 Add dark green around the inside edges of the eyes and blend into the yellow. Add a light black rim to the outer outline of the eye and deepen the tones on the nose.

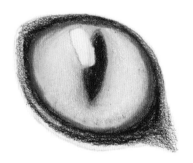

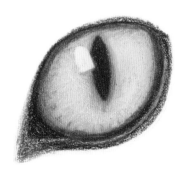

7 Deepen the tones and blend until a glossy finish is achieved on the eye. Erase any pigment that may have been left in the highlight.

Serene Swan

This classic pose is a great example of starting with very simple shapes. Follow the steps so you don't end up with an ugly duckling.

PENCIL SKETCH

1 Draw a simple hill with a flat bottom. Add a small oval near the upper right.

2 Connect the oval and hill with two curvy lines. This will be the swan's neck.

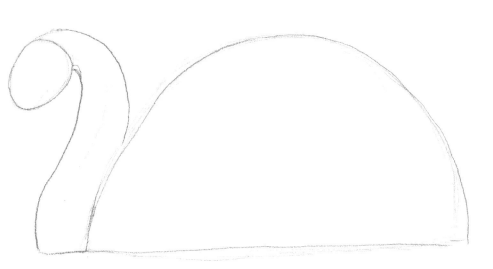

3 Use the oval as a guide to refine the head and add an extending beak. Use the hill shape to form a wing outline and tail.

Wing

The wing and the tail follow the curve of the hill shape.

Tail

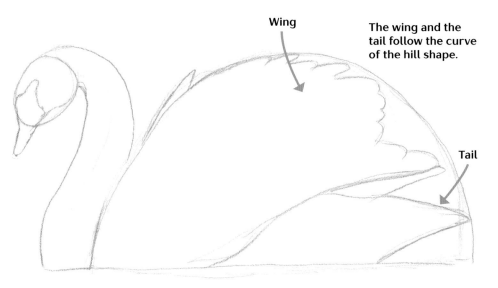

Light source

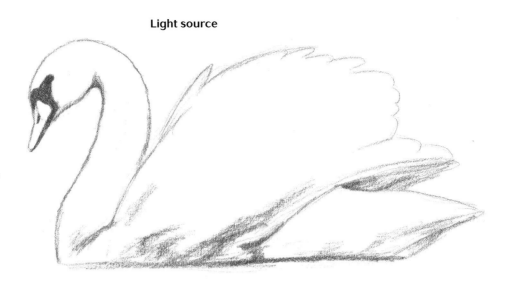

BEGIN SHADING

4 Erase the original guidelines. Add dark tone to the undersides of the swan, opposite the light source on top. This includes under the neck and near the base.

Leave area around head unshaded.

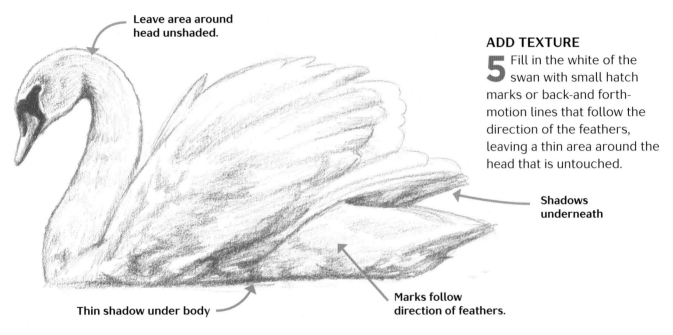

ADD TEXTURE

5 Fill in the white of the swan with small hatch marks or back-and forth-motion lines that follow the direction of the feathers, leaving a thin area around the head that is untouched.

Shadows underneath

Thin shadow under body

Marks follow direction of feathers.

BLENDING AND HIGHLIGHTS

6 Blend the light tones and add a few more lines for feathers. Erase areas for highlights, including a small spot on the eye. Add a few back-and-forth lines under and around the swan for a reflective water surface.

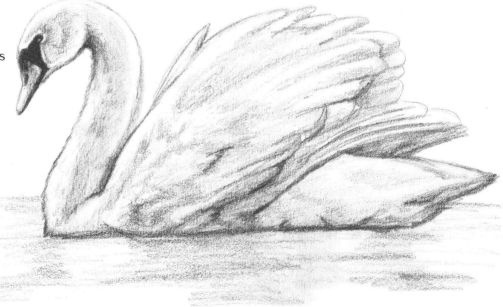

Gentle Giant

This peaceful pachyderm is a sculptural delight to draw. Getting the wrinkles just right will make this drawing come to life.

SIMPLE SHAPES

1 Draw a small and large oval shape. Notice the placement and size difference. These will be the head and body guidelines.

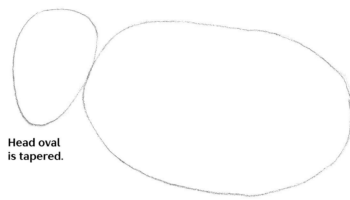

Head oval is tapered.

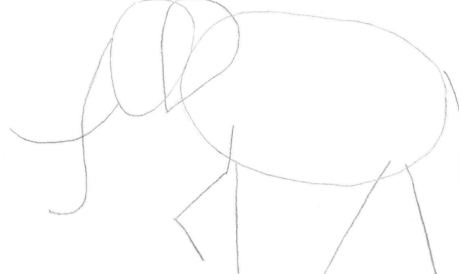

ADD DETAILS

2 Add simple lines to indicate the trunk, tusk, ear, legs, and tail.

3 Use the simple lines drawn in Step 2 to thicken the trunk, tusk, ear, legs, and tail.

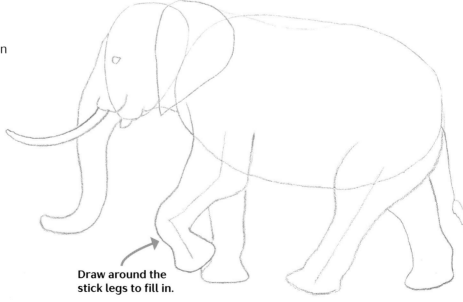

Draw around the stick legs to fill in.

REFINE THE DRAWING

4 Erase the guidelines still seen from Step 2 and add a few lines for wrinkles and curves for toenails.

Wrinkles follow shape of trunk. →

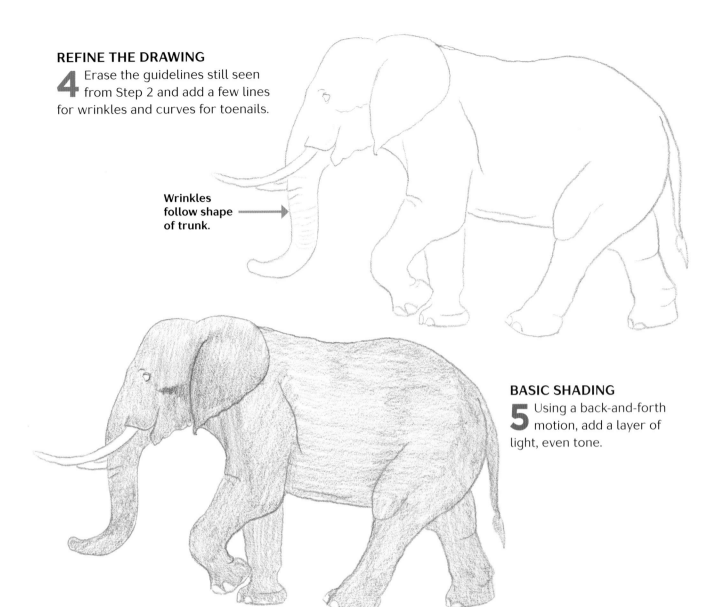

BASIC SHADING

5 Using a back-and-forth motion, add a layer of light, even tone.

DARKEN AND BLEND

6 Use heavier pencil pressure to darken areas of shadow. Blend the tones using a light touch. Add a few more lines that wrap around the trunk and legs for wrinkles. Add light lines under the neck.

Light area adds bulk.

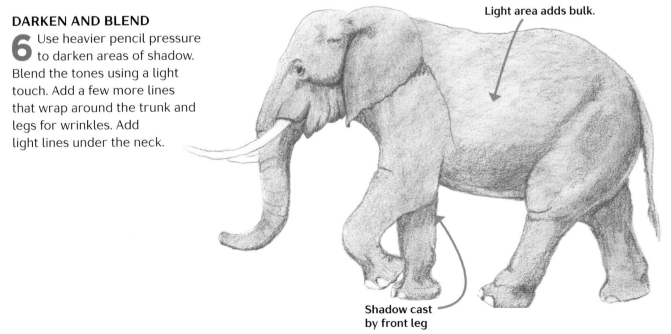

Shadow cast by front leg

HIGHLIGHTS AND WRINKLES

7 Erase some areas for highlights and use a light pencil to create fine wrinkles by following the contours of the body.

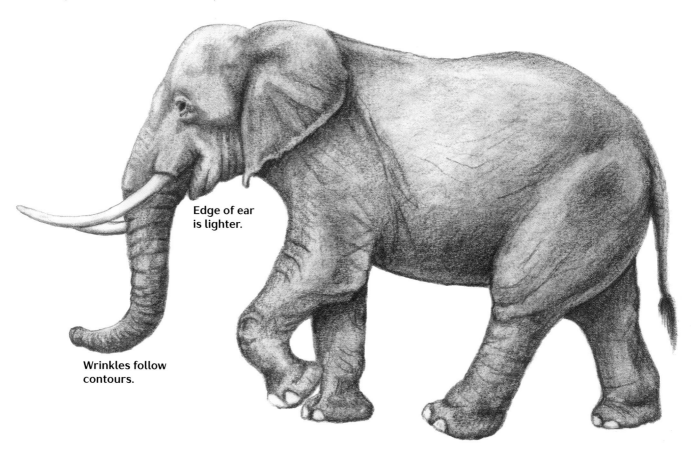

Edge of ear
is lighter.

Wrinkles follow
contours.

Wrinkles and Folds

Elephants are a great opportunity to practice drawing wrinkles because they have very little hair on their bodies. And drawing the wrinkles accurately makes the drawing more realistic.

When drawing wrinkles, be sure to observe where the natural light hits the folds and which areas are in shadow. The contrast between these areas is where the wrinkles are defined.

Don't use the same tone for the entire wrinkle; variation makes a wrinkle appear realistic. It may help to draw the entire wrinkle line, then add and change that line, erasing areas to create lightness or darkening areas so the fold stands out.

Add any finishing touches to create more contrast, erasing and darkening as needed. With a little practice and observation, realistic wrinkles can be achieved.

Notice the areas of shadow and highlight that create realistic-looking wrinkles.

Busy Bee

In a close-up view, a bee is as furry as a bear cub. The fuzzy body contrasts with the delicate wings and the shiny eye.

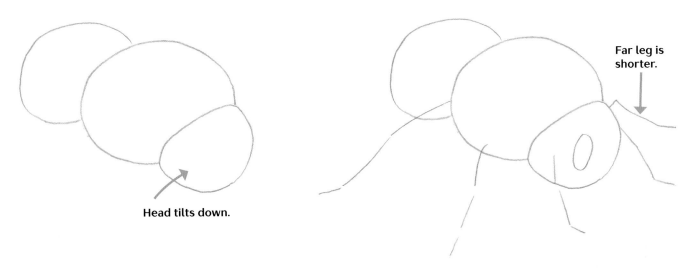

Head tilts down.

Far leg is shorter.

SIMPLE SHAPES

1 Draw oval shapes for the head, thorax, and abdomen, allowing them to overlap.

ADD THE LEGS AND WINGS

2 Add sticks to indicate where the legs will go. Add an oval for the eye.

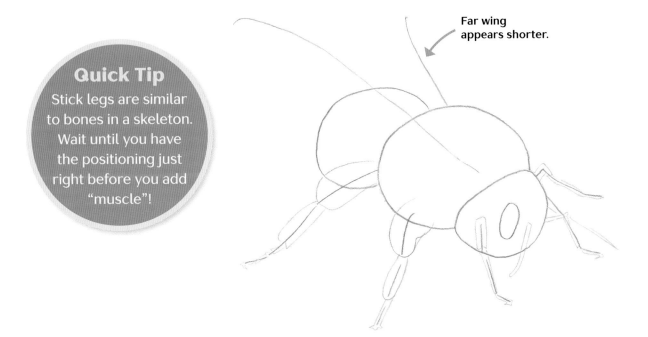

Quick Tip
Stick legs are similar to bones in a skeleton. Wait until you have the positioning just right before you add "muscle"!

Far wing appears shorter.

3 Thicken the legs by drawing segments around the original guidelines. Add a line to indicate where the wings will be and draw short antennae in front of the head.

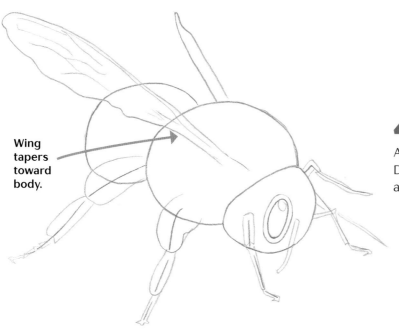

Wing tapers toward body.

4 Draw the wings around the guidelines added in Step 3 using a wavy, organic line. Add light lines in the wing for the subtle veins. Draw a small circle in the eye for a highlight and a border around the eye.

Shade in the direction of the body segments.

START SHADING
5 Block in the areas that will eventually be the darkest using short dashed lines or a tight zigzag motion.

6 Fill in the center of the length of each leg, then add short dash marks around them to show fuzzy texture, leaving the edges slightly lighter than the center. Darken the value on the stripes made in Step 5.

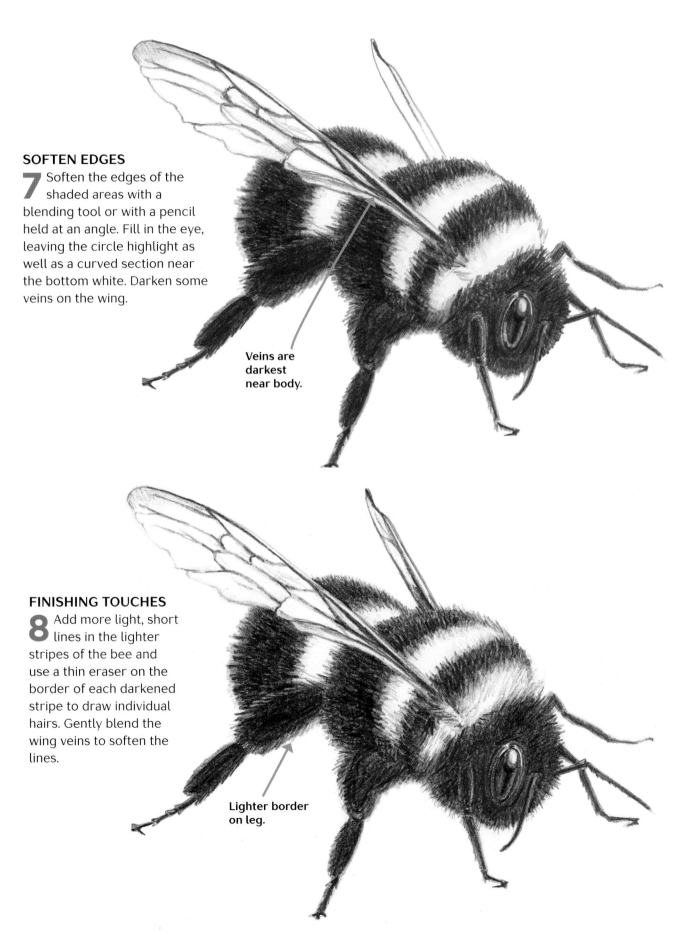

SOFTEN EDGES

7 Soften the edges of the shaded areas with a blending tool or with a pencil held at an angle. Fill in the eye, leaving the circle highlight as well as a curved section near the bottom white. Darken some veins on the wing.

Veins are darkest near body.

FINISHING TOUCHES

8 Add more light, short lines in the lighter stripes of the bee and use a thin eraser on the border of each darkened stripe to draw individual hairs. Gently blend the wing veins to soften the lines.

Lighter border on leg.

Peaceful Dove

In this drawing, I demonstrate *low-contrast shading*—shading within a narrow range of values. There is still enough contrast to show volume and form, but the overall effect is soft and lovely.

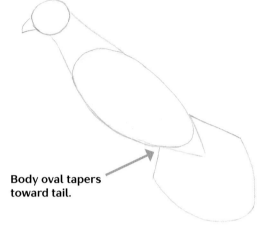

Body oval tapers toward tail.

PENCIL DRAWING

1 Start with a small oval for the head and a larger oval-like shape for the body.

2 Connect the head and body with lines. Add a small triangle beak shape and start shaping the tail with straight lines and curves.

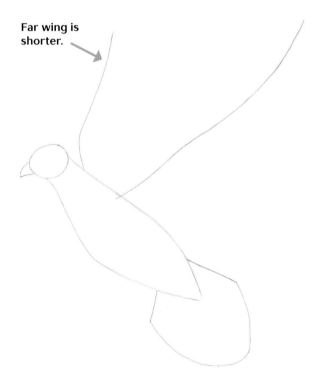

Far wing is shorter.

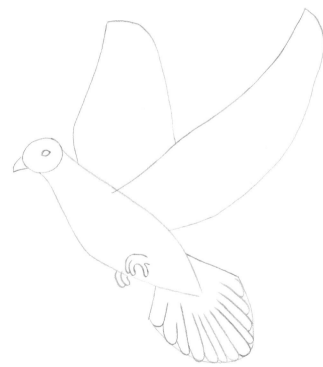

3 Erase the original inner oval. Draw lines to indicate the tops of the wings.

ADD DETAILS

4 Draw the individual tail feathers using the outer curves as guides. Connect lines to the wing tops. Add feet and the eye. Fill in the feet and the eye. Add individual wing feathers.

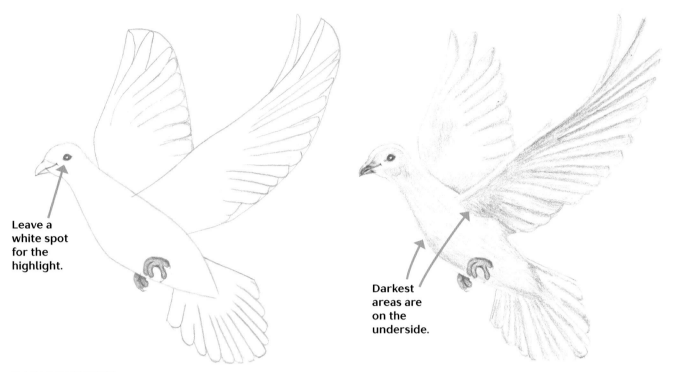

Leave a white spot for the highlight.

Darkest areas are on the underside.

BASIC SHADING

5 Using the edge of your pencil, add a light layer of tone to the entire bird. Make the lines between the feathers, the underside of the body, under the base of the eye, and the point near the tail slightly darker than the rest.

6 Use a blending tool to smooth the tones to create a smooth transition.

Quick Tip
Using the edge (side) of the pencil instead of the tip creates a softer tone.

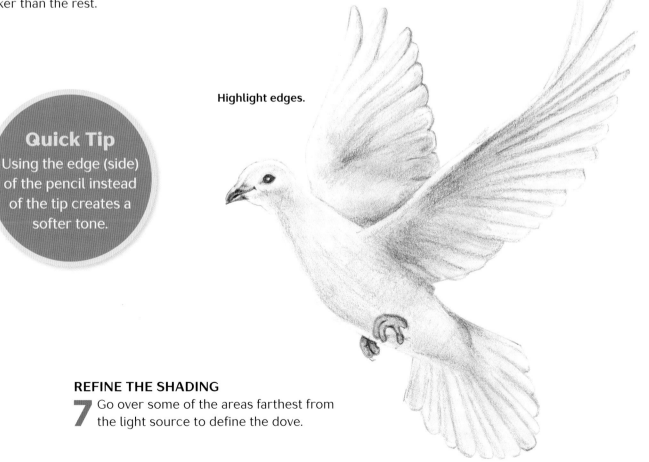

Highlight edges.

REFINE THE SHADING

7 Go over some of the areas farthest from the light source to define the dove.

Lovely Ladybug

Blending colored pencil and leaving distinct highlights creates an incredibly glossy shine for this pretty insect.

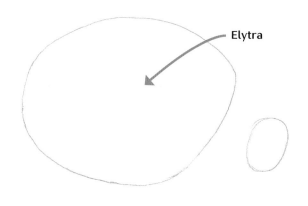

Elytra

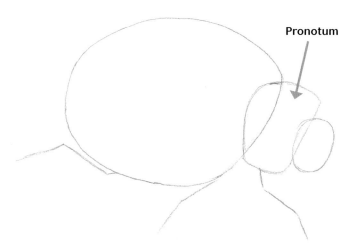

Pronotum

THE BASIC SHAPE

1 Start with a large circular shape for the main body (elytra) and a small oval for the head.

2 Add a shape (pronotum) between the head and the main body to connect them and add lines to indicate legs.

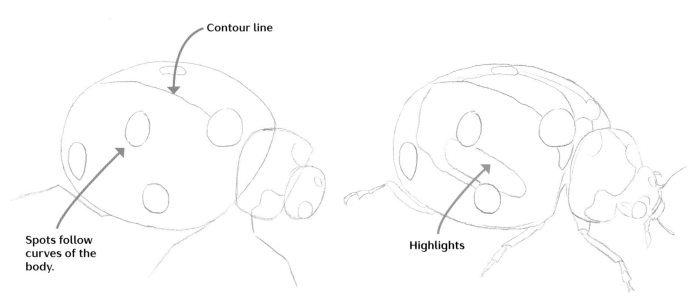

Contour line

Spots follow curves of the body.

Highlights

ADD SPOTS AND DETAILS

3 Draw a line that follows the contour of the body along with a few small circle shapes for spots. Draw circular eyes on the head and a pattern on the pronotum.

4 Draw a light line to indicate where color and tone change will occur. Define the legs and add antennae.

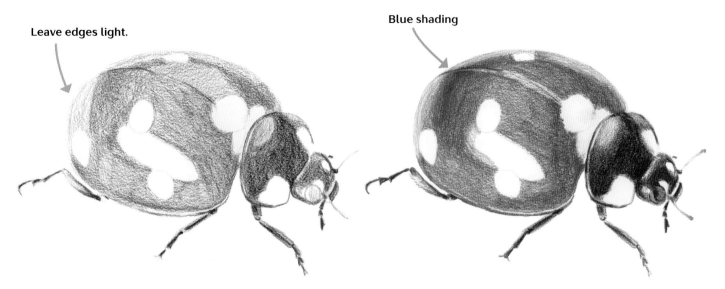

Leave edges light.

Blue shading

ADD COLOR

5 Begin to add a light layer of color. Using red and black, press hard in areas that will eventually be the darkest, leaving areas around the edges of the main shapes lighter.

6 Add a coat of orange-red and yellow on the red to create interest. Use a light blue near the back of the bug and on the head areas.

> **Quick Tip**
> Adding cool colors like blue and purple to the red and orange tones gives an iridescent effect.

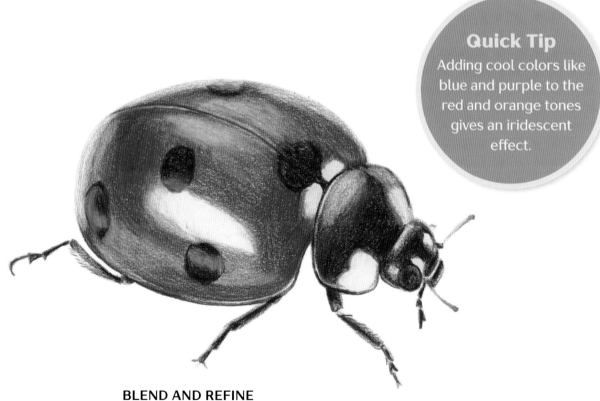

BLEND AND REFINE

7 Add a light coat of purple to the wing separation line and to the darkest areas of red. Refine and erase for highlights. The eraser can also be used lightly to blend tones together.

Wise Owl

Charcoal is a wonderful drawing medium that creates an entirely different look than pencil. Colored pencil eyes create a compelling focal point.

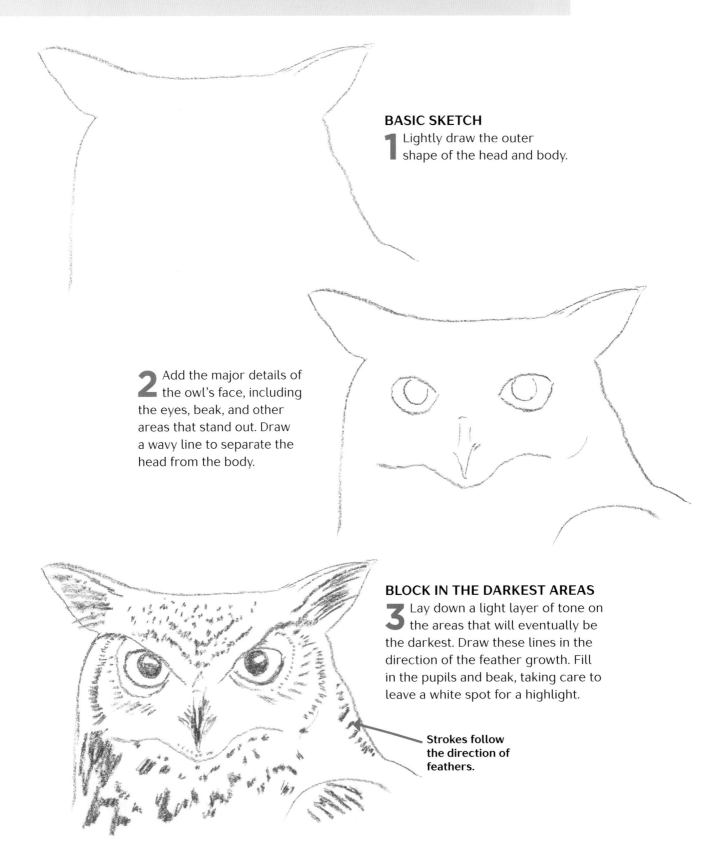

BASIC SKETCH

1 Lightly draw the outer shape of the head and body.

2 Add the major details of the owl's face, including the eyes, beak, and other areas that stand out. Draw a wavy line to separate the head from the body.

BLOCK IN THE DARKEST AREAS

3 Lay down a light layer of tone on the areas that will eventually be the darkest. Draw these lines in the direction of the feather growth. Fill in the pupils and beak, taking care to leave a white spot for a highlight.

Strokes follow the direction of feathers.

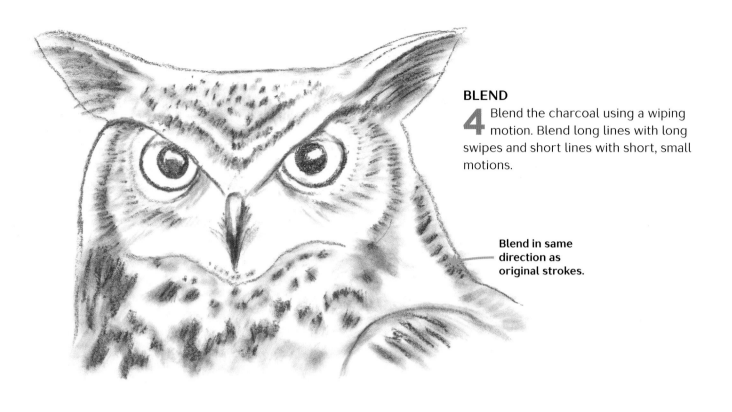

BLEND

4 Blend the charcoal using a wiping motion. Blend long lines with long swipes and short lines with short, small motions.

Blend in same direction as original strokes.

MORE CHARCOAL

5 Go back in and darken up some areas to make the image more intense.

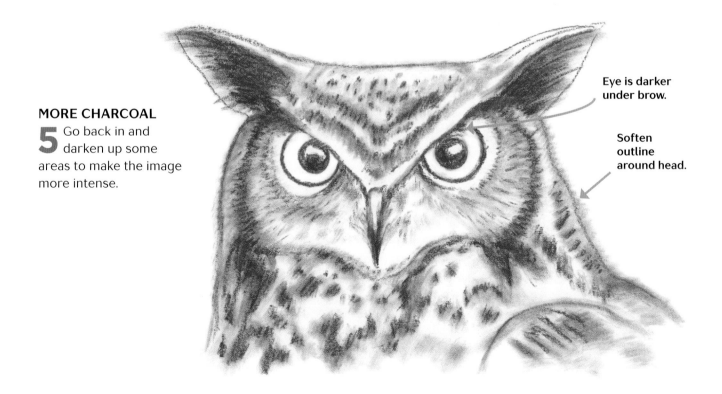

Eye is darker under brow.

Soften outline around head.

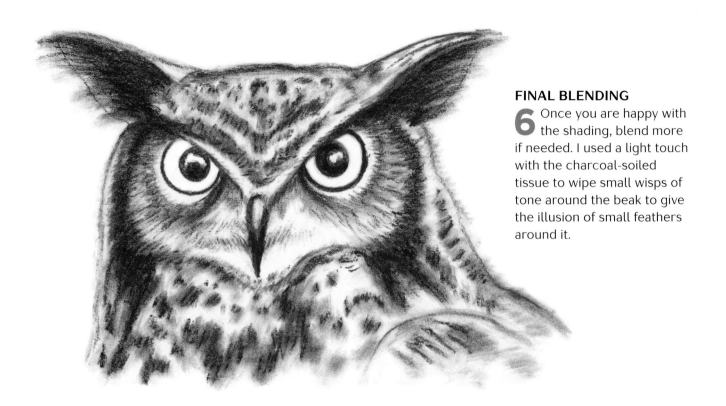

FINAL BLENDING

6 Once you are happy with the shading, blend more if needed. I used a light touch with the charcoal-soiled tissue to wipe small wisps of tone around the beak to give the illusion of small feathers around it.

COLOR THE EYES

7 Fill in the iris area around the pupil with yellow colored pencil. Next, fill in the top part of the area around the pupil with orange. The orange and yellow should overlap and blend into one another for a smooth transition of color.

Elegant Flamingo

You don't have to draw individual feathers to create a convincing effect. Try drawing this lovely bird with shades of pink and orange colored pencil.

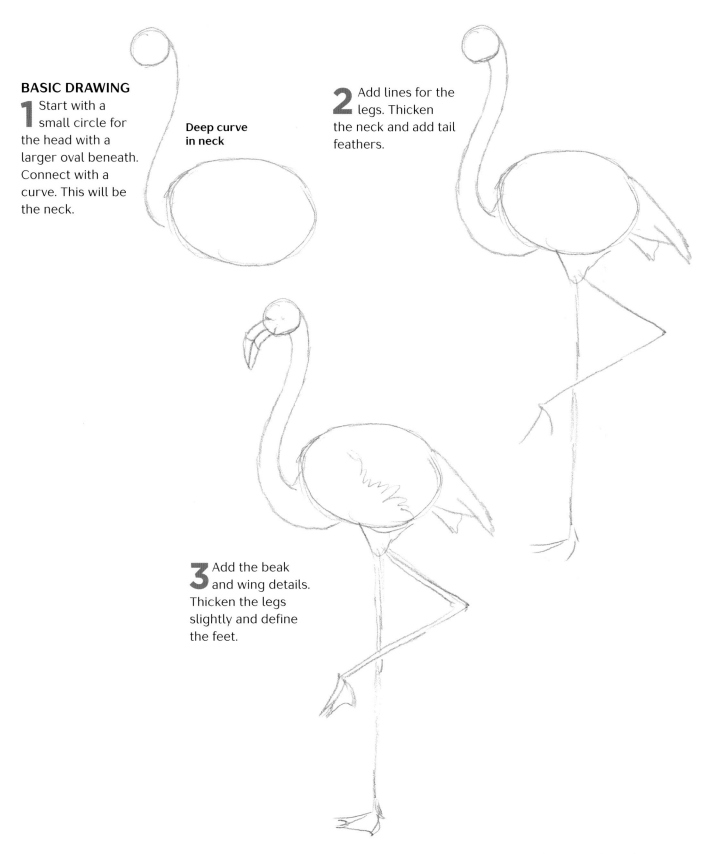

BASIC DRAWING

1 Start with a small circle for the head with a larger oval beneath. Connect with a curve. This will be the neck.

Deep curve in neck

2 Add lines for the legs. Thicken the neck and add tail feathers.

3 Add the beak and wing details. Thicken the legs slightly and define the feet.

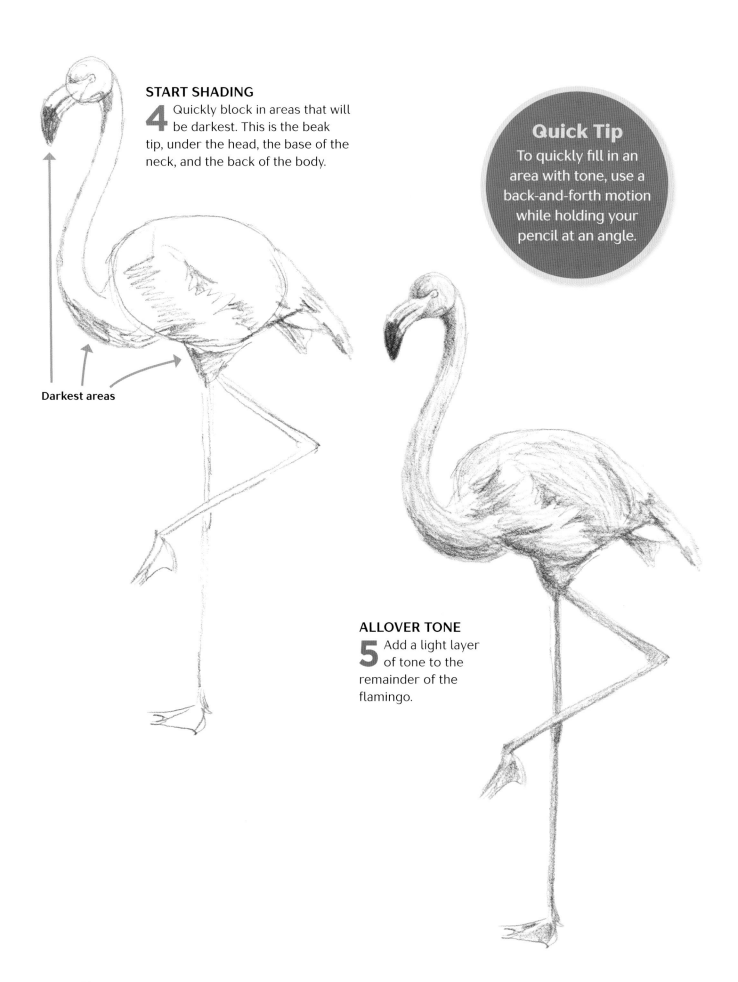

START SHADING

4 Quickly block in areas that will be darkest. This is the beak tip, under the head, the base of the neck, and the back of the body.

Darkest areas

Quick Tip

To quickly fill in an area with tone, use a back-and-forth motion while holding your pencil at an angle.

ALLOVER TONE

5 Add a light layer of tone to the remainder of the flamingo.

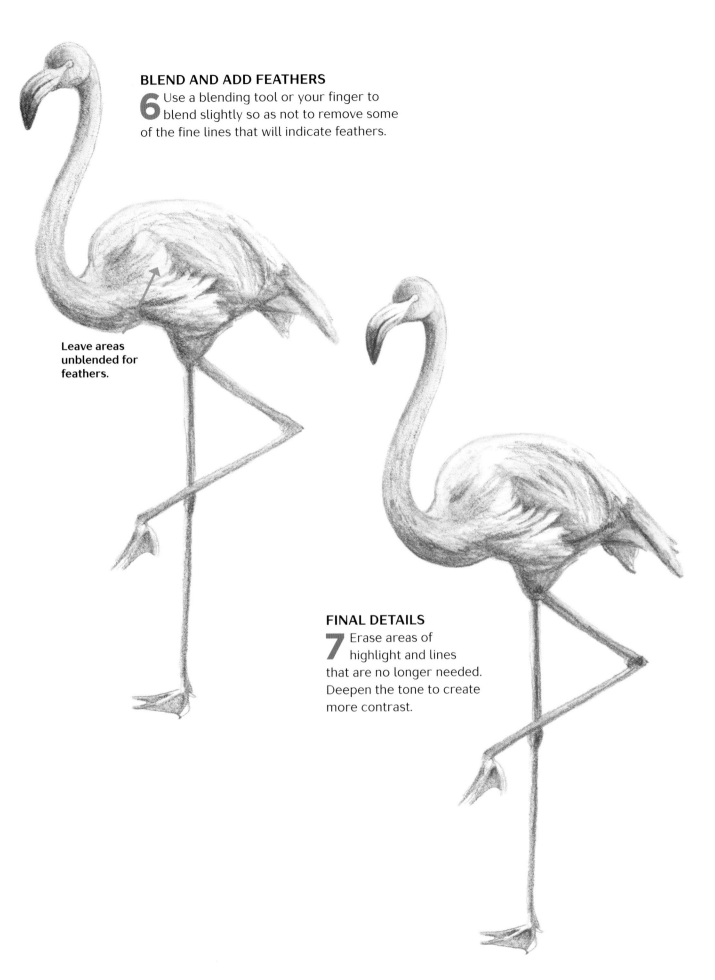

BLEND AND ADD FEATHERS

6 Use a blending tool or your finger to blend slightly so as not to remove some of the fine lines that will indicate feathers.

Leave areas unblended for feathers.

FINAL DETAILS

7 Erase areas of highlight and lines that are no longer needed. Deepen the tone to create more contrast.

Little Frog

This friendly frog looks ready to hop off the page.
Create convincing texture with simple shading.

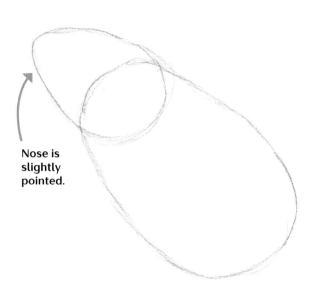

Nose is
slightly
pointed.

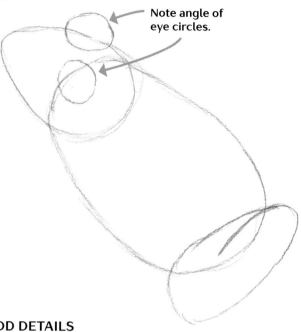

Note angle of
eye circles.

BASIC SHAPES

1 Start with an egg shape and an overlapping oval.

ADD DETAILS

2 Add circles for the eyes and an irregular oval for the hind leg.

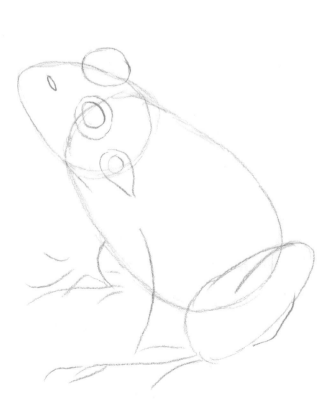

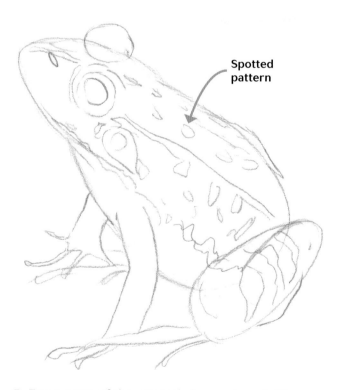

Spotted
pattern

3 Sketch in lines where the legs and toes will go. Make an upside-down raindrop shape and circle for the ear.

4 Erase parts of the original shapes done in Step 1 that are no longer needed. Draw a pattern if desired.

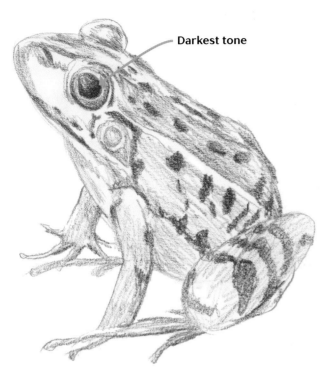

Darkest tone

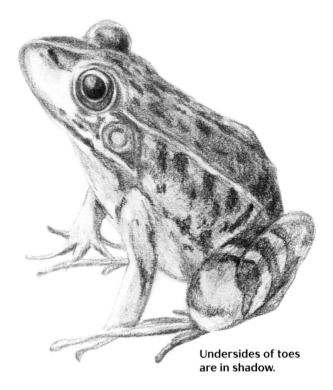

Undersides of toes
are in shadow.

SHADE THE FROG

5 Start to add tone, making it darker on the pattern and lighter around it. The pupil should be one of the darkest tones in the drawing.

6 Blend and add even darker tone to the shadow areas. Erase areas of highlight and lines that are no longer needed. Deepen the tone to create more contrast. Add some dots for skin texture.

Creating Texture

Texture is the way something feels to the touch—rough, smooth, soft, bumpy, etc. Implied texture, or the perception of texture, can be created visually.

Each texture is unique and requires specific marks to recreate them. You may use light, dark, narrow, broad, hard, or soft marks. Adding shadow and highlights in the proper places will help make your texture appear three-dimensional and realistic.

Textures can be organic, as in the skin of this frog, or man-made. Textures can be random or follow a specific pattern. Organic textures are generally more random or irregular.

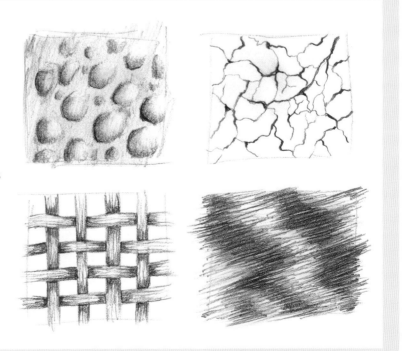

Inside the Nautilus Shell

This drawing offers an unusual view of a shell—from the inside. This cross-section focuses on drawing the delicate inner chambers of the shell.

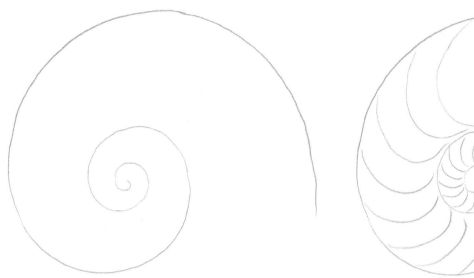

Curves get closer together toward the center.

BASIC SWIRL

1 Start with a spiral that progressively gets wider with each curve.

ADD DETAILS

2 Draw short curves through the length of the spiral that become closer together as they move toward the spiral center.

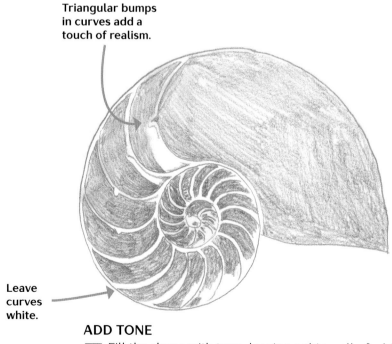

Triangular bumps in curves add a touch of realism.

Leave curves white.

ADD TONE

3 Fill the shape with tone, leaving a thin wall of white between the curves for a three-dimensional edge.

Light source

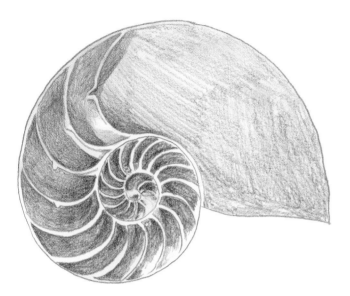

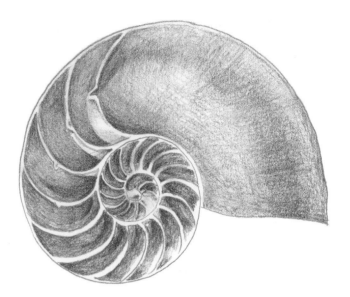

DEEPEN SHADING

4 The light source here is from above and left of the shell. Darken portions inside the curve where the light source is not direct.

5 Blend and darken areas as needed.

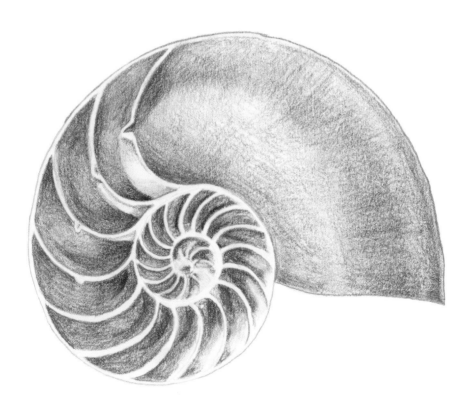

DEFINE AND HIGHLIGHT

6 Focus on the separating walls: use an eraser to highlight them and a hard graphite pencil to define them.

Ghostly Jellyfish

Undulating tentacles give movement to this otherworldly creature, which is also known as a sea jelly. The underside of the "bell" is visible as if the jelly is floating above you.

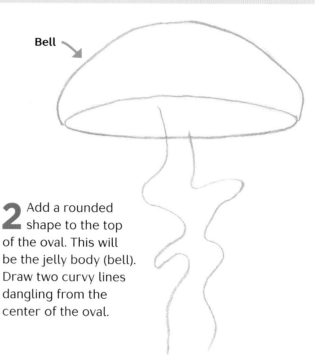

Bell

THE BASIC DRAWING

1 Start with a flattened oval at the top of your paper

2 Add a rounded shape to the top of the oval. This will be the jelly body (bell). Draw two curvy lines dangling from the center of the oval.

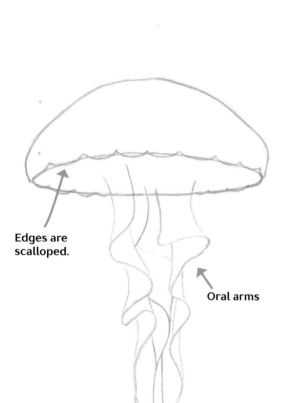

Edges are scalloped.

Oral arms

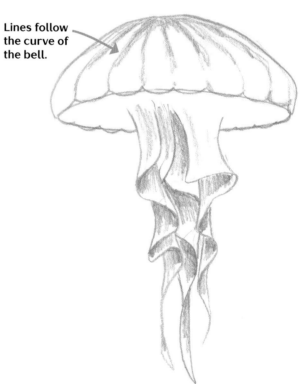

Lines follow the curve of the bell.

3 Connect the curves with lines to create the look of waving banners with folds curling in and out. These will be the "oral arms." Add one more oral arm between them. Scallop the edges of the bell.

ADD TONE AND DETAILS

4 Erase part of the oval behind the oral arms. Add lines that follow the contour of the jelly body, shading in the very top. Add light tone to the folds of the oral arms.

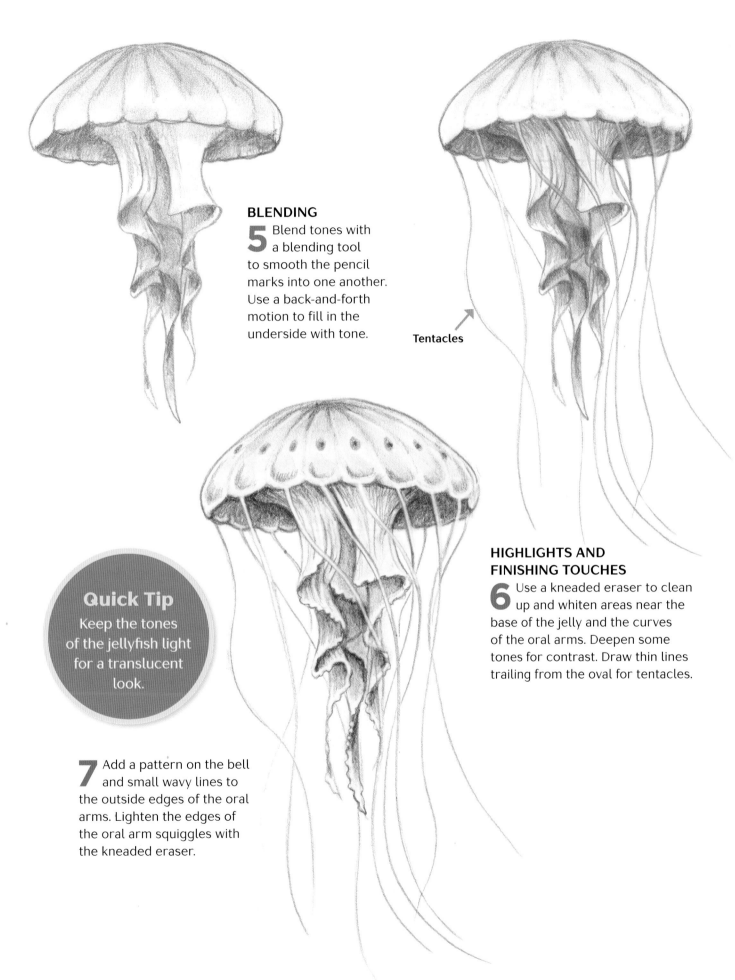

BLENDING

5 Blend tones with a blending tool to smooth the pencil marks into one another. Use a back-and-forth motion to fill in the underside with tone.

Tentacles

Quick Tip

Keep the tones of the jellyfish light for a translucent look.

HIGHLIGHTS AND FINISHING TOUCHES

6 Use a kneaded eraser to clean up and whiten areas near the base of the jelly and the curves of the oral arms. Deepen some tones for contrast. Draw thin lines trailing from the oval for tentacles.

7 Add a pattern on the bell and small wavy lines to the outside edges of the oral arms. Lighten the edges of the oral arm squiggles with the kneaded eraser.

Serpent's Head

This vibrant drawing shows how you don't have to draw the entire animal to create a compelling subject.

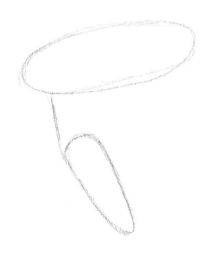

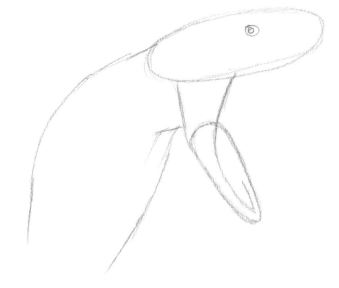

THE BASIC SKETCH

1 Draw two lean ovals connected with a line.

2 Draw lines for the jaw and portion of the body. Add small circles for the eye.

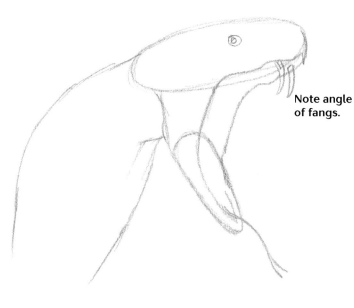

Note angle of fangs.

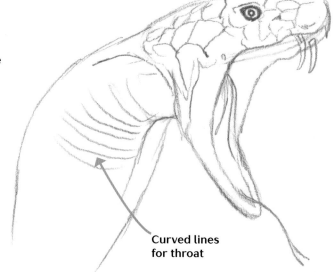

Curved lines for throat

3 Add the far end of the jaw, the fangs, and the lean forked tongue.

ADD SCALES

4 Erase the portions of the original oval guides that are no longer needed. Add a scaly pattern to the head.

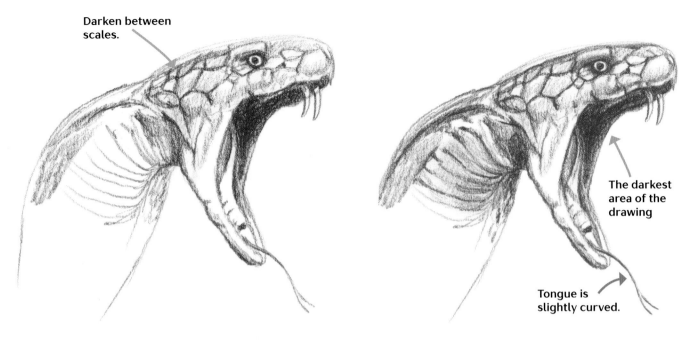

Darken between scales.

The darkest area of the drawing

Tongue is slightly curved.

BEGIN SHADING

5 Start to block in the darkest tones inside the mouth, around the eye, and between scales.

DEEPEN SHADING

6 Add more contrast by darkening lines where the scales meet and under the head.

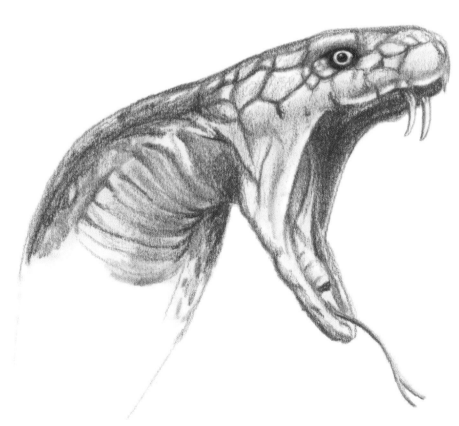

7 Blend tones for a smooth finish. Add a highlight to the eye.

A Whale of a Tail

Focusing on the *planes,* or surfaces, that make up a simple composition like this enables you to give your subject believable volume.

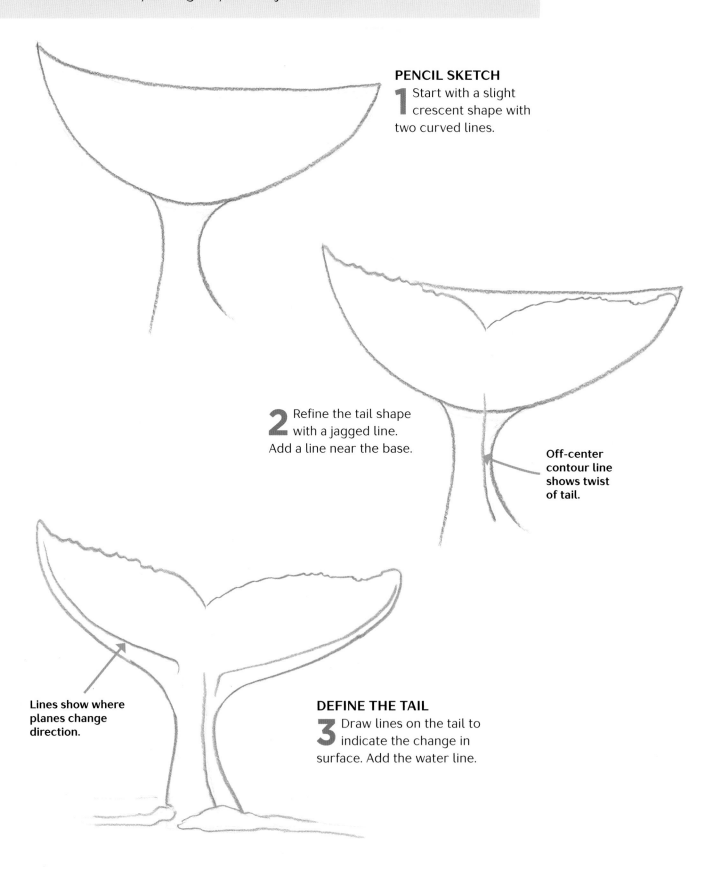

PENCIL SKETCH

1 Start with a slight crescent shape with two curved lines.

2 Refine the tail shape with a jagged line. Add a line near the base.

Off-center contour line shows twist of tail.

Lines show where planes change direction.

DEFINE THE TAIL

3 Draw lines on the tail to indicate the change in surface. Add the water line.

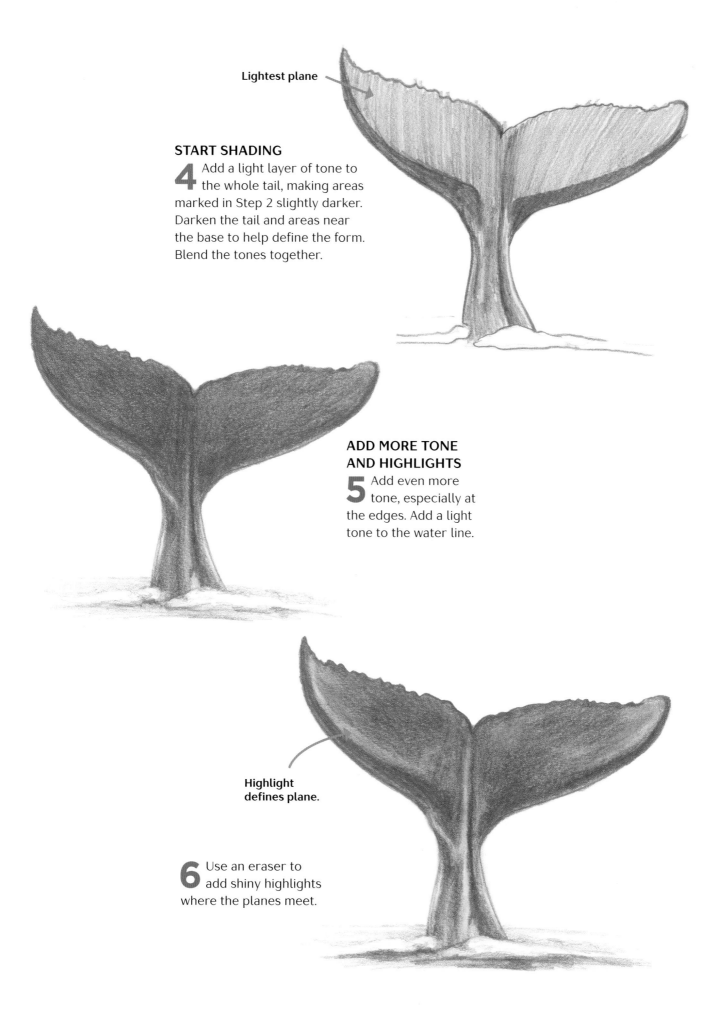

Lightest plane

START SHADING

4 Add a light layer of tone to the whole tail, making areas marked in Step 2 slightly darker. Darken the tail and areas near the base to help define the form. Blend the tones together.

ADD MORE TONE AND HIGHLIGHTS

5 Add even more tone, especially at the edges. Add a light tone to the water line.

Highlight defines plane.

6 Use an eraser to add shiny highlights where the planes meet.

Lone Wolf

Subjects like this are probably best drawn from photographs. Get up close to create soft fur with shading and highlights.

Shapes do not overlap.

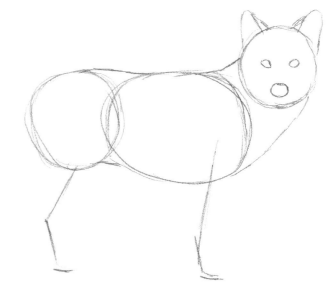

BASIC SHAPES

1 Start with a large oval for the chest with an overlapping circle for the rump. Draw a smaller circle on the opposite end for the head.

ADD THE LIMBS AND FEATURES

2 Connect the shapes with curved lines. Draw ear shapes and ovals for the eyes and nose on the smallest circle. Draw simple lines to indicate leg direction.

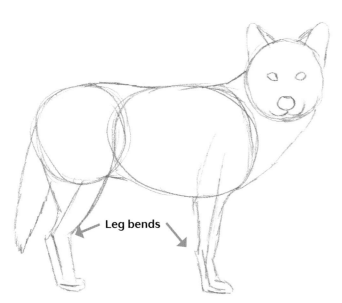

Leg bends

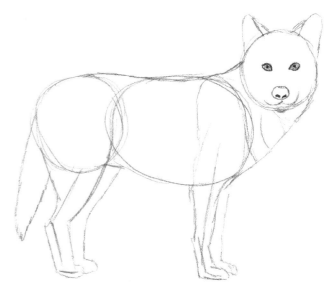

3 Use the leg lines as guides to draw more detailed legs. Notice where they bend. Add a tail and curves for a mouth directly under the nose.

4 Add legs "behind" the ones drawn in Step 3. Draw fold lines in the fur and pupil and nostril details.

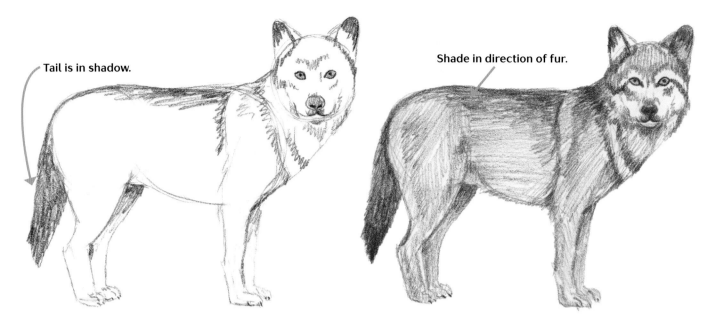

Tail is in shadow.

Shade in direction of fur.

BEGIN SHADING

5 Erase the parts of the original ovals and stick legs that are no longer needed. Start to add tone to the areas that will be the darkest.

DEEPEN SHADING

6 Fill in the entire wolf using medium tones, darkening the areas near the eyes, ears, nose, top of the back, and tip of the tail.

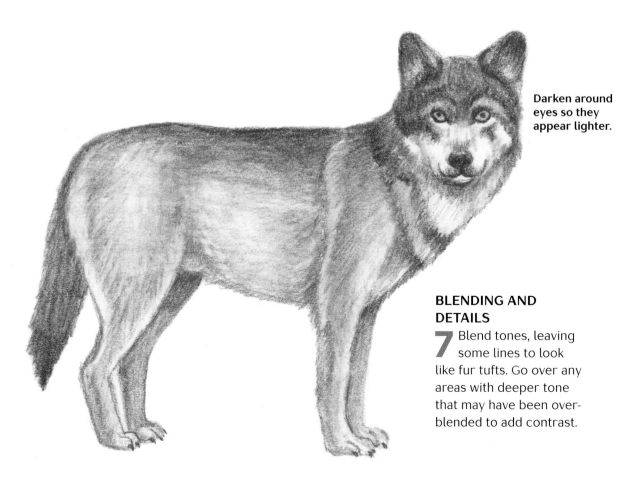

Darken around eyes so they appear lighter.

BLENDING AND DETAILS

7 Blend tones, leaving some lines to look like fur tufts. Go over any areas with deeper tone that may have been over-blended to add contrast.

Dexter the Cat

Pen can be an unforgiving drawing tool, but hatching and crosshatching are a sketchy way to draw with ink that can hide small mistakes and create a lively effect.

Ears curve forward.

PENCIL SKETCH

1 Draw the head and ear shapes using pencil first. This is an oval for the head, a half-rounded oval for the snout, and curved triangular ears.

2 Lay out the basic features of the face, including triangles for the eyes and connecting lines for the nose, and define the mouth and ears further.

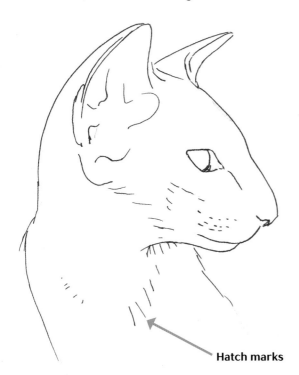

Hatch marks

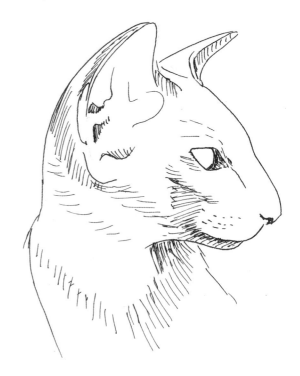

OUTLINE WITH PEN

3 With a fine-point, fiber-tip pen, outline the major features of the face that were already drawn. Erase the pencil lines. Add a few hatch marks to indicate shadow or a change in plane.

HATCHING

4 Add more hatch marks to indicate dark areas. The face will have shadow under the eye, near the chin, the corner of the eye, and behind the ears.

Crosshatching

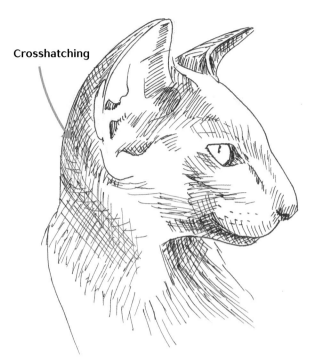

Lightest area

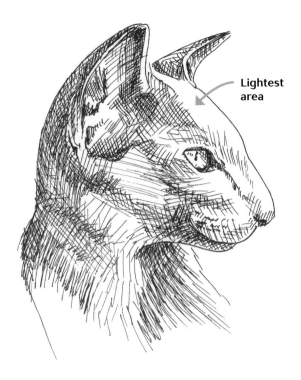

CROSSHATCHING

5 Start to crosshatch to make certain areas darker. This will create more contrast so that lighter areas stand out more.

6 Add more crosshatching to further define the mouth, cheekbone, neck, and ears. Add a few hatch marks to areas previously untouched, including the cheek area and the side of the head.

Quick Tip
Remember to leave areas white for highlights. You can't erase as with pencil.

FINISHING TOUCHES

7 Add hatching and crosshatching to smooth out any areas that show a sudden change in tone. Add more contrast so that certain features stand out. I left the eye, forehead, bridge of the nose, and top of the cheek lighter while darkening around them.

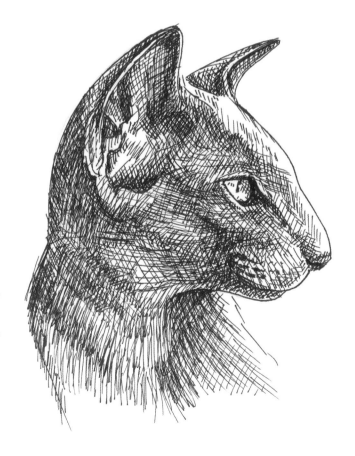

Affable Ant

This friendly ant drawing is all about the little details, like tiny hairs on the legs, that make an animal portrait lifelike. It's easier than it looks.

BASIC SHAPES

1 Draw three ovals. Notice that the first shape (the abdomen) doesn't touch the second (the thorax).

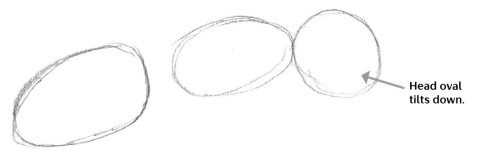

Head oval tilts down.

DRAW THE DETAILS

2 Add a beak-like mouth, an eye, and antennae to the head. Connect the abdomen to the thorax with curved lines.

Far antenna is shorter.

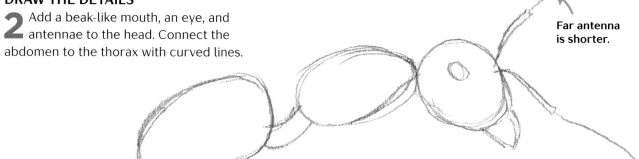

3 Add lines to indicate the direction of each leg.

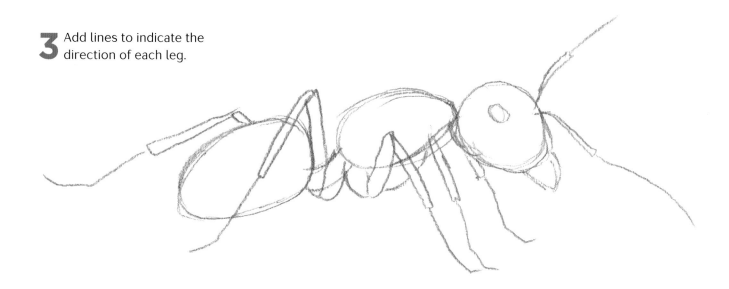

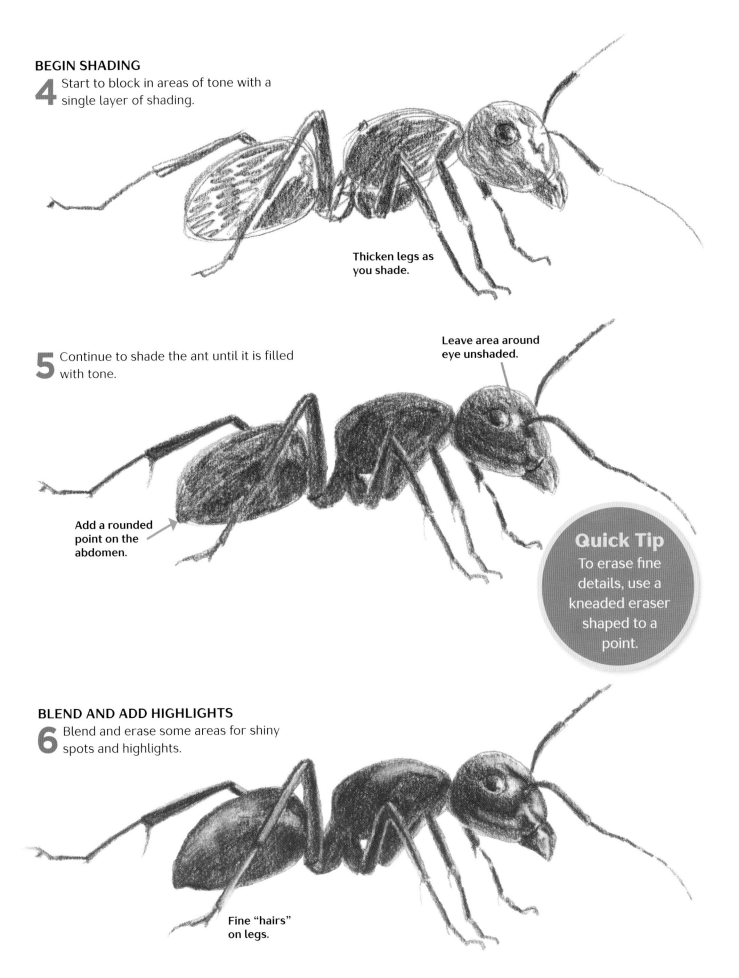

BEGIN SHADING

4 Start to block in areas of tone with a single layer of shading.

Thicken legs as you shade.

5 Continue to shade the ant until it is filled with tone.

Leave area around eye unshaded.

Add a rounded point on the abdomen.

Quick Tip
To erase fine details, use a kneaded eraser shaped to a point.

BLEND AND ADD HIGHLIGHTS

6 Blend and erase some areas for shiny spots and highlights.

Fine "hairs" on legs.

Sand Dollar

The sea provides an endless source of fascinating drawing subjects, such as this sand dollar, which is actually a type of sea urchin.

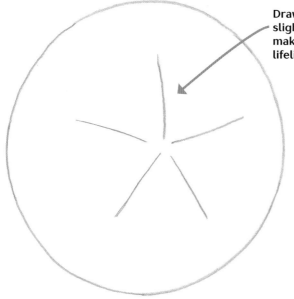

Drawing the star slightly off center makes it look more lifelike.

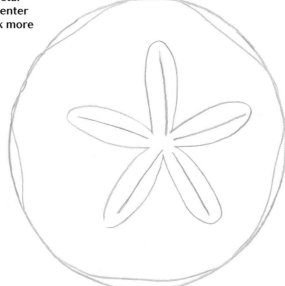

THE BASIC DRAWING

1 Start with a circle shape with five lines radiating out from the center in a star pattern.

2 Draw curved lines around the star spokes to form a starfish-type shape. Reshape the original outer circle to slightly curve inward between each leg of the star.

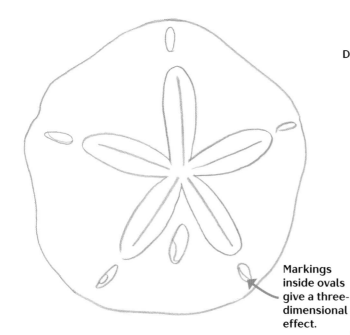

Markings inside ovals give a three-dimensional effect.

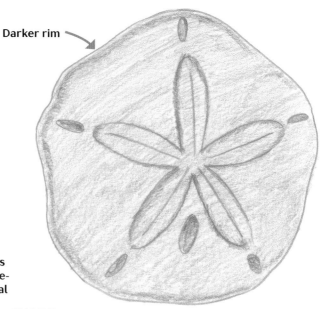

Darker rim

SHADE

3 Erase the outer circle drawn in Step 1. Add small ovals at the ends of each star spoke as well as a slightly larger one between two of the spokes.

4 Add a light layer of tone to the entire shape, darkening the tone inside the small ovals. Darken the rim of one side. Add a layer of tone to the outer star shape to further define it.

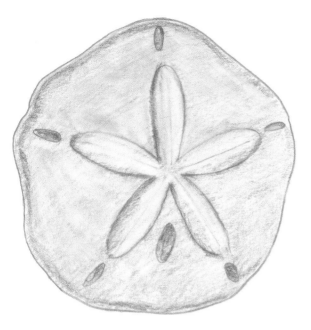

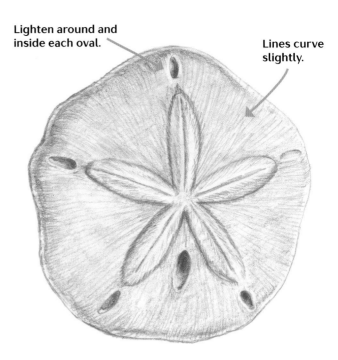

Lighten around and inside each oval.

Lines curve slightly.

BLEND AND ERASE

5 Use a blending tool to smooth out the tones. Press a kneaded eraser on the area outside and inside the star shape to lighten it, leaving the dark rim added in Step 4 intact.

ADD TEXTURE

6 Draw light lines radiating from the center to show texture. Erase a thin line around each oval as well as a small section inside to show depth.

Quick Tip
Use the kneaded eraser to lighten the whole sand dollar if it appears too dark. This will create a subtle, low-contrast drawing.

Reflected light

Light source

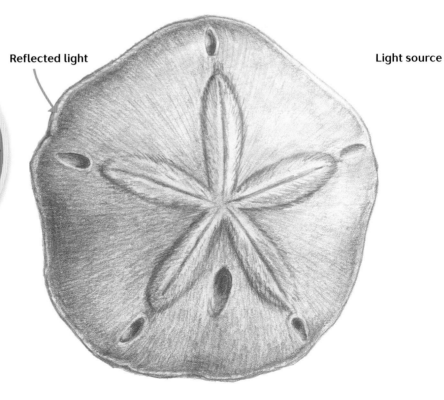

FINISHING TOUCHES

7 Add more texture lines. Darken areas away from the light source, leaving a light area near the dark side to indicate reflected light. Press the eraser on areas near the highest parts of the object to lighten.

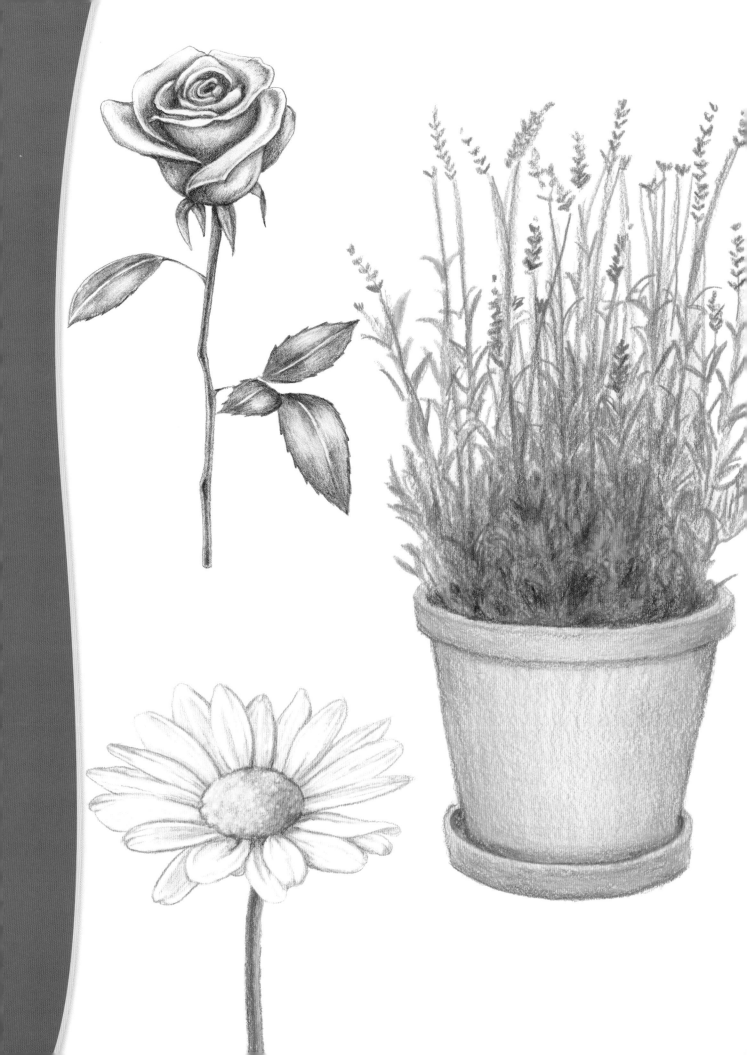

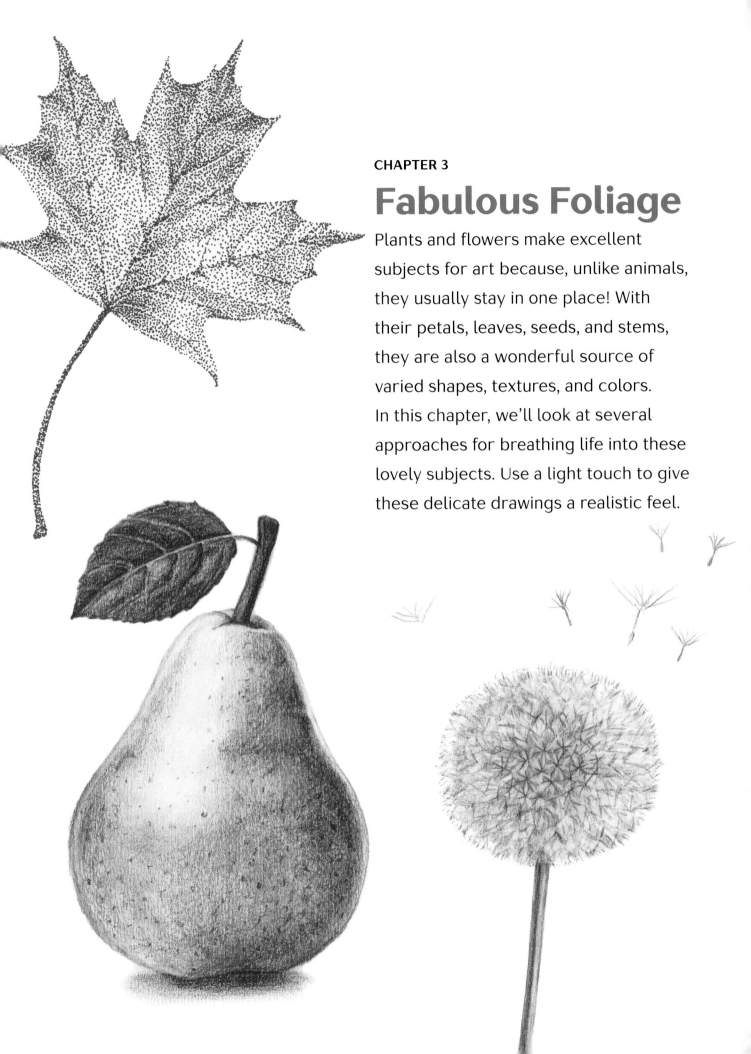

CHAPTER 3
Fabulous Foliage

Plants and flowers make excellent subjects for art because, unlike animals, they usually stay in one place! With their petals, leaves, seeds, and stems, they are also a wonderful source of varied shapes, textures, and colors. In this chapter, we'll look at several approaches for breathing life into these lovely subjects. Use a light touch to give these delicate drawings a realistic feel.

Dandelion Puff

Here, we are drawing something that isn't really a solid object, using simple Vs and Xs to create an ethereal texture, while still giving it volume.

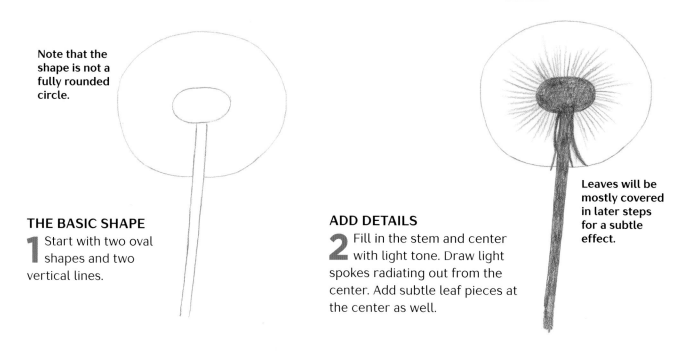

Note that the shape is not a fully rounded circle.

Leaves will be mostly covered in later steps for a subtle effect.

THE BASIC SHAPE

1 Start with two oval shapes and two vertical lines.

ADD DETAILS

2 Fill in the stem and center with light tone. Draw light spokes radiating out from the center. Add subtle leaf pieces at the center as well.

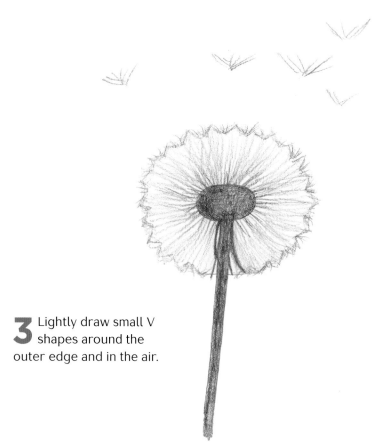

3 Lightly draw small V shapes around the outer edge and in the air.

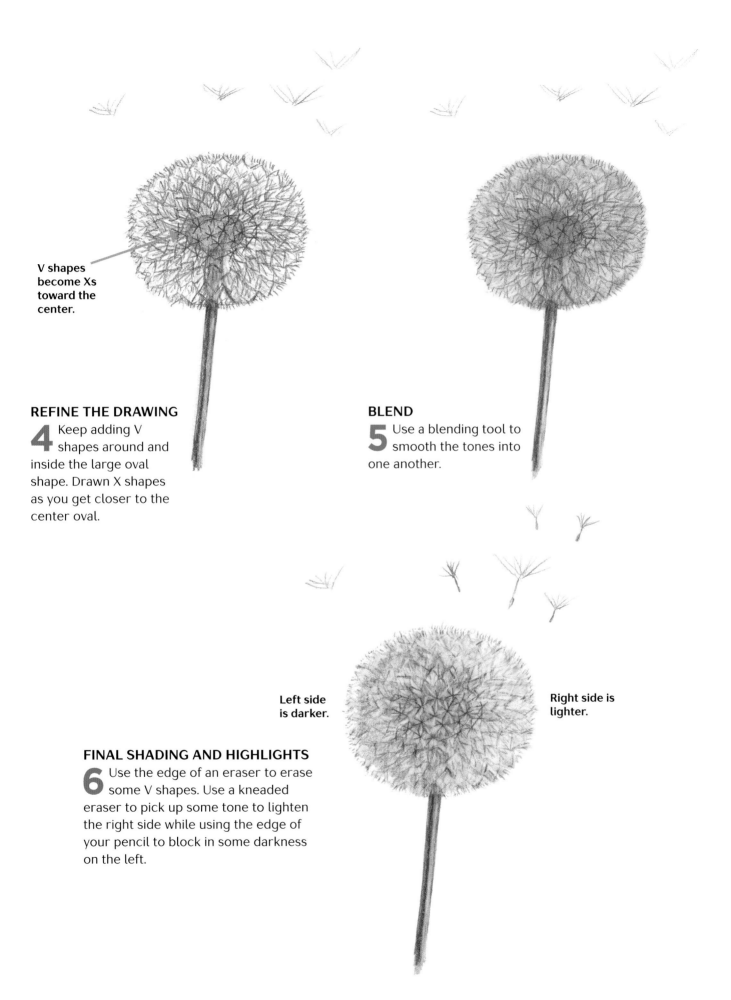

V shapes become Xs toward the center.

REFINE THE DRAWING

4 Keep adding V shapes around and inside the large oval shape. Drawn X shapes as you get closer to the center oval.

BLEND

5 Use a blending tool to smooth the tones into one another.

Left side is darker.

Right side is lighter.

FINAL SHADING AND HIGHLIGHTS

6 Use the edge of an eraser to erase some V shapes. Use a kneaded eraser to pick up some tone to lighten the right side while using the edge of your pencil to block in some darkness on the left.

Sunshine Daisy

Because we're drawing the daisy from the side instead of from straight above, the petals that are closest appear shorter. This effect is called *foreshortening*. Try using a similar approach but vary the petal shapes and sizes to create a variety of blooms.

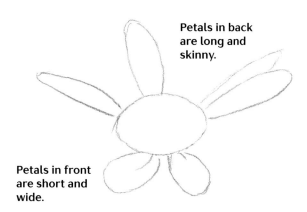

Petals in back are long and skinny.

Petals in front are short and wide.

DRAW THE PETALS

1 Start with an ellipse. Draw a few petals around the perimeter to start. Draw the petals near the bottom of the ellipse shorter and wider to make them appear closer.

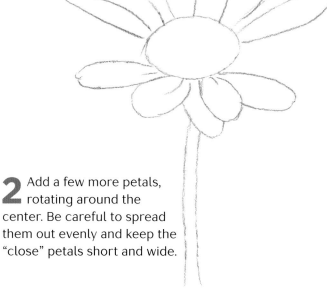

2 Add a few more petals, rotating around the center. Be careful to spread them out evenly and keep the "close" petals short and wide.

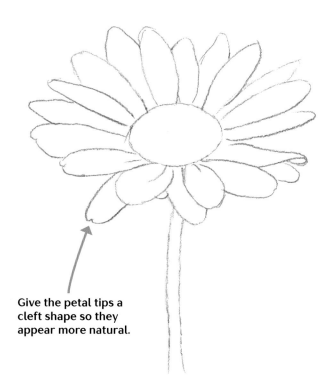

Give the petal tips a cleft shape so they appear more natural.

3 Fill in the remainder of the petals. No two petals should look alike! Draw two lines for the stem.

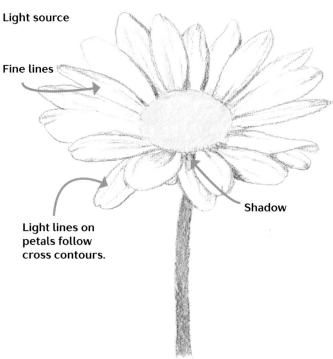

Light source

Fine lines

Light lines on petals follow cross contours.

Shadow

BEGIN SHADING AND ADD COLOR

4 Add a few light lines inside each petal and add a layer of tone to the area that will be hidden from the light source. Add color to the center and stem.

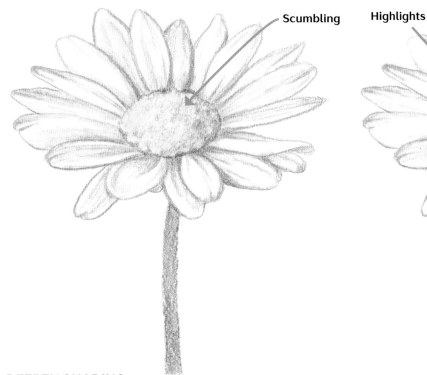

Scumbling **Highlights**

DEEPEN SHADING

5 Add a deeper tone to the center using a scumbling (small circles) motion. Blend the petal tone using a blending tool.

ADD HIGHLIGHTS AND TEXTURE

6 Use an eraser to highlight some of the lighter spots on each petal. Use green, golden yellow, and dark brown to add texture to the center. Add an area of darker green tone to the left side of the stem.

Quick Tip

Be careful not to outline the petals when shading them. That would make them look less natural.

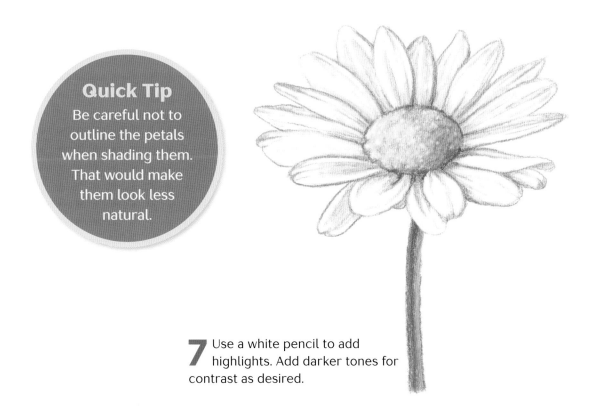

7 Use a white pencil to add highlights. Add darker tones for contrast as desired.

Perfect Pear

Starting with a round shape rather than an outline helps with shading, which conveys luscious roundness in the final drawing.

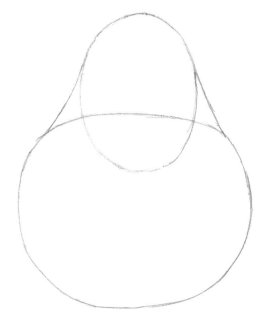

SIMPLE SHAPES

1 Start with a large oval for the base and a leaner, smaller oval for the top. Connect with two curved lines.

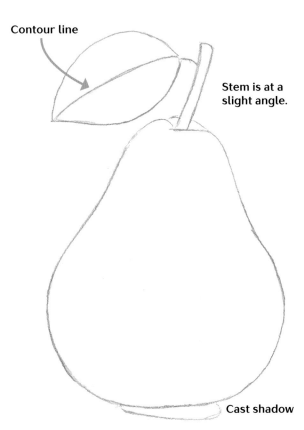

Contour line

Stem is at a slight angle.

Cast shadow

REFINE THE SHAPE

2 Erase the original ovals. Add a stem at the top with attaching lines. Add a leaf shape to the top. Add a slight shadow at the base.

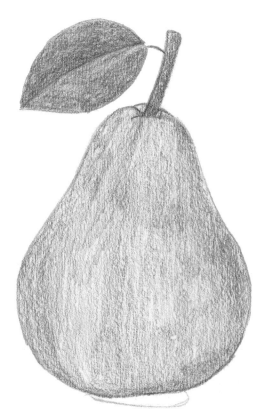

ADD TONE

3 Add a light layer of tone to the entire pear. Make the leaf and stem darker on one side.

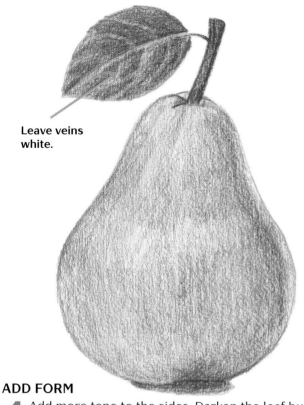

Leave veins white.

ADD FORM

4 Add more tone to the sides. Darken the leaf but leave small sections of white to indicate veining.

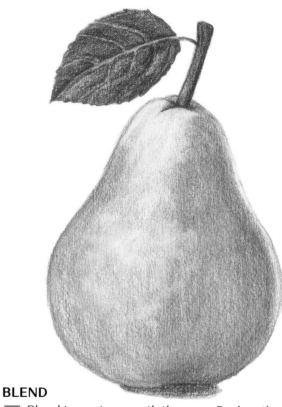

BLEND

5 Blend tones to smooth the pear. Darken the edges around the white veins of the leaf.

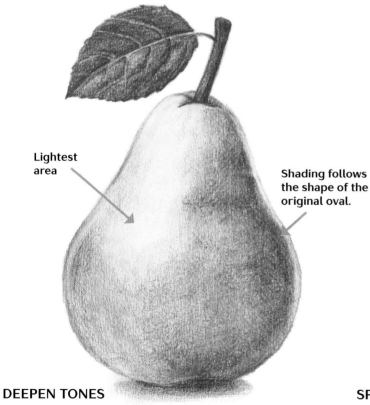

Lightest area

Shading follows the shape of the original oval.

DEEPEN TONES

6 Add more tone on the dark side, leaving a thin line of lightness to be reflected light. Add more darkness around the top right section where the original oval defined the lower half in Step 1.

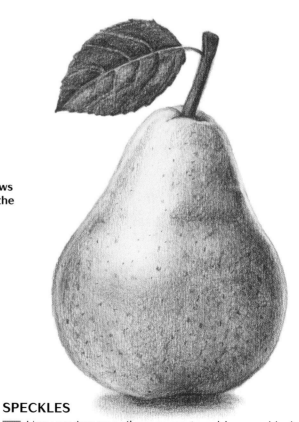

SPECKLES

7 Use varying pencil pressure to add a speckled pattern to the pear skin.

Fragrant Lavender

This subject may appear complex, but I will show you a simple approach, so you don't get bogged down in the details of the leaves and flowers, but still end up with a lovely floral.

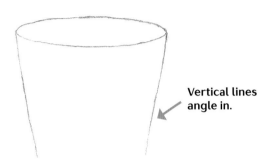

Vertical lines angle in.

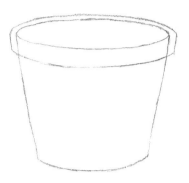

PENCIL SKETCH

1 Draw an ellipse with two lines extending down.

2 Close the base with a curve. Add a three-dimensional rim to the top and to the base by following the contours of the original ellipse.

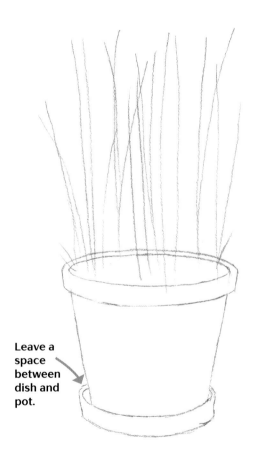

Leave a space between dish and pot.

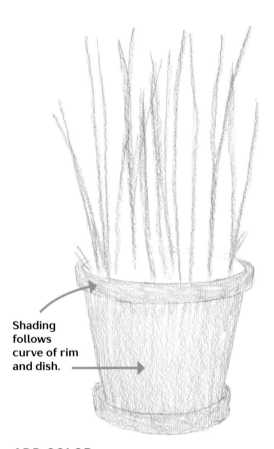

Shading follows curve of rim and dish.

3 Draw long vertical lines coming from the top ellipse. These will be the lavender stems.

ADD COLOR

4 Fill in a quick layer of orange on the pot and green on the stems.

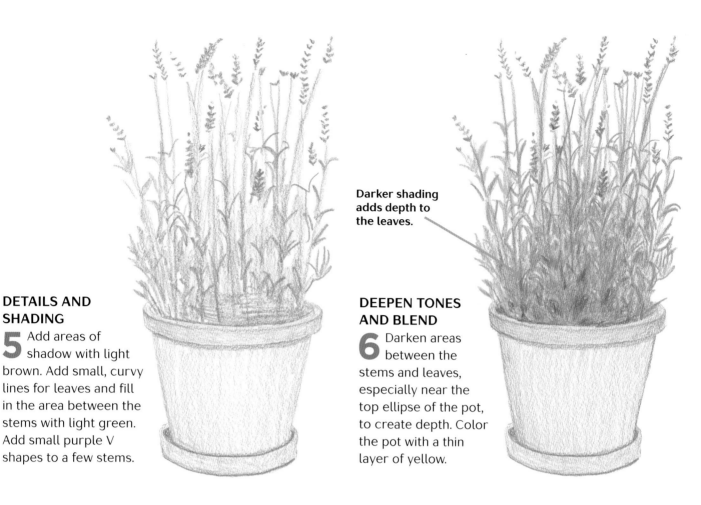

DETAILS AND SHADING

5 Add areas of shadow with light brown. Add small, curvy lines for leaves and fill in the area between the stems with light green. Add small purple V shapes to a few stems.

DEEPEN TONES AND BLEND

6 Darken areas between the stems and leaves, especially near the top ellipse of the pot, to create depth. Color the pot with a thin layer of yellow.

Darker shading adds depth to the leaves.

Quick Tip
Use a light shade of a similar color or white or the light touch of an eraser to blend tones.

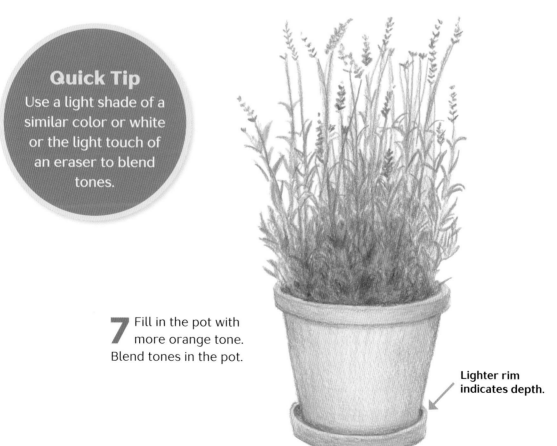

7 Fill in the pot with more orange tone. Blend tones in the pot.

Lighter rim indicates depth.

Woodland Mushroom

This fun tutorial gives you an ant's-eye view of a mushroom. Draw several in different sizes and colors for a mushroom patch fit for a fairy tale.

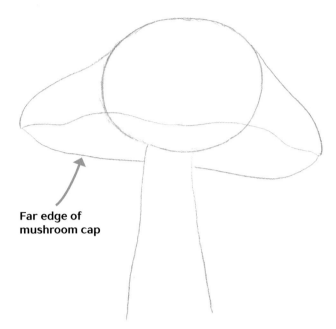

Far edge of mushroom cap

THE BASIC DRAWING

1 Start with a circle as a guideline. Form an arch over the circle and add two lines for the stem.

2 Draw a curve to close the mushroom cap and add a line to show thickness as if we were looking up at the mushroom cap.

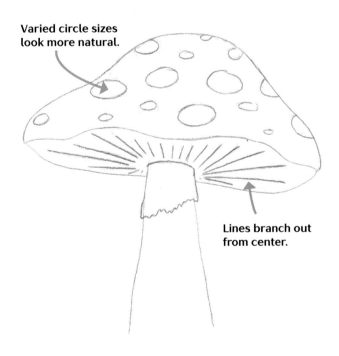

Varied circle sizes look more natural.

Lines branch out from center.

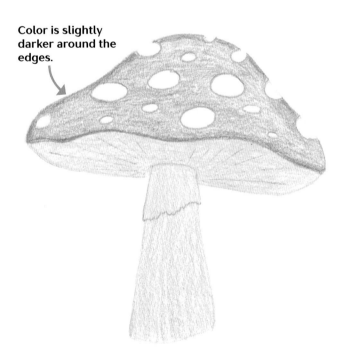

Color is slightly darker around the edges.

3 Erase the original circle guide and add various sized circles to the mushroom top. Add lines radiating from the stem top.

START TO ADD COLOR

4 Begin to add light, even layers of the colors of your choice.

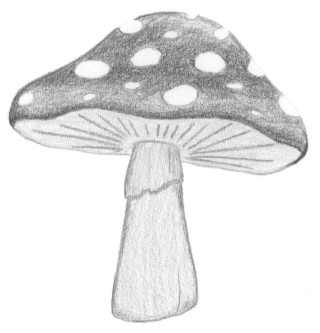

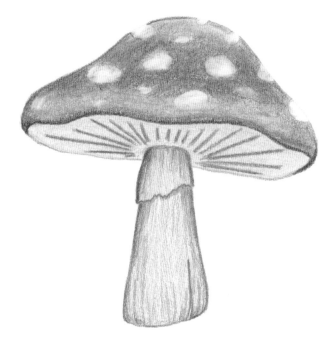

BEGIN SHADING

5 Darken the center of the mushroom cap and the sides of the stem using the same colors as in the last step.

BLEND

6 Use a lighter shade of the same color to go over the colored areas and blend away any paper that may be showing through.

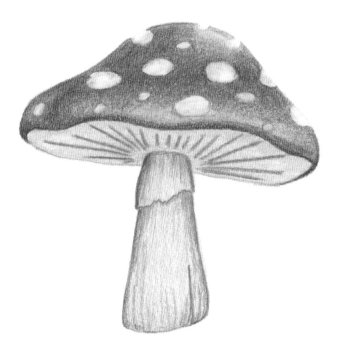

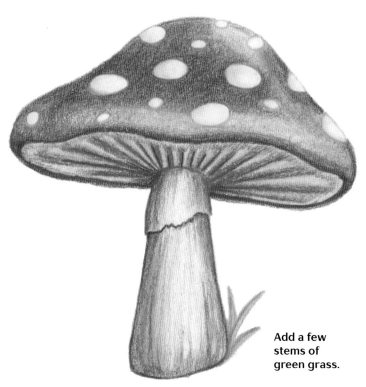

ADD CONTRAST

7 Deepen the values (see page 12) near the shadow areas using similar tones. Erase any of the white circles that may have been drawn on.

Add a few stems of green grass.

FINISHING TOUCHES

8 Erase highlights to make them more intense. Draw all around the underside of the mushroom with a deep red. Deepen the tones and blend. Add light blue and white to the spots for contrast.

Long-Stemmed Rose

This beauty is a classic subject. A single bloom like the daisy we drew earlier, it is created with a completely different approach—building up concentric curves.

Curves get closer at sides.

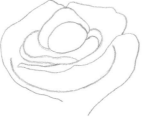

Thinner layers are petals that fold over.

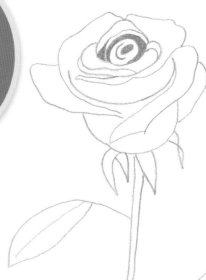

DRAW THE BLOOM

1 Start with a simple oval. This will become the center of the bloom. Draw two curves beneath the oval that will be the guide for where the petal layers will go.

2 Add some curvy petal shapes radiating around the center oval.

3 Draw some more layers of curves. Finish connecting the petals and draw the base of the bloom.

Quick Tip

Don't use a ruler for the stem, as a perfectly straight line doesn't look as authentic as a line with subtle variations.

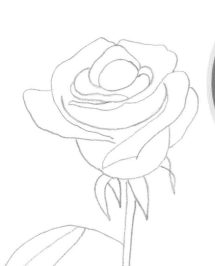

STEM AND LEAVES

4 Add a simple stem with some leaves on either side.

START SHADING

5 Darken areas in the center oval, leaving a few thin rings of white. These rings will indicate the tiniest petals in the center of the bloom.

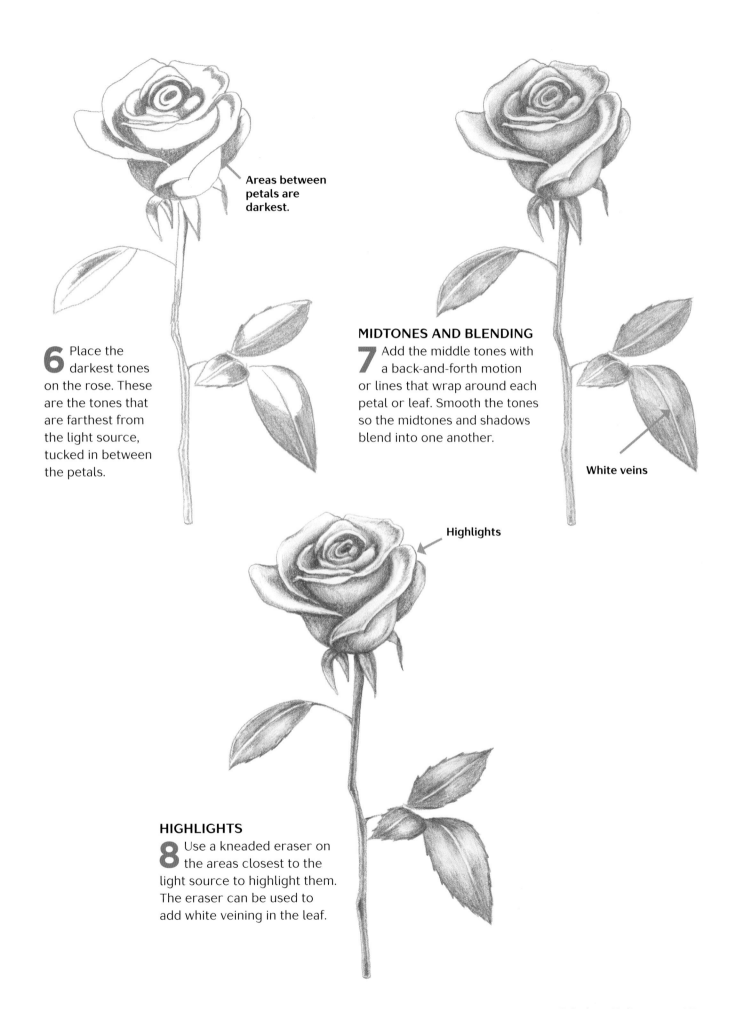

Areas between petals are darkest.

6 Place the darkest tones on the rose. These are the tones that are farthest from the light source, tucked in between the petals.

MIDTONES AND BLENDING

7 Add the middle tones with a back-and-forth motion or lines that wrap around each petal or leaf. Smooth the tones so the midtones and shadows blend into one another.

White veins

Highlights

HIGHLIGHTS

8 Use a kneaded eraser on the areas closest to the light source to highlight them. The eraser can be used to add white veining in the leaf.

Maple Leaf

Ink is a wonderful medium for drawing, but because you can't erase it, it's best to start with a pencil sketch. *Stippling*—making a series of tiny dots—is a fun technique that forces you to slow down just a bit and gradually build up shading.

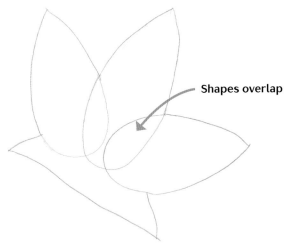

Shapes overlap

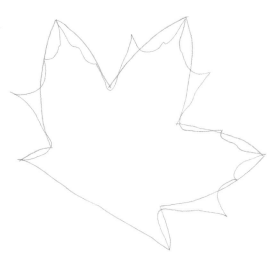

THE PENCIL SKETCH

1 Using light pencil, draw three overlapping raindrop shapes as guidelines. Add a base.

2 Add detail to the leaf using curves and pointed edges to resemble a maple leaf.

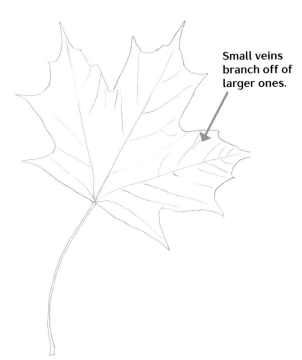

Small veins branch off of larger ones.

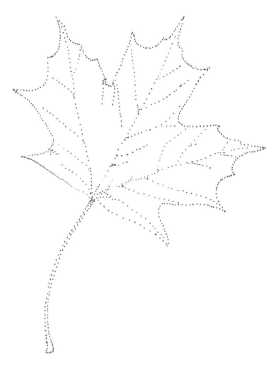

3 Erase the initial guidelines from Step 1. Add lines for the stem and veins. Notice how the main veins are attached to the stem while the small ones branch off of them.

BEGIN INKING

4 Go over the pencil with pen. Instead of outlining with line, find the shape using small dots, known as stippling. Carefully lift and press the pen onto the paper. When the ink dries, erase the pencil.

The veins and some tips of the leaves should be darkest.

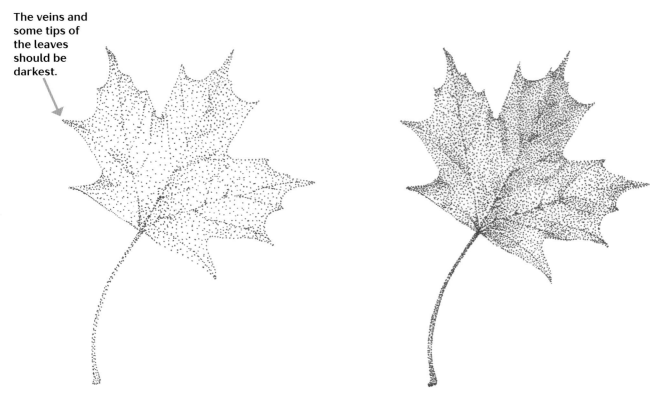

BEGIN SHADING

5 Start to shade with stippling. Starting with the darkest point, create areas of darkness with dots that are close together and dots that are far apart to indicate lighter areas.

DEEPEN THE SHADING

6 Work around the image and further darken areas with dots to define the shadows. Keep the areas between veins and next to veins light. Add more dots.

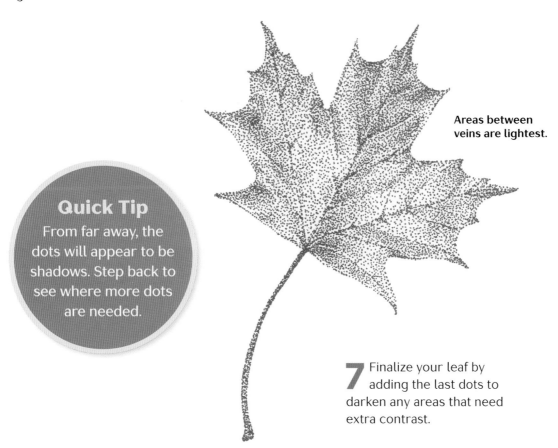

Areas between veins are lightest.

Quick Tip
From far away, the dots will appear to be shadows. Step back to see where more dots are needed.

7 Finalize your leaf by adding the last dots to darken any areas that need extra contrast.

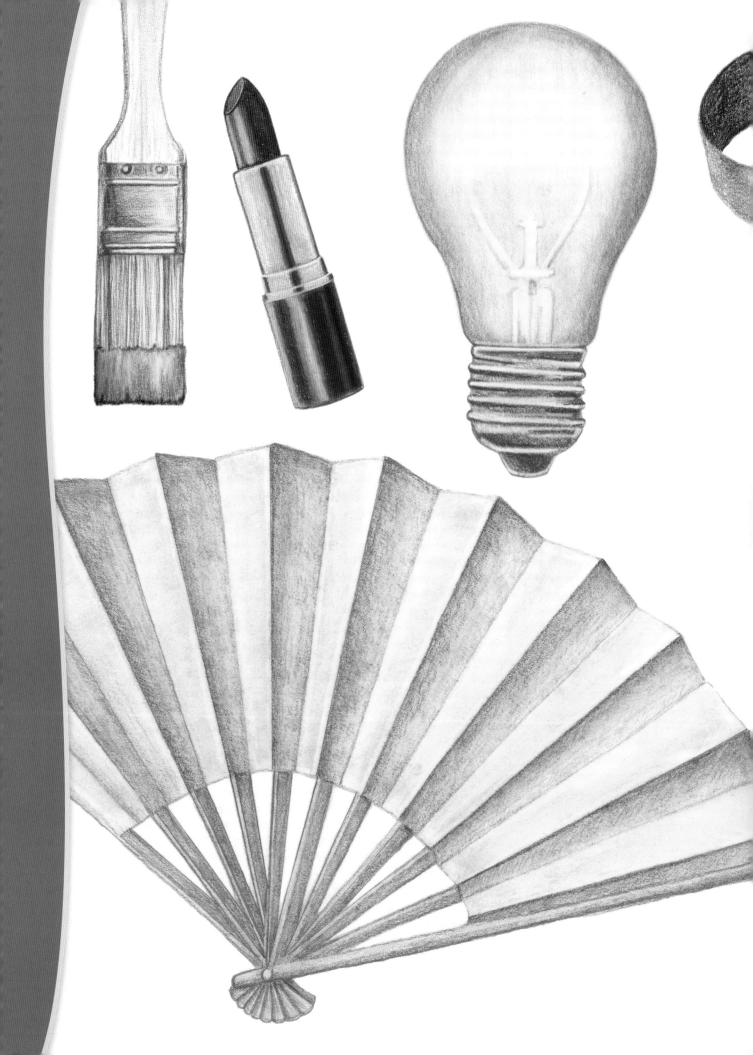

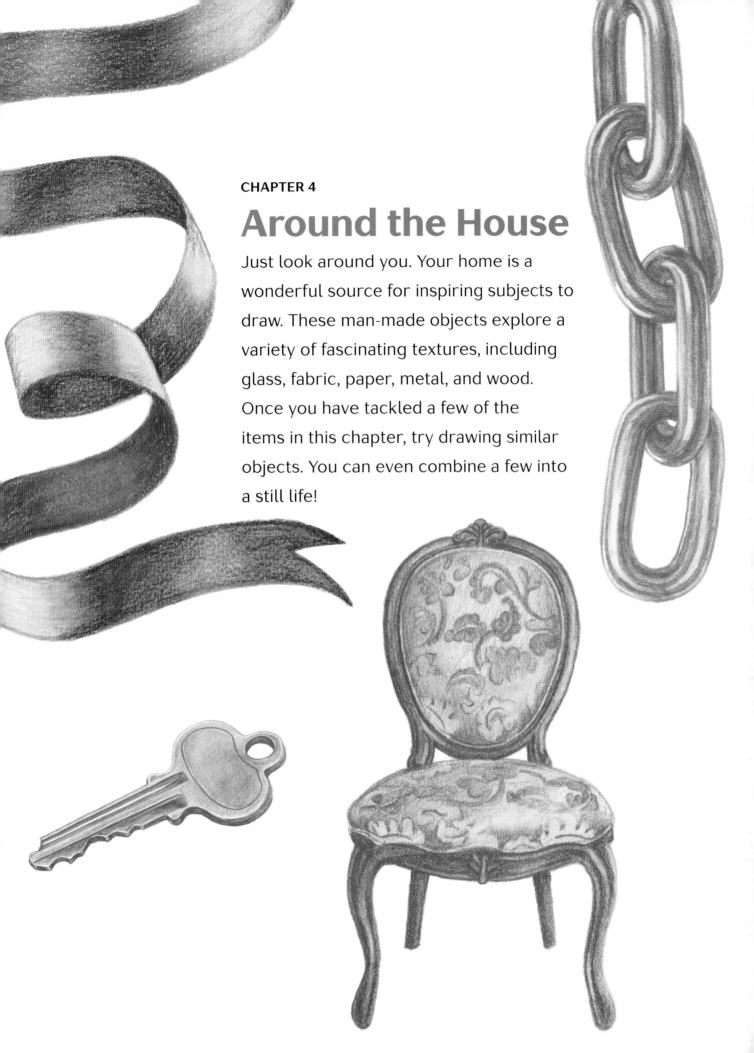

CHAPTER 4

Around the House

Just look around you. Your home is a
wonderful source for inspiring subjects to
draw. These man-made objects explore a
variety of fascinating textures, including
glass, fabric, paper, metal, and wood.
Once you have tackled a few of the
items in this chapter, try drawing similar
objects. You can even combine a few into
a still life!

Chain Links

Start with simple lines to easily build up to a complex-looking drawing. Notice how because of perspective, the links appear as rectangles from one angle and ovals from another.

THE BASIC OUTLINE

1 Start with a rounded rectangle.

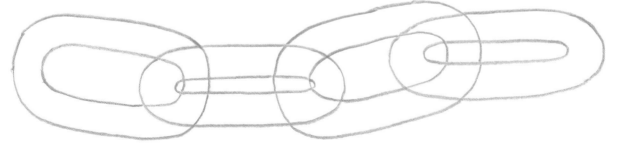

Line curves gently.

Make the line as long as the chain will be.

2 Draw a light line to guide where the rest of the chain links will be placed. Draw this line in the direction of and as long as you want your chain to be.

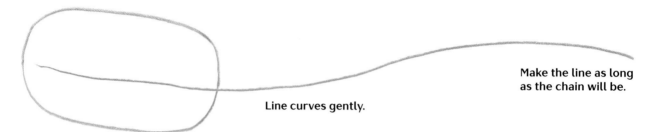

Rounded rectangle

Oval

Rounded rectangle

Oval

3 Draw a series of alternating rounded rectangles and ovals. Be sure to overlap them.

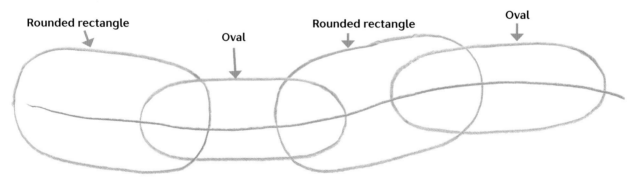

OVERLAPPING SHAPES

4 Draw the insides of the links using oval shapes. Erase the initial guideline.

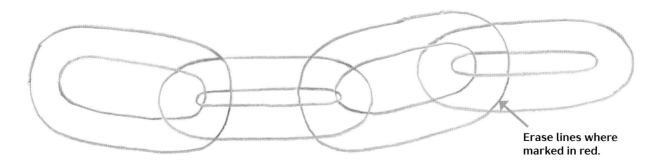

Erase lines where marked in red.

5 Parts of the chain will be visible while other parts will be obscured by overlapping. Erase the red lines.

Leave some areas white for highlights.

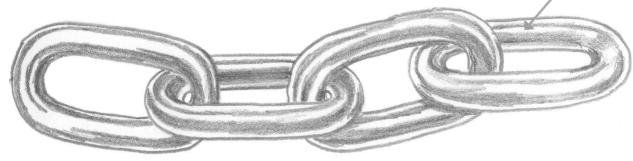

START SHADING

6 Block in areas that will be the darkest using a back-and-forth motion and following the inner contours of each link.

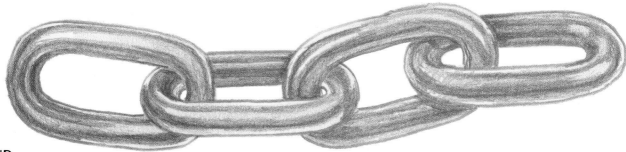

BLEND

7 Use a blending tool to gently blend the tones over each link so the hard lines made in Step 6 appear smoother.

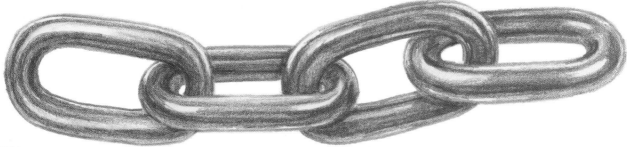

DARKEN

8 Add more tone to the areas that will be the darkest to create contrast. Erase the lightest areas to indicate highlights.

Lustrous Lipstick

Simple shading combined with blending creates a metallic effect that is incredibly shiny and convincing. Feel free to customize your lip color!

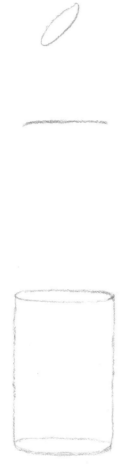

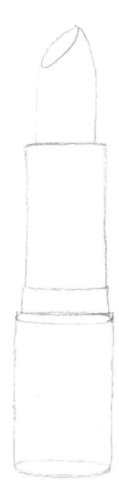

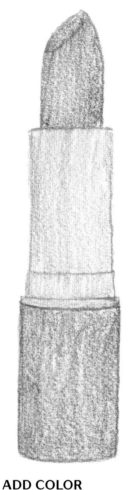

Block in stripes of color.

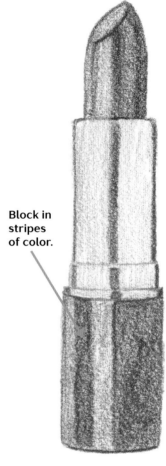

BASIC SHAPES

1 Start with two ellipses connected with vertical lines for the base. Draw a line and an ellipse drawn at a diagonal for the lipstick.

2 Connect the top ellipse and the first line with curves. Use two vertical lines and one horizontal to complete the initial drawing.

ADD COLOR

3 Erase the tops of the first two ellipses drawn in Step 1. Add a layer of color.

4 Using the same colors, press harder to get a darker tone on the edges and center, creating stripes of darkness.

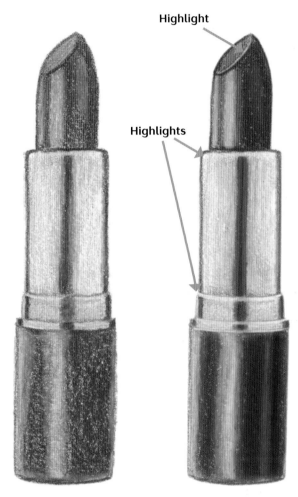

Highlight

Highlights

DEEPEN AND REFINE SHADING

5 Go over each area with a darker shade of the same color on the darker side and white on the lighter side.

6 Deepen the highlights and shadow sides, blending as needed. Leave a lighter ring of tone at the tops of each ellipse for a rim reflection.

Metallic Shine

Metal is a highly reflective surface with lots of glossy spots and areas of highlight. Try to replicate the highlights and shadows by drawing the shapes they make. There will be both large and small shapes to render. While drawing them, be sure to note how these shapes curve or bend around the object. Your drawing should follow these curves.

Once the shapes are drawn, fill them in with tone. It is a good idea to create a value scale before shading in an artwork to determine how much pressure to use or what type of pencil to use when trying to create a specific tone. (See page 12.) When creating high-contrast drawings that appear to have areas of high shine and deep shadow, the lightest and darkest tones from a value scale should be utilized. For the brightest parts of the object, do not add tone.

Line quality is another factor to consider. Hard lines can enhance the contrast in areas of high shine, while softer, blended tones can be used in areas of the object where the contrast is not as great. Finding the perfect balance of dark and light, soft and hard lines will help the surface look shiny and realistic.

Finally, refine the drawing by blending, erasing smudges, and defining highlights as needed.

With practice, your metal objects will look realistic and shiny.

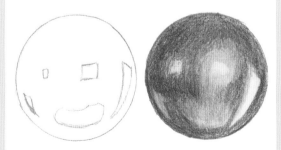

Drawing the shapes of the highlights before you begin shading will help create realistic-looking metal objects.

House Key

This is a great subject to learn how to create depth in an object that may seem flat. Gather up all the keys in your house to practice drawing different shapes.

PENCIL SKETCH

1 Draw a tilted oval with a circle and two lines.

2 Add ridges to one side of the two lines and "thicken" the small circle.

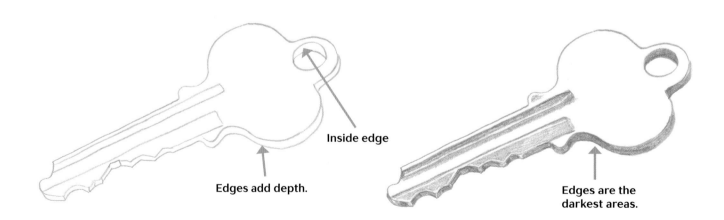

Inside edge

Edges add depth.

Edges are the darkest areas.

3 Add a three-dimensional edge to the ridge side of the key to add depth. Add a notch inside the hole.

BASIC SHADING

4 Add tone to the three-dimensional edge as well as to the grooves on the key length.

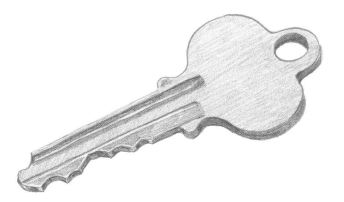

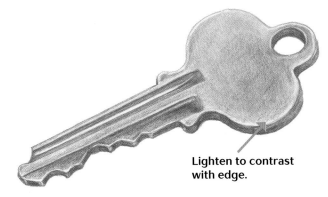

Lighten to contrast with edge.

OVERALL SHADING

5 Add tone to the remainder of the key.

REFINING

6 Deepen the dark areas with more tone. Erase some areas closest to the edges to enhance the plane change.

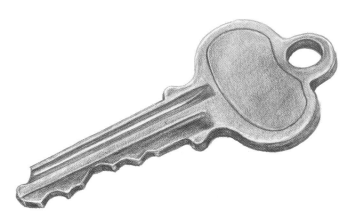

7 Erase more highlights and darken the shadows.

Creating Three Dimensions

Unless you're drawing a piece of paper, most objects you draw are three-dimensional even if they appear "flat," such as this key.

Creating the appearance of depth can be achieved by drawing three-dimensional (3D) edges. This usually involves following the contour of one side of an object and copying it just below to indicate that it has a "thickness" and is not actually flat. Shade this edge based on the direction of the light source—usually darker or lighter tones from the plane above it. This conveys the different surface planes and enhances the sense of form.

Upholstered Chair

This traditional wooden chair features patterned fabric. Draw your own design and follow the steps to learn how to add shading and highlights without obscuring the pattern.

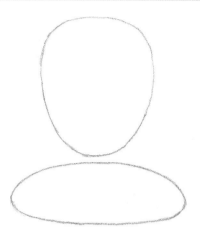

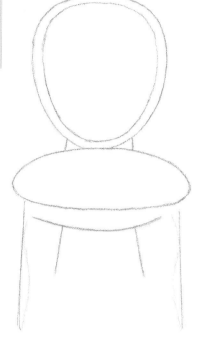

BASIC SKETCH

1 Start with an upside-down egg shape over an ellipse.

2 Add two long lines at the base as a guide for the front legs with a curve and two smaller lines in the center for the back legs. Follow the contour of the egg shape and draw another line.

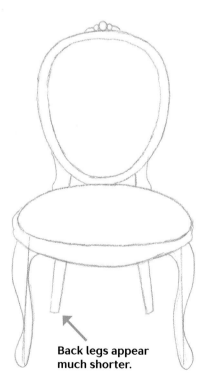

Back legs appear much shorter.

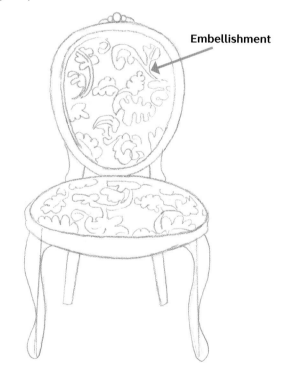

Embellishment

3 Use the lines drawn in Step 2 as a guide and draw curves around the front legs to thicken them and make long rectangles for the back legs. Connect the curve around the chair to create a frame with a small embellishment at the top.

ADD PATTERN

4 Add a pattern such as flowers or stripes to create interest.

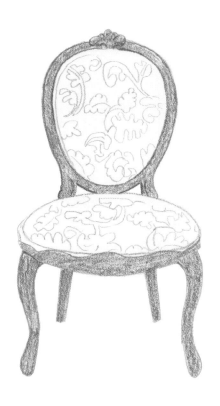

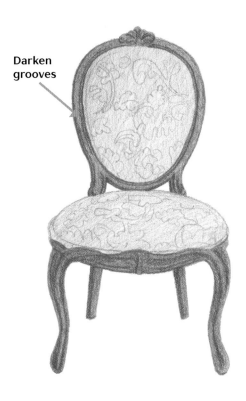

Darken grooves

SHADE

5 Add a layer of dark tone to the chair frame, leaving the upholstered area light.

6 Darken the frame to create grooves. Add a light layer of tone to the upholstered area.

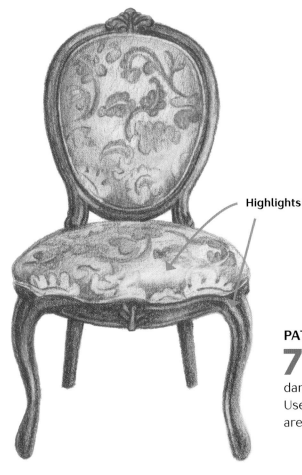

Highlights

Quick Tip
Be careful not to erase too much of your pattern when adding highlights to the upholstery fabric.

PATTERN DETAILS AND HIGHLIGHTS

7 Add light and dark tone to the pattern to create interest. Lightly blend the upholstery area and darken the tone in shadow areas to create contrast. Use a kneaded eraser to remove the pigment on light areas to create highlights.

Paper Fan

All of the lines that make up the folds in this fan radiate from a single point. This is called *one-point perspective*. Use a ruler if you like to keep things straight.

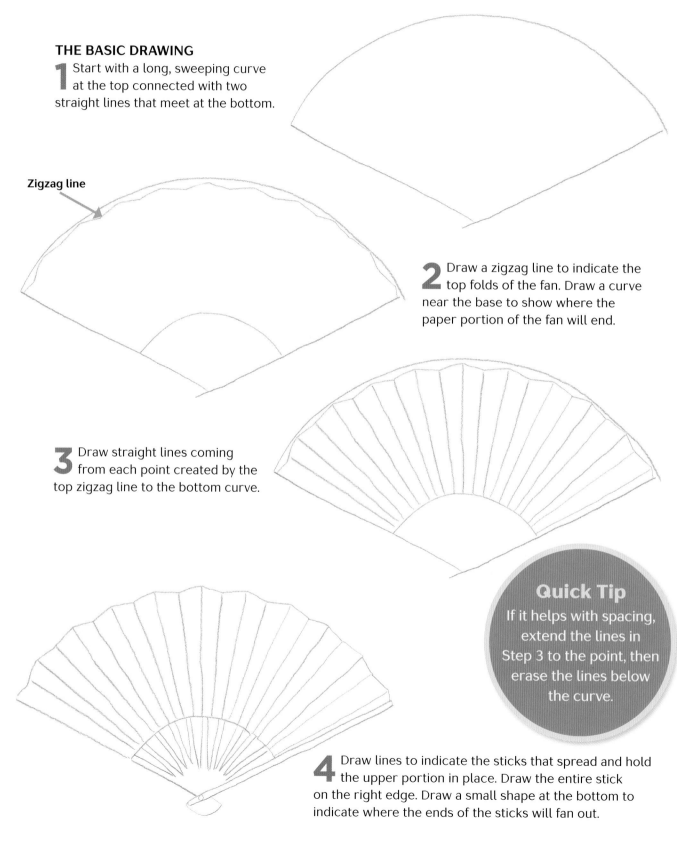

THE BASIC DRAWING

1 Start with a long, sweeping curve at the top connected with two straight lines that meet at the bottom.

Zigzag line

2 Draw a zigzag line to indicate the top folds of the fan. Draw a curve near the base to show where the paper portion of the fan will end.

3 Draw straight lines coming from each point created by the top zigzag line to the bottom curve.

Quick Tip

If it helps with spacing, extend the lines in Step 3 to the point, then erase the lines below the curve.

4 Draw lines to indicate the sticks that spread and hold the upper portion in place. Draw the entire stick on the right edge. Draw a small shape at the bottom to indicate where the ends of the sticks will fan out.

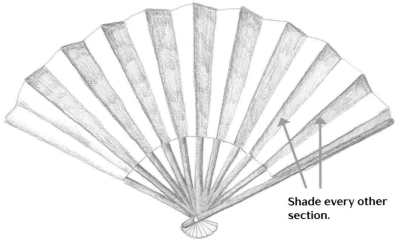

BEGIN SHADING

5 Add tone to every other section of the fan. Add tone to the sticks, keeping the right side of each individual stick slightly darker.

Shade every other section.

6 Add a light layer of tone to the remainder of the fan and gently blend to smooth the tones.

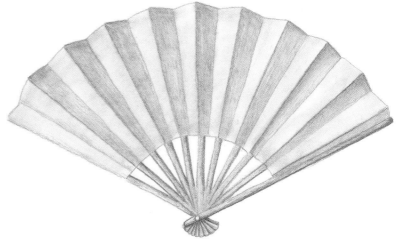

Lighten tops of peaks on light sections.

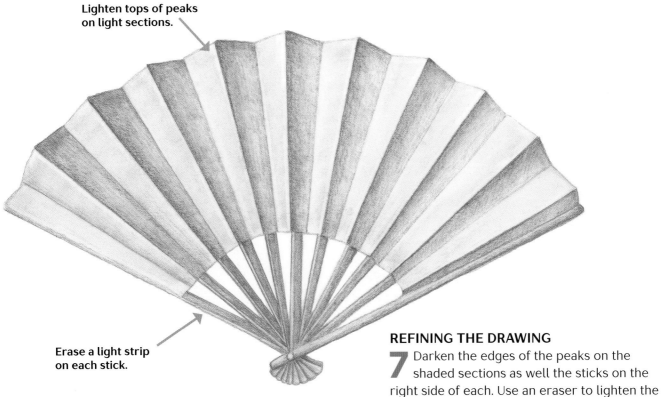

Erase a light strip on each stick.

REFINING THE DRAWING

7 Darken the edges of the peaks on the shaded sections as well the sticks on the right side of each. Use an eraser to lighten the tops of each peak on the light side. Remove some tone to make a light strip on each stick.

Bright Bulb

Like the pear we drew earlier (see page 80), this light bulb is built up from a sphere. Use an eraser to "draw" the filament details for a finishing touch.

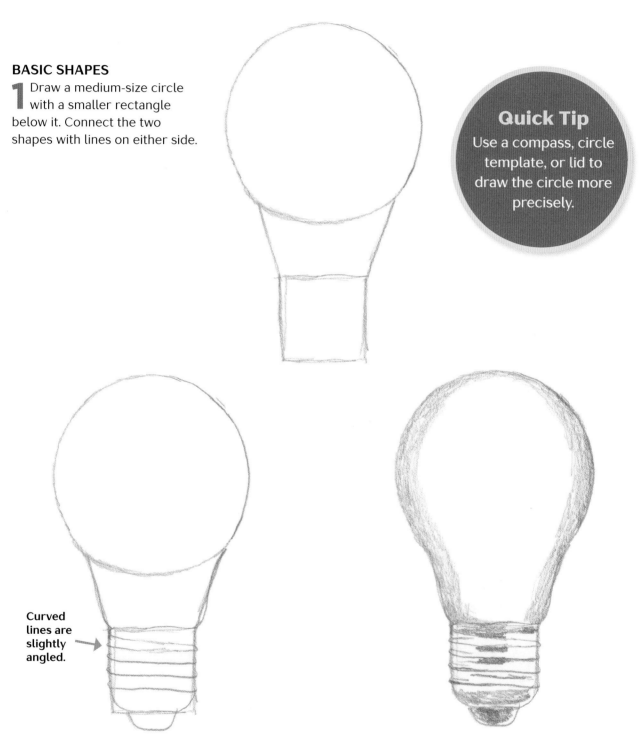

BASIC SHAPES

1 Draw a medium-size circle with a smaller rectangle below it. Connect the two shapes with lines on either side.

Quick Tip
Use a compass, circle template, or lid to draw the circle more precisely.

Curved lines are slightly angled. →

2 Add curved lines on the rectangle shape. Draw a curve for the very bottom of the light bulb.

ADD TONE

3 Erase the parts of the guide shapes that are no longer needed. Add a light layer of tone around the edges of the bulb, the center, and the base.

Center is lighter.

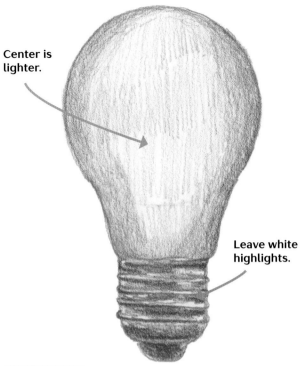

Leave white highlights.

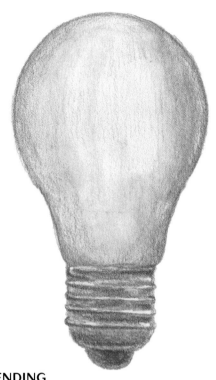

MORE TONE

4 Add tone to the base, leaving a strip of white on each curve. Fill in the center bulb with a light tone.

BLENDING

5 Blend the tones together to smooth them out.

Highlight

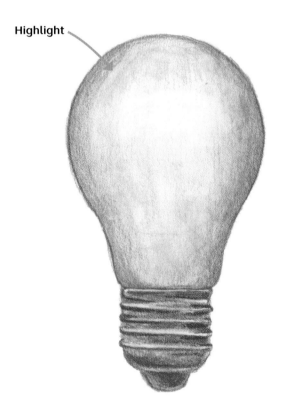

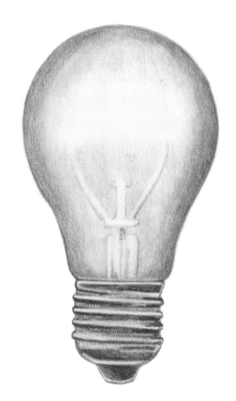

6 Darken any areas that may have been smoothed out to a lighter tone. Erase the center top of the bulb to create a highlight.

FINAL DETAILS

7 Erase to create filament details in the center and add light lines with hard graphite pencil as needed for definition.

Winding Ribbon

This project is drawn using a fun technique—holding two pencils together to create parallel lines. It's an easy way to draw accurate loops and curls.

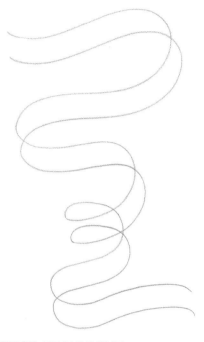

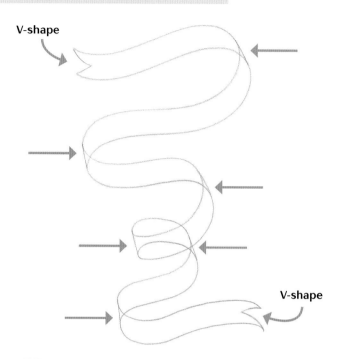

V-shape

V-shape

TWO-PENCIL TECHNIQUE

1 Hold two pencils in one hand perpendicular to the paper. Keeping your wrist straight, move your arm over the paper, guiding the pencils around so they overlap in a few places to resemble a flowing ribbon.

REFINE THE RIBBON

2 Draw "V" shapes at each end to close the lines. Draw straight lines at the edges of each curve to close those as well (see blue arrows).

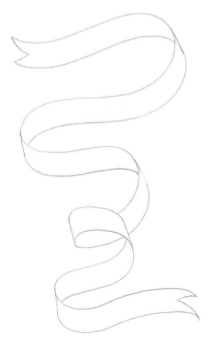

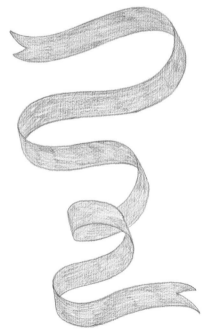

3 Erase the lines where ribbon overlaps.

ADD COLOR

4 Begin to add a light, even layer of the color of your choice.

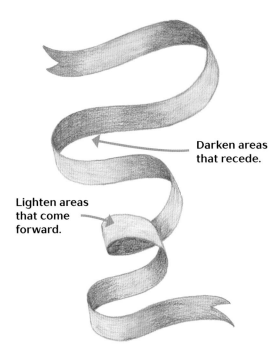

Darken areas that recede.

Lighten areas that come forward.

Quick Tip
You can use an eraser or a white colored pencil to blend the tones.

DARKEN AND HIGHLIGHT

5 Darken the areas of the ribbon that curve away from the front or that have a portion of the ribbon overlapping them. Use an eraser to lighten the tone on the ribbon that appears to come forward.

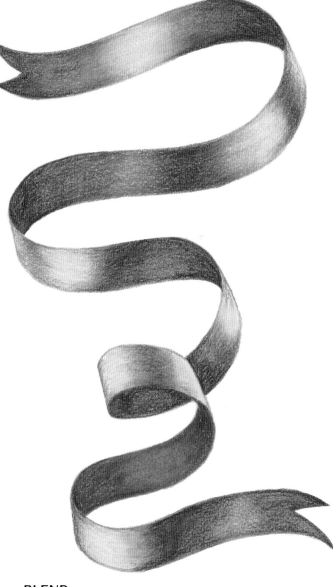

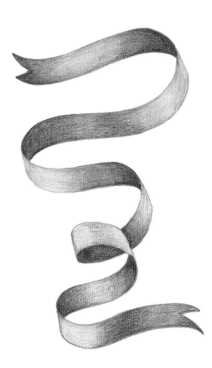

6 Darken the shadow areas even more using a heavier pencil pressure. Be sure to gradually change from dark to light tones.

BLEND

7 Blend the gradation together so it appears smoother. This may darken the tones a bit so use an eraser with heavy pressure on the lightest areas to brighten highlights.

Nice Shades

Three-quarter view—between a straight-on view and a side view—creates interesting perspective in this drawing. You'll strengthen your skills of creating depth and pattern as well.

SIMPLE SHAPES

1 Start with two egg shapes. These will be the lenses.

The closer lens is a bit larger due to perspective.

DRAW THE FRAME AND BEGIN PATTERN

2 Draw a frame around the contour of the lenses. Refine the lens as needed.

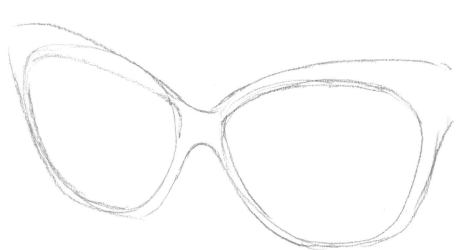

Earpiece is longer due to perspective.

Earpiece is shorter due to perspective.

3 Draw stick lines for the earpieces of the glasses. Draw a pattern on the frames if desired.

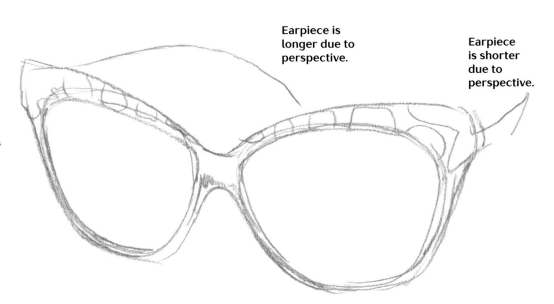

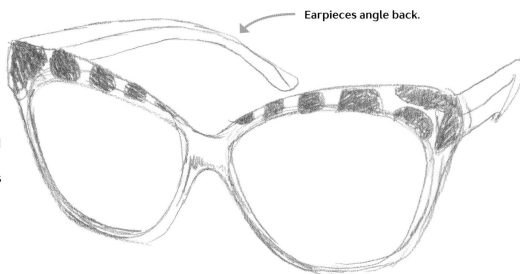

Earpieces angle back.

SHADE THE PATTERN

4 Fill in the pattern. Draw the earpieces with more detail using the lines as a guide.

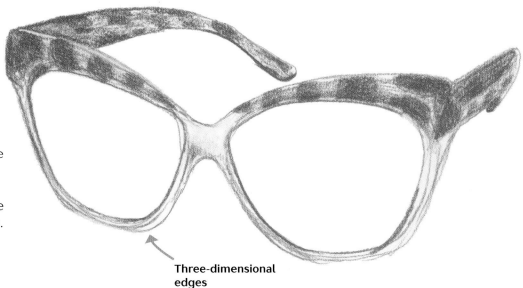

5 Add pattern to the earpieces. Refine the lens further to indicate thickness. Add three-dimensional edges to the frames with thicker lines.

Three-dimensional edges

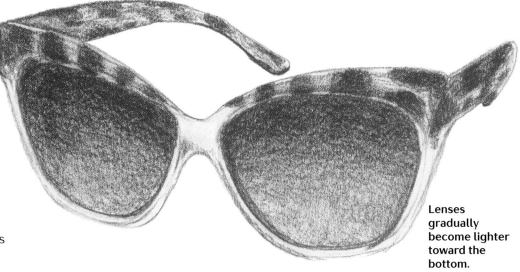

SHADE THE LENSES

6 Add shading to the lenses, keeping the bottom halves lighter. Darken the pattern and three-dimensional edges as needed.

Lenses gradually become lighter toward the bottom.

All-Star Sneaker

This lesson will help you learn about observing an object and adding subtle tones to create a realistic likeness. After practicing with this demo, try drawing your own shoe!

DRAW THE BASIC SHAPE

1 Start with a simple shoe outline.

ADD DETAILS

2 Add the tongue and a few lines to start the details. Draw a full circle and partial circles to indicate the eyelets (lace holes).

Far side of tongue peeks out.

3 Draw overlapping lines for laces as shown. Add more lines to indicate detail near the base of the shoe and the tag on the tongue.

Laces overlap.

ADD TONE

4 Begin laying down tone. The upper shoe can quickly be filled in using a back-and-forth motion. Add two thin, dark stripes to the base.

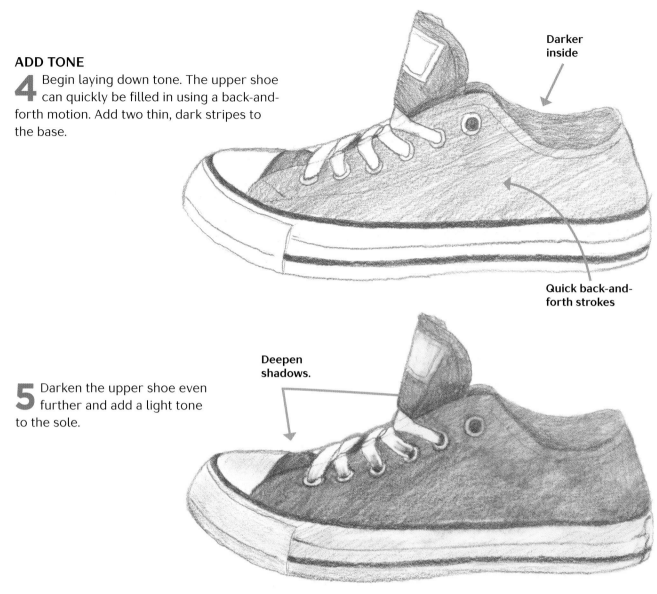

Darker inside

Quick back-and-forth strokes

5 Darken the upper shoe even further and add a light tone to the sole.

Deepen shadows.

FINISHING TOUCHES

6 Deepen the upper shoe tone to create contrast. Erase some areas on the lightest spots on the eyelets, the edge of the shoe opening, and the edges of the shoe base to create highlights.

Quick Tip
Make areas that are overlapped by other areas even darker to indicate shadows.

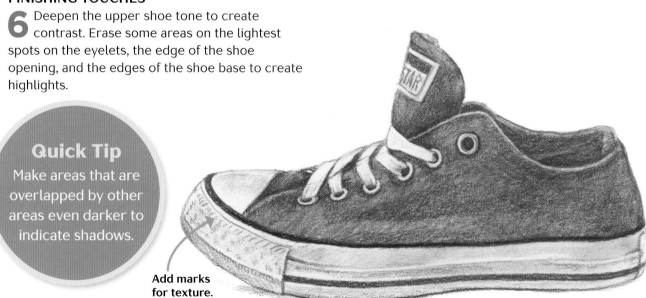

Add marks for texture.

Slight shadow underneath

A Brush with Color

Several textures—wood, metal, bristles, and paint—converge in a small, simple subject. Add just a splash of color for a drawing that pops off the page.

SIMPLE SHAPES

1 Draw a rectangle for the brush and a simple line to indicate where the handle will be.

ADD DETAILS

2 Draw curves for the handle, a circle for a hole, and some lines for the bristle detail.

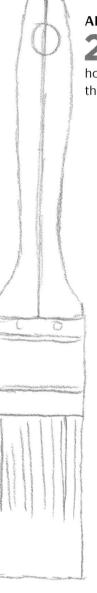

Three-dimensional edge for depth

Shade with horizontal strokes.

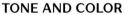

3 Add a curve inside the circle for a three-dimensional edge. Make marks to indicate where the darkest tone of shadow will go.

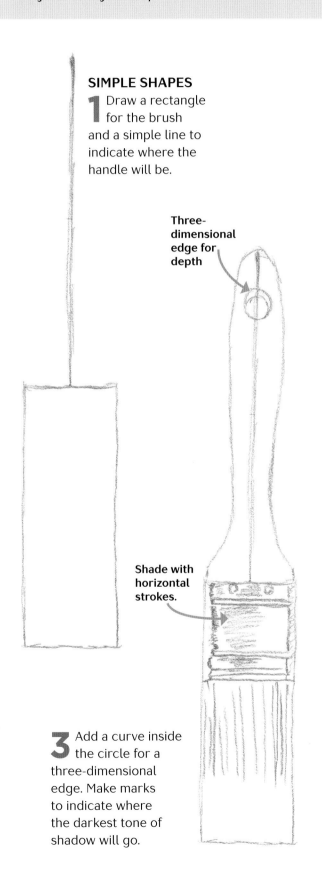

TONE AND COLOR

4 Erase the brush handle guideline. Add a three-dimensional edge to the left side of the handle. Darken the upper brush portion and add a light layer of color to the bristles.

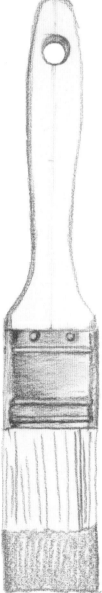

Use vertical strokes to shade and add a wood-grain pattern.

TEXTURE AND DETAILS

5 Add light lines for the wood pattern on the handle. Add a variety of light and dark lines above the paint-dipped area. Add another layer of color, pressing harder on the shadow side.

6 Blend bristle hairs to smooth the tone. Add more contrast to the upper brush area. Add a darker shade of the same color to the paint-dipped area, adding short zigzag lines at the base.

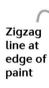

Zigzag line at edge of paint

Quick Tip
For extra-fine lines, use a mechanical pencil to add the brush hairs.

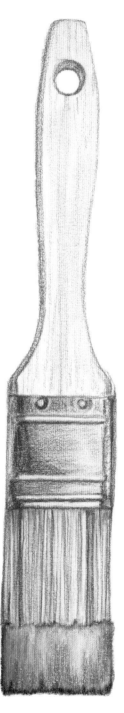

7 Blend the color area with a white pencil, highlighting the lightest areas on the right.

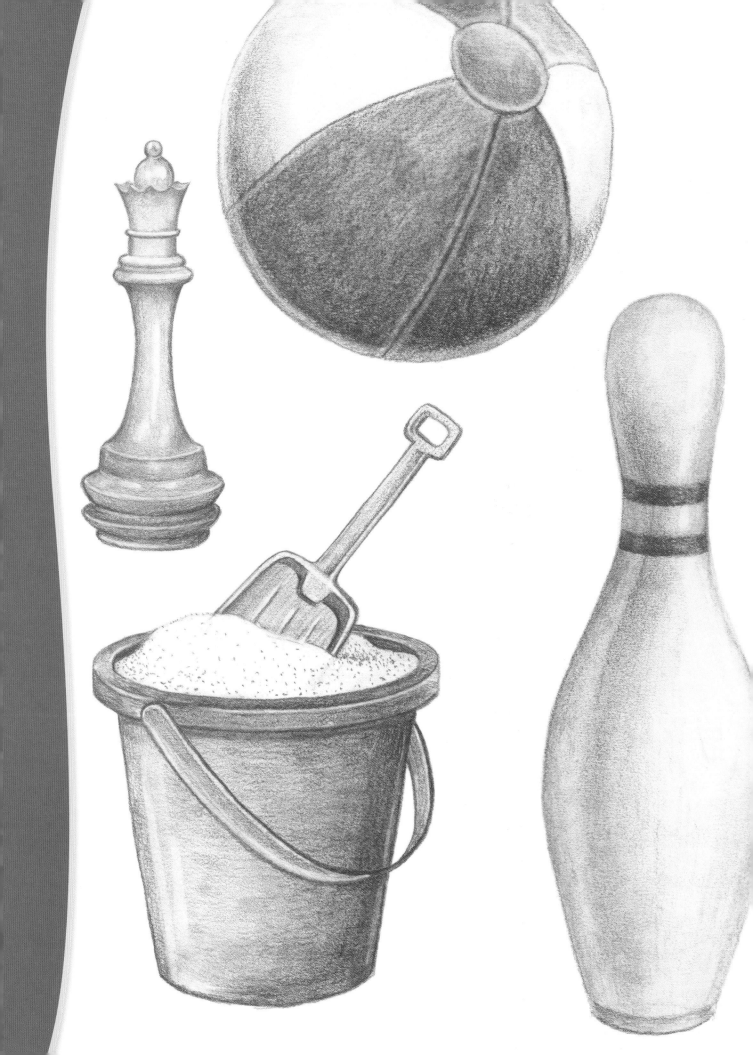

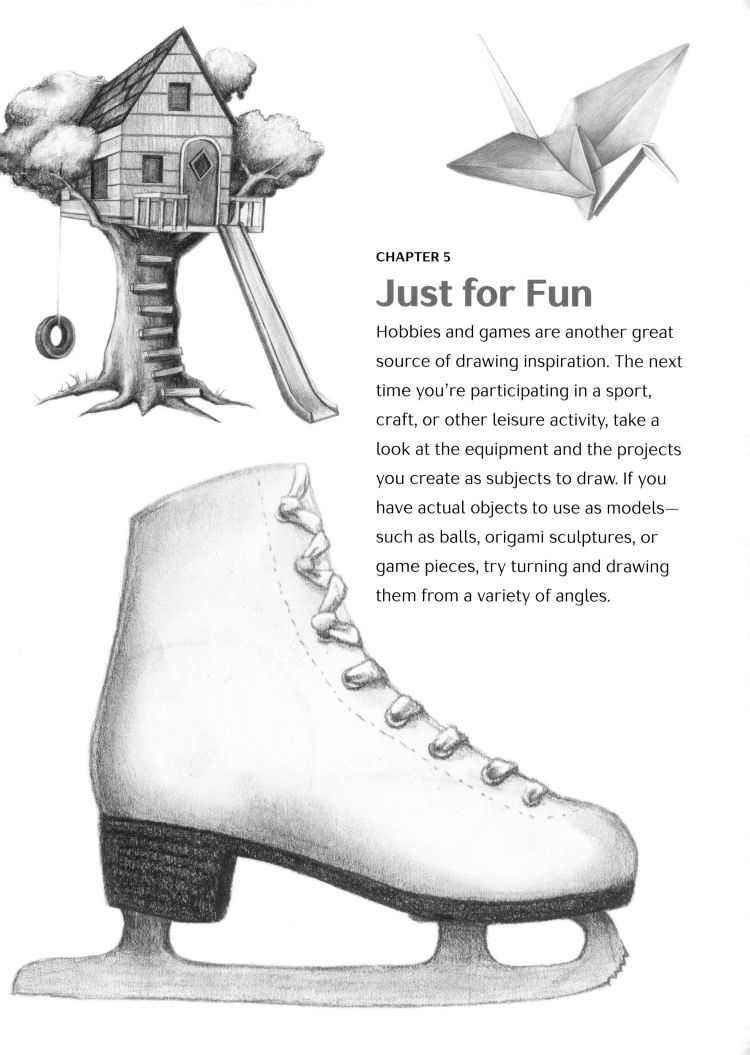

CHAPTER 5

Just for Fun

Hobbies and games are another great source of drawing inspiration. The next time you're participating in a sport, craft, or other leisure activity, take a look at the equipment and the projects you create as subjects to draw. If you have actual objects to use as models—such as balls, origami sculptures, or game pieces, try turning and drawing them from a variety of angles.

Bouncing Ball

Because there is no shadow on the ground (cast shadow), this beach ball looks like it's flying through the air. Try drawing it with the smaller circle in different positions, on the ground with a cast shadow, or in color.

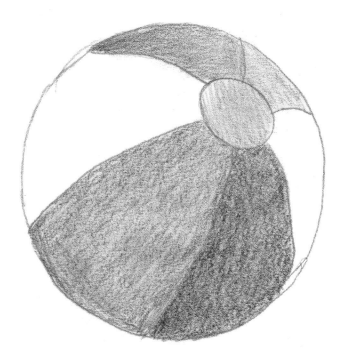

Curved lines show the ball is round.

PENCIL SKETCH

1 Start with a large circle and a smaller circle inside (not centered).

2 Draw equally spaced curves coming from the center circle to form sections.

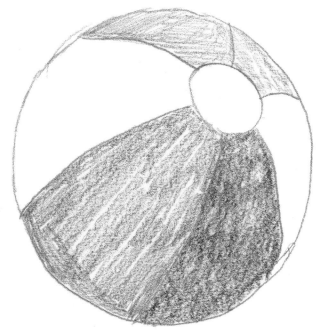

ADD TONE

3 Fill in each section with a different value of tone. (See page 12.)

4 Blend to smooth the tones. Add tone to the center.

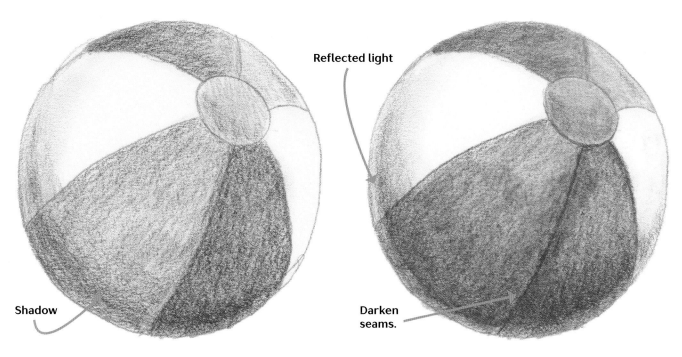

Reflected light

Shadow

Darken seams.

BEGIN SHADING

5 Choose a light source. Add darker tone to the areas farthest away from the light source. Leave a rim of white for reflected light.

6 Deepen the dark tones and blend, then darken the seams.

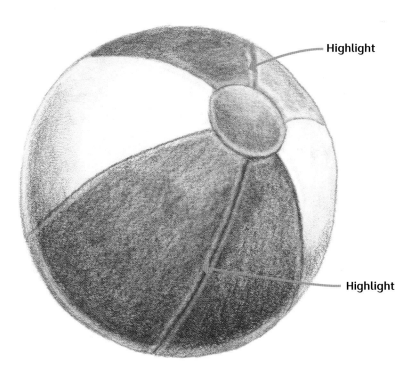

Highlight

Highlight

ADD CONTRAST AND HIGHLIGHTS

7 Erase areas of highlight and lines that are no longer needed. Deepen the tone to create more contrast. Erase a thin line on areas next to the seams for highlights.

Classic Figure Skate

Ice skates combine several different materials—leather, wood, and metal—for a rich drawing subject.

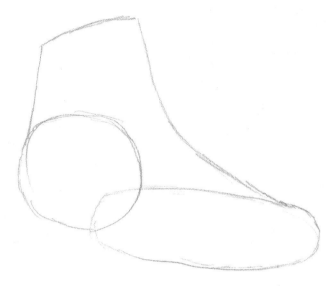

STARTER SHAPES

1 Start with a circle for the heel and a long oval for the skate length.

2 Add an upper part of the skate with curves.

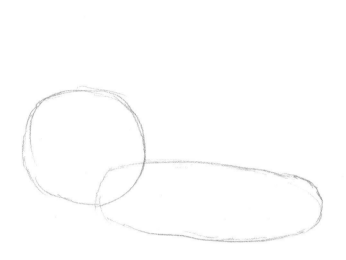

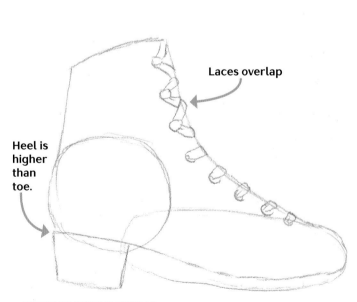

Laces overlap

Heel is higher than toe.

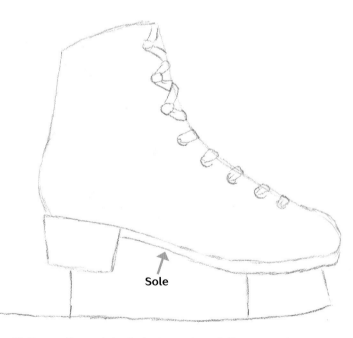

Sole

REFINE THE DESIGN

3 Draw through the original oval and circle to form the base. The heel end should be higher than the toe. Draw evenly spaced "C" shapes for the lace holes. Block in the heel. Add lines for laces.

4 Erase the original circle and oval. Draw a sole along the base of the skate. Draw three short vertical lines and one long line for the skate blade.

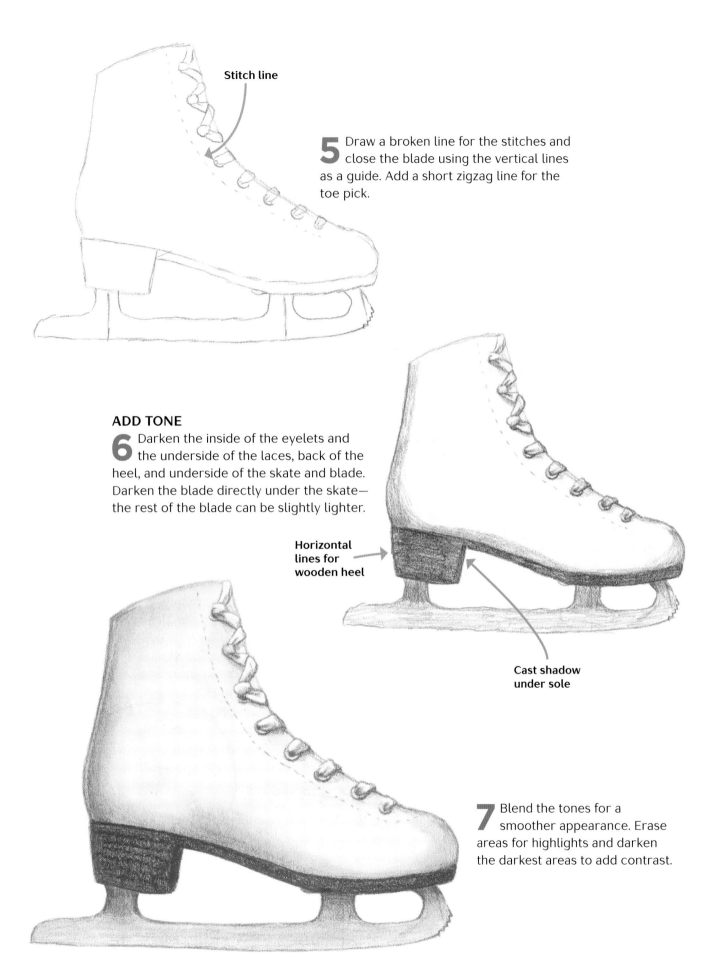

Stitch line

5 Draw a broken line for the stitches and close the blade using the vertical lines as a guide. Add a short zigzag line for the toe pick.

ADD TONE

6 Darken the inside of the eyelets and the underside of the laces, back of the heel, and underside of the skate and blade. Darken the blade directly under the skate—the rest of the blade can be slightly lighter.

Horizontal lines for wooden heel

Cast shadow under sole

7 Blend the tones for a smoother appearance. Erase areas for highlights and darken the darkest areas to add contrast.

Ten-Pin Bowling

Once again, it helps to start with a circle—rather than an outline—to convey shape and volume. The curved stripes around the neck give a clue that we're looking at it from a slight angle, rather than dead on.

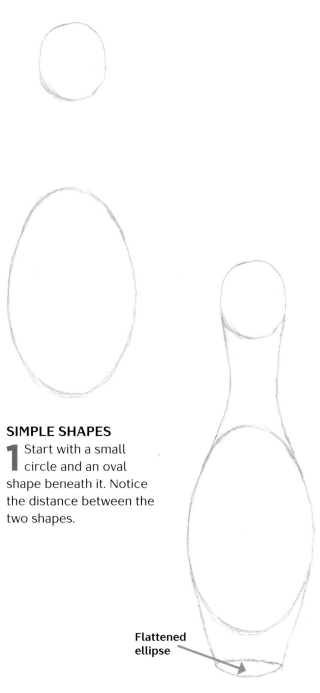

SIMPLE SHAPES

1 Start with a small circle and an oval shape beneath it. Notice the distance between the two shapes.

Flattened ellipse

REFINE THE PENCIL SKETCH

2 Draw an ellipse at the bottom. Connect all three shapes with curved lines.

3 Erase the parts of the guide shapes that are no longer needed. Draw four lines at the neck for stripes.

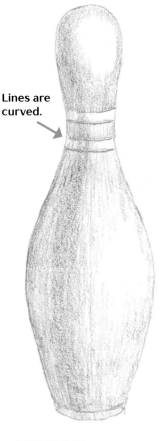

Lines are curved.

ADD TONE

4 Change the neck stripes to be slightly curved. Start to add tone, making it slightly darker on the left side.

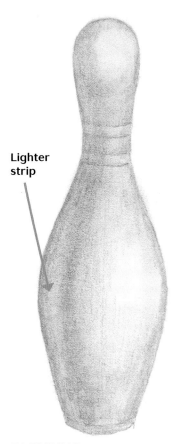

Lighter strip

BLENDING

5 Blend the tone so it appears seamless and smooth.

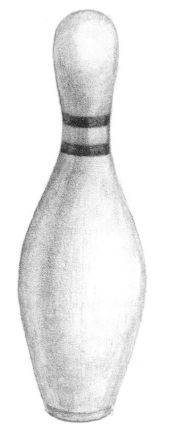

REFINE SHADING

6 Darken the stripes or add a color of your choice, following the same shadows and highlights as the pin.

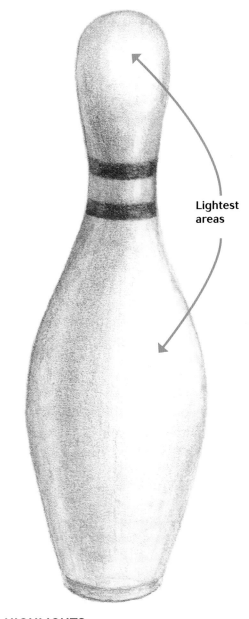

Lightest areas

HIGHLIGHTS

7 Erase areas of highlight and lines that are no longer needed. Deepen the tone to create more contrast.

Queen of Chess

This regal subject displays perfect symmetry made interesting by a combination of sharp and rounded edges. Try drawing it in black or tackle the whole chess board!

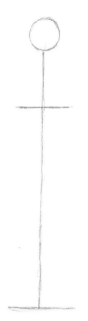

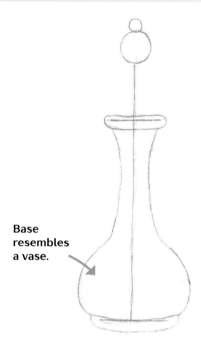

Base resembles a vase.

THE BASIC DRAWING

1 Start with two horizontal lines with a vertical line in the center. Top it with a small circle.

2 Draw lines that curve inward. Add a rounded base. Add a rounded line for the base. Draw an ellipse around the upper horizontal line drawn in Step 1. Top with a tiny circle shape.

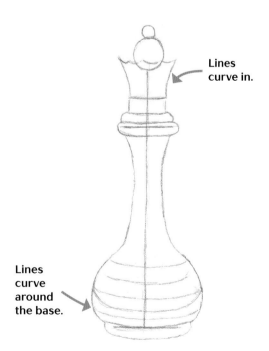

Lines curve in.

Lines curve around the base.

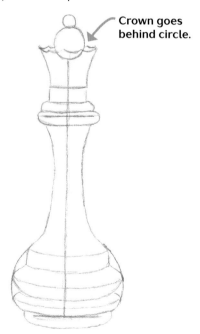

Crown goes behind circle.

3 Add a small scalloped edge at or near the base of the larger circle. Draw a line curving down and in from each edge of the scalloped pattern. Segment the base with curves.

4 Draw the crown so it appears to go behind the larger circle. Refine the shape of the base.

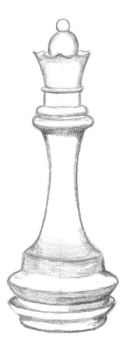

Hard and Soft Edges

An edge is where two surfaces meet together. A hard edge is a crisp line that indicates changes in shape or angularity or an area of high contrast. A soft edge has lower contrast and often suggests the idea of roundness or a gradual transition. The chess piece includes both hard and soft edges.

Remember that in nature there are rarely any hard edges or sharp lines. What is seen is the natural boundaries between the object and the space around it. If it is drawn with a line, it can look harsh and cartoonish.

BEGIN SHADING

5 Erase the original center guideline and the base of the larger circle. Start to add tone to the darkest areas around the edges of the piece and under the grooves.

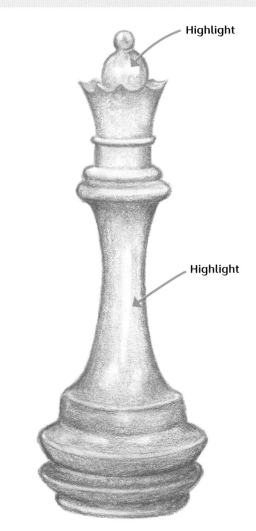

Highlight

Highlight

Soft edge

Hard edge

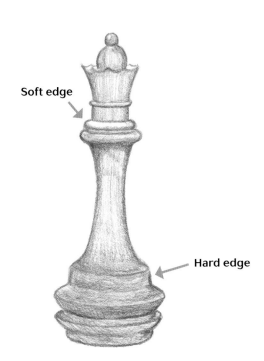

6 Add the midtones in a quick back-and-forth motion to fill in the whole chess piece.

BLEND AND REFINE

7 Erase areas for highlights and add more tone to darken some areas that may have become overblended.

Old-School Game Controller

Warning: Drawing this retro joystick may bring on a feeling of nostalgia. Adding a pop of color creates a fun focal point.

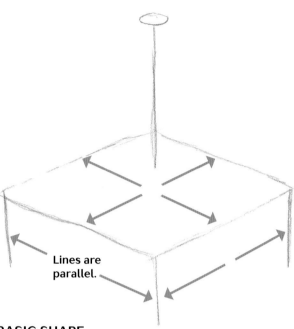

Lines are parallel.

Hexagon

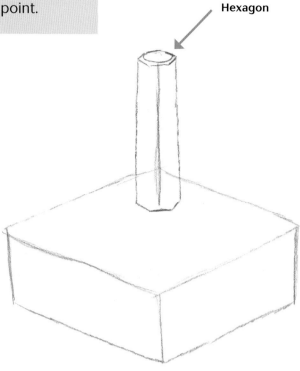

BASIC SHAPE

1 Start with a rhombus (diamond) shape. Draw three vertical lines from the rhombus. Add an ellipse high on the page with a long vertical line coming from it. This will be the joystick.

2 Follow the contour of the original rhombus to close the base. Add a distorted hexagon at the top ellipse with two vertical lines extending from the far ends.

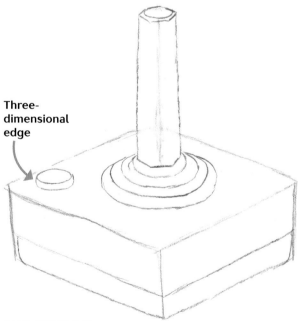

Three-dimensional edge

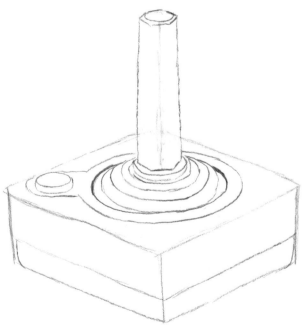

ADD DETAILS

3 Create a series of stacked semicircles at the base of the joystick. Draw an ellipse with a three-dimensional edge for the button.

REFINE THE DRAWING

4 Draw a frame around the joystick base's semicircles.

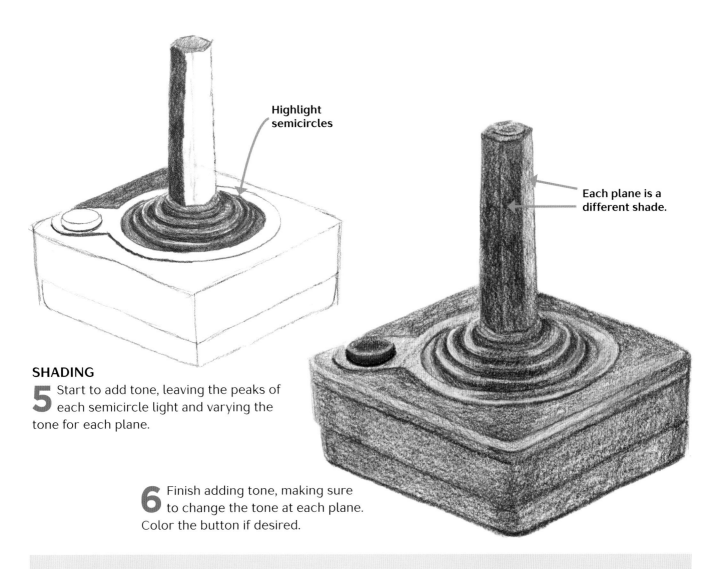

Highlight semicircles

Each plane is a different shade.

SHADING

5 Start to add tone, leaving the peaks of each semicircle light and varying the tone for each plane.

6 Finish adding tone, making sure to change the tone at each plane. Color the button if desired.

Focal Points

A focal point is an area of an artwork that first draws the viewer's attention. Focal points allow the artist control over how the artwork is viewed and perceived, placing emphasis or dramatic impact on parts of an artwork. Focal points can hold the viewer's interest by providing a visual "surprise" while helping to create movement so the viewer's eye keeps moving.

When creating a focal point, first decide where you want viewers to look. Is there a specific area that is more important or could be enhanced?

Next, figure out the technique or method that will highlight the focal point. How should it stand out? Will it be color choice? Dark against light? Hard edges against soft edges? Detail next to simplification? Will you use actual or implied lines to lead a viewer's eyes there? In the drawing of the bee (see page 43), the eye is the main focal point. The shininess of the eye contrasts with the furry texture of the rest of the bee, and the lines of the wings lead the eye to the focal point.

A focal point is often most pleasing when it's placed off-center in the composition, not directly in the center, as it may appear unnatural and forced. This is not a strict rule.

A drawing can have more than one focal point. Multiple focal points can lead the viewer through the artwork from one area to another. The main focal point should have the greatest visual weight. Keep in mind that too many can make an artwork too busy.

The focal point(s) should help tell a story in the artwork while still captivating the imagination of the viewer so they can explore the details and unravel what is being seen in their own way.

Origami Crane

This may be one of the more challenging projects in the book. Accurately drawing and shading the many folds requires a bit of concentration. Try making your own origami pieces and drawing them, too, for additional practice.

Lines follow major folds.

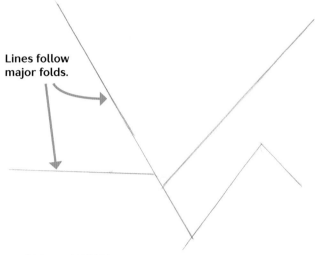

Build shapes around the original guidelines.

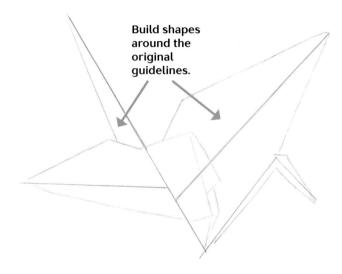

BASIC DRAWING

1 Start with a stick-figure bird. Draw this lightly, as it is a guideline that will eventually be partially erased.

2 Add triangles on the sides of the stick-figure lines for the tail, wings, and head. Draw shapes along the center line to represent the body.

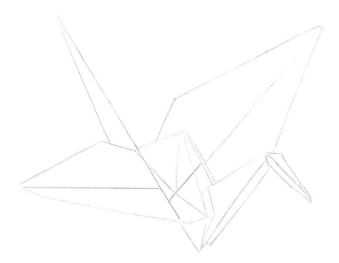

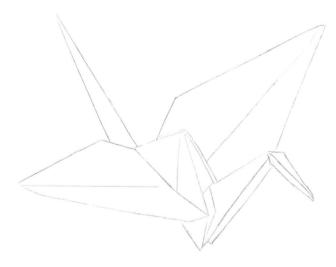

REFINE THE DESIGN

3 Add more lines to define the neck and body.

4 Erase areas of initial guidelines that are no longer needed.

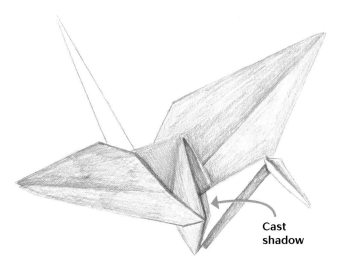

Cast
shadow

Darkest
area

Lightest area

BEGIN SHADING

5 Using the edge of the pencil, fill in the wings and body, making the area in the center of the body and under the neck darker. Leave a white rim around the head and body front near the dark area.

6 Deepen the shades and smooth them out using a blending tool.

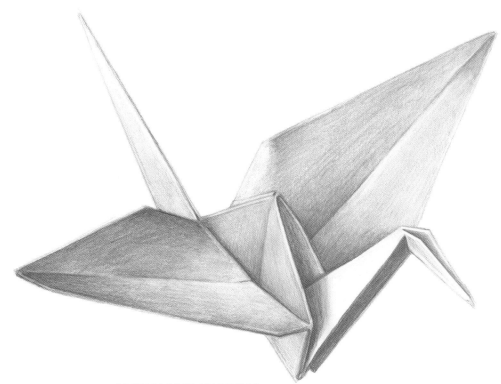

REFINE THE SHADING

7 Erase on one side of each paper crease. Make the edges more crisp as needed using a mechanical pencil.

At the Beach

This slightly more complex subject combines several items to draw—a pail, a shovel, and sand. Breaking it down into its simple components and focusing on shading makes it easy.

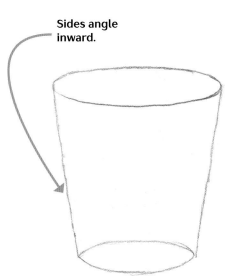

Sides angle inward.

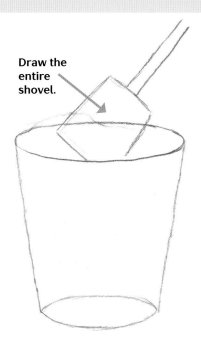

Draw the entire shovel.

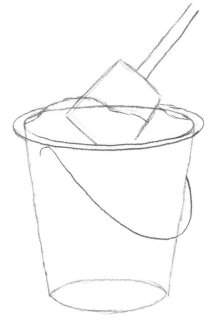

PENCIL DRAWING

1 Start with a large ellipse shape above a slightly smaller ellipse connected by two vertical lines.

2 Add a rectangle-like shape inside the top ellipse with two long verticals. This will be part of the shovel.

3 Draw a curve around the pail for a handle, a curvy line inside/above the top ellipse for a mound of sand, and a rim for the top ellipse.

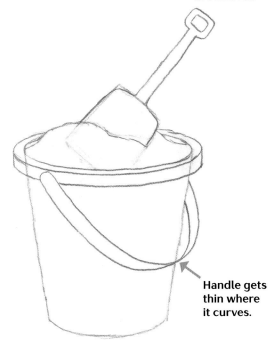

Handle gets thin where it curves.

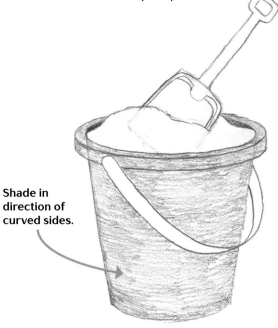

Shade in direction of curved sides.

BEGIN SHADING

5 Add detail lines to the shovel. Start to add a light layer of tone over the whole bucket.

4 Erase the top portion of the bottom ellipse and the area of the top ellipse and shovel that is covered by sand. Add "thickness" to the top rim and handle. Draw the shovel handle.

Drawing "Through" an Object

Why waste time drawing the whole object if part of it will eventually be obscured, erased, or covered by another area of the drawing? Drawing the entire object helps keep objects proportionate and aids in avoiding a warped look.

Drawing only part of a shape, the part that is visible in the final drawing, can be done realistically, but it takes lots of practice. Even professional artists frequently draw the whole object (in this case, the entire ellipse of the sand pail and the bottom of the shovel), as it makes drawing the rest of the image much easier.

Once an item is placed in front of this shape, the overlap will offer a satisfying sense of depth.

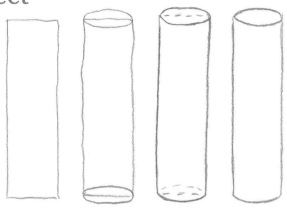

Drawing the top and bottom ellipses of the cylinder helps with accuracy and gives a feeling of solidity even after the unseen lines are erased.

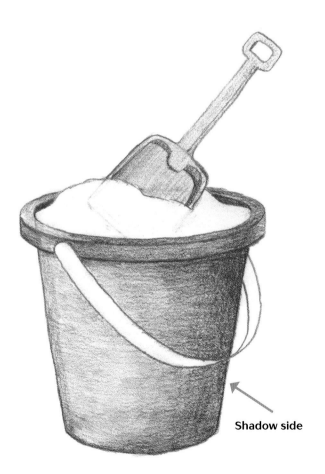

Shadow side

DEEPEN SHADING

6 Add some darker tones to the shadow side of the pail. Add a light layer of tone to the shovel. Blend and add even darker tone to the shadows.

FINISHING TOUCHES

7 Erase areas of highlight and lines that are no longer needed. Deepen the tone to create more contrast and add dots to the sand to create texture.

Artist's Manikin

Wooden artist's manikins are wonderful tools for practicing drawing people, because you can pose them in many different ways. They help with learning the basic proportions. Be sure to draw what you see, not what you think you see!

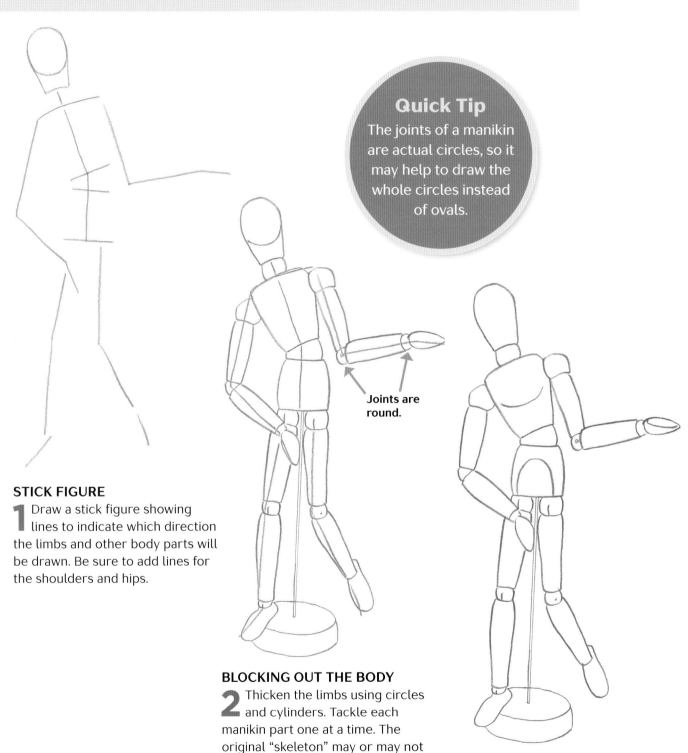

Quick Tip

The joints of a manikin are actual circles, so it may help to draw the whole circles instead of ovals.

Joints are round.

STICK FIGURE

1 Draw a stick figure showing lines to indicate which direction the limbs and other body parts will be drawn. Be sure to add lines for the shoulders and hips.

BLOCKING OUT THE BODY

2 Thicken the limbs using circles and cylinders. Tackle each manikin part one at a time. The original "skeleton" may or may not fall directly in the center of the body parts.

3 Once you are happy with the placement of each joint, limb, etc., erase the original stick figure.

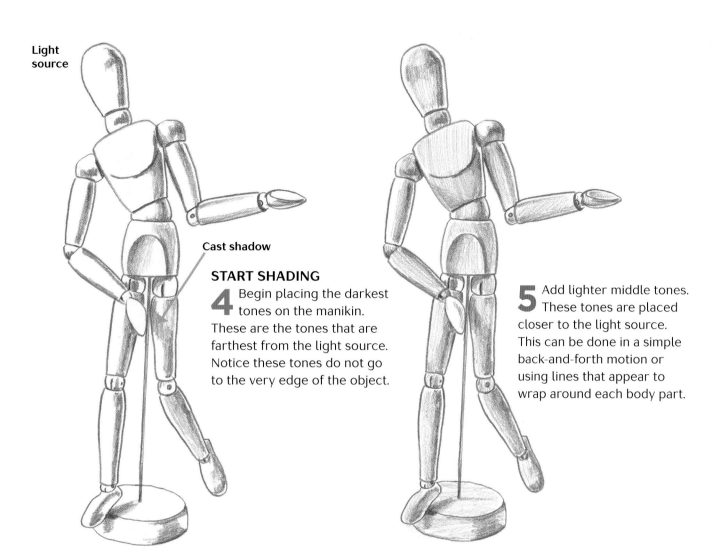

Light source

Cast shadow

START SHADING

4 Begin placing the darkest tones on the manikin. These are the tones that are farthest from the light source. Notice these tones do not go to the very edge of the object.

5 Add lighter middle tones. These tones are placed closer to the light source. This can be done in a simple back-and-forth motion or using lines that appear to wrap around each body part.

Negative Space

When trying to draw accurately, it can be helpful to look at the *negative space*—the space around the object, including shapes that are created by the object.

Observing and replicating shapes formed by negative space in your drawing can help with an approximate rendering. Make sure that the negative spaces in your drawing match up with the negative spaces around the object.

Notice some of the shapes around the manikin—a diamond-like shape within the left arm and body, a lean triangle between the body and the right arm, and a long, lean, bent triangle between the legs.

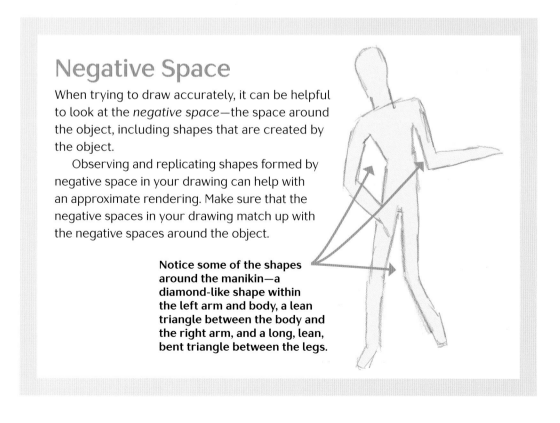

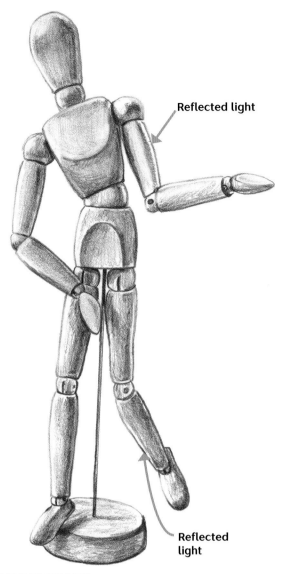

Reflected light

Reflected light

Quick Tip
Be careful not to overblend, which may cause the tones to become muddy.

BLENDING TONES

6 Use a light touch with your favorite blending tool and smooth the tones just a bit so the midtones and shadows blend into one another but are still distinct from one another.

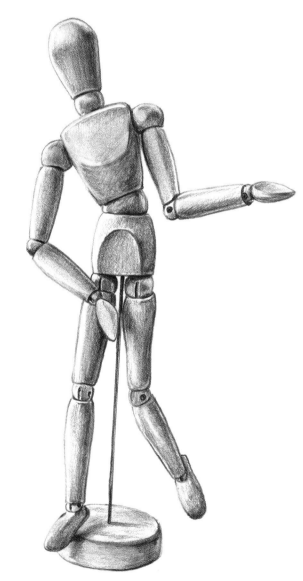

HIGHLIGHTS

7 Use a kneaded eraser on the areas closest to the light source to highlight them. The shadow areas can be darkened. Each shadow should have a light area of tone to the right to indicate reflected light.

Idyllic Tree House

This perfect tree house would be the envy of most kids (and some adults). Practicing some simple one-point perspective keeps everything on the level and makes it easy to add fun details.

Vanishing point

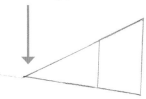

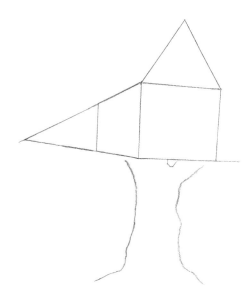

THE BASIC HOUSE

1 Start with a point (called the "vanishing point") near the left side of the page. Create a triangle with two lines. This will be the side of the house.

2 Add a square with a triangle on top next to the triangle drawn in Step 1 to indicate where the front of the tree house will be. Start a simple tree trunk beneath.

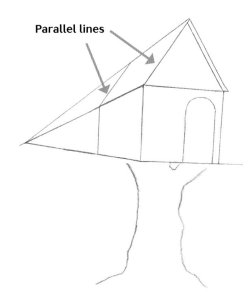
Parallel lines

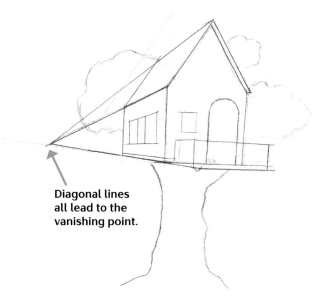
Diagonal lines all lead to the vanishing point.

3 Draw a line from the top triangle to the vanishing point for the roof. Draw the far end of the roof using a line parallel to the left triangle line. Add a door and thickness to the roof line on the right.

ADDING DETAILS

4 Use the point at the left as a guide for the windows on the side of the house. Add lines for a porch. Add some light tufts for leaves.

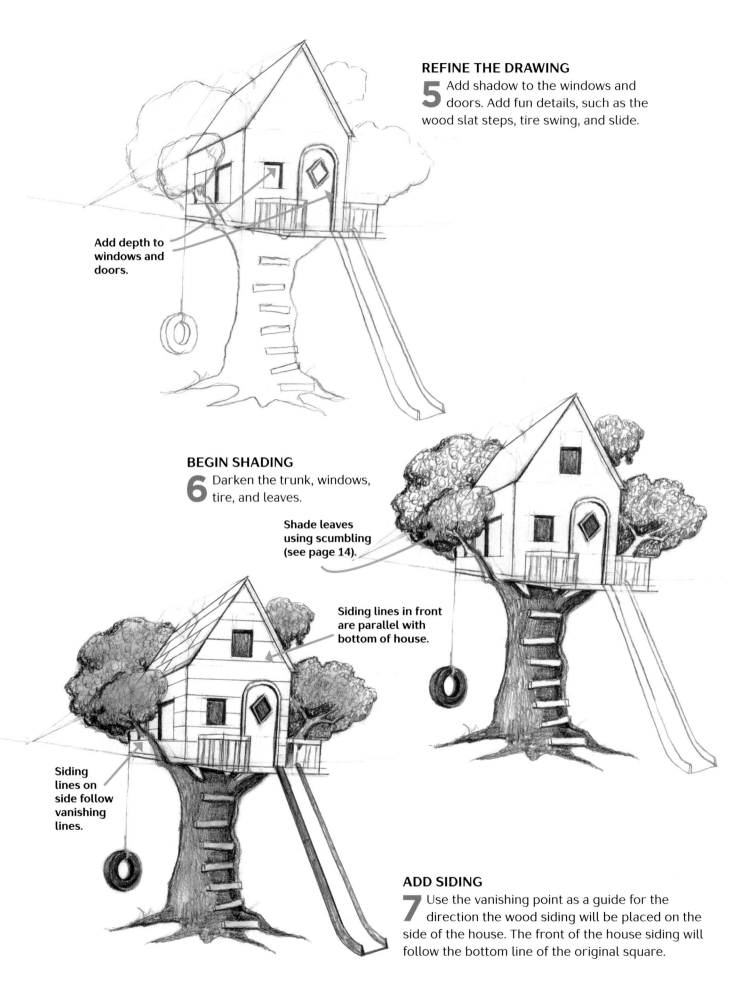

REFINE THE DRAWING

5 Add shadow to the windows and doors. Add fun details, such as the wood slat steps, tire swing, and slide.

Add depth to windows and doors.

BEGIN SHADING

6 Darken the trunk, windows, tire, and leaves.

Shade leaves using scumbling (see page 14).

Siding lines in front are parallel with bottom of house.

Siding lines on side follow vanishing lines.

ADD SIDING

7 Use the vanishing point as a guide for the direction the wood siding will be placed on the side of the house. The front of the house siding will follow the bottom line of the original square.

8 Add highlights and shadows to create depth and dimension. Erase any vanishing lines that remain.

Quick Tip
To darken shadows, you can press harder with the same pencil or use a darker lead, such as B.

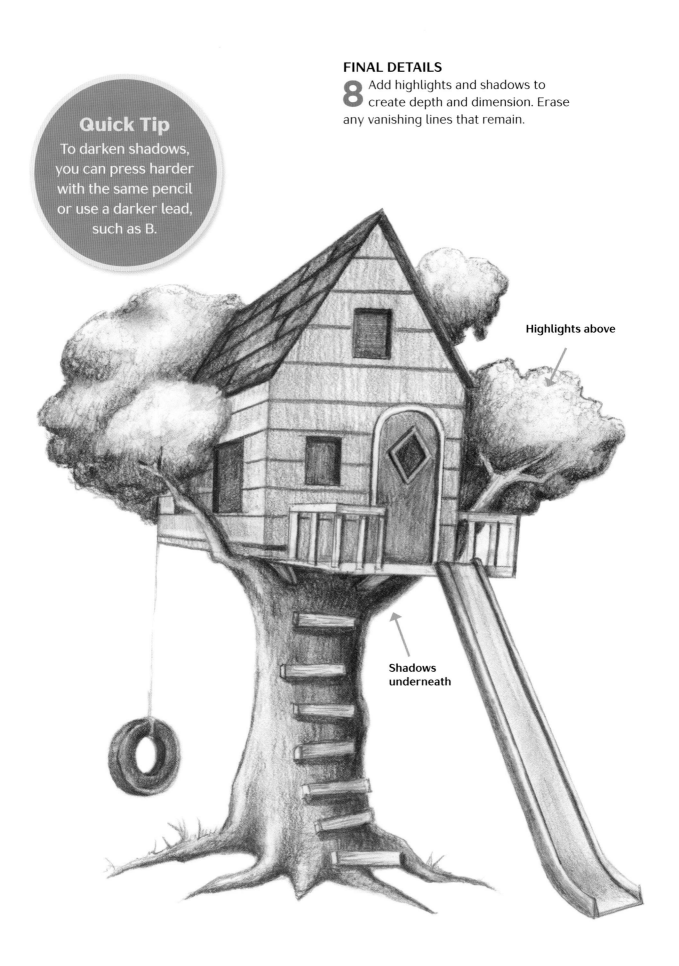

Highlights above

Shadows underneath

Spinning Top

Follow the shape of the top when shading to give this drawing volume and life. Starting with an accurate sketch makes it easy to get it right.

THE BASIC DRAWING

1 Start with an ellipse drawn on a slight diagonal.

2 Draw two small ellipses, noticing the placement and distance between each. Draw a bowl shape beneath the ellipse drawn in Step 1.

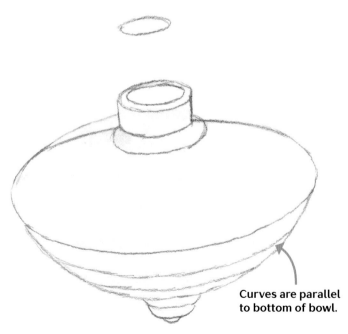

Curves are parallel to bottom of bowl.

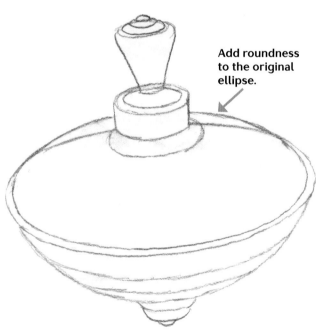

Add roundness to the original ellipse.

3 Turn the middle ellipse into a short cylinder. Add three curves at the base of the bowl. Erase the inside of the short cylinder, adding another ellipse to the top. Add lines to the bowl.

4 Draw a handle. Add a series of stacked ellipses to the handle.

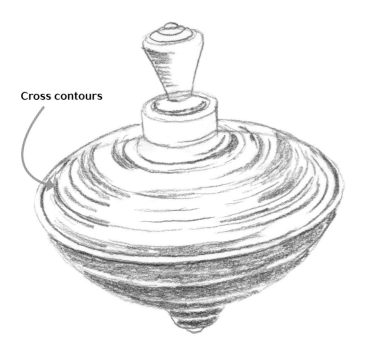

Cross contours

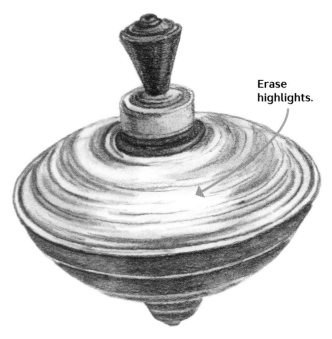

Erase highlights.

CROSS CONTOURS AND SHADING

5 Draw a series of lines that follow the contour of the newly shaped large ellipse ("cross contours"). These do not have to be exactly as long. Add more lines and start to block in some areas on the top, still following the cross contours.

BLENDING AND HIGHLIGHTS

6 Using a blending tool, smooth the tones, following the inner shape of the top. Add more tone in areas that have been overblended. Erase areas on the right and center for highlights.

Cross-Contour Lines

When drawing rounded objects, make sure that any lines or shading on the object follow the shape of the object—the *cross contours*.

Cross-contour lines on a sphere should appear to wrap around the outer surface and define its form. The lines should not cut straight across, as they will not show the depth of the sphere, making it just look like a pattern on a circle.

Remember that shading and erasing for highlights should follow cross contours.

No cross contours

With cross contours

Cross contours around an irregular object

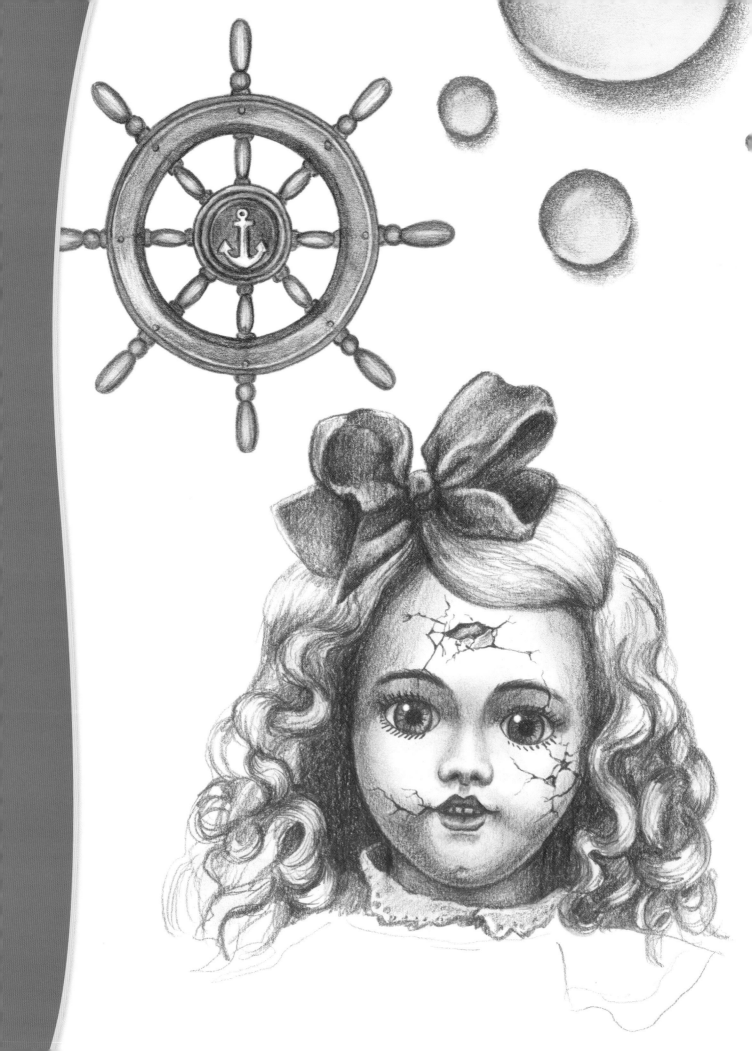

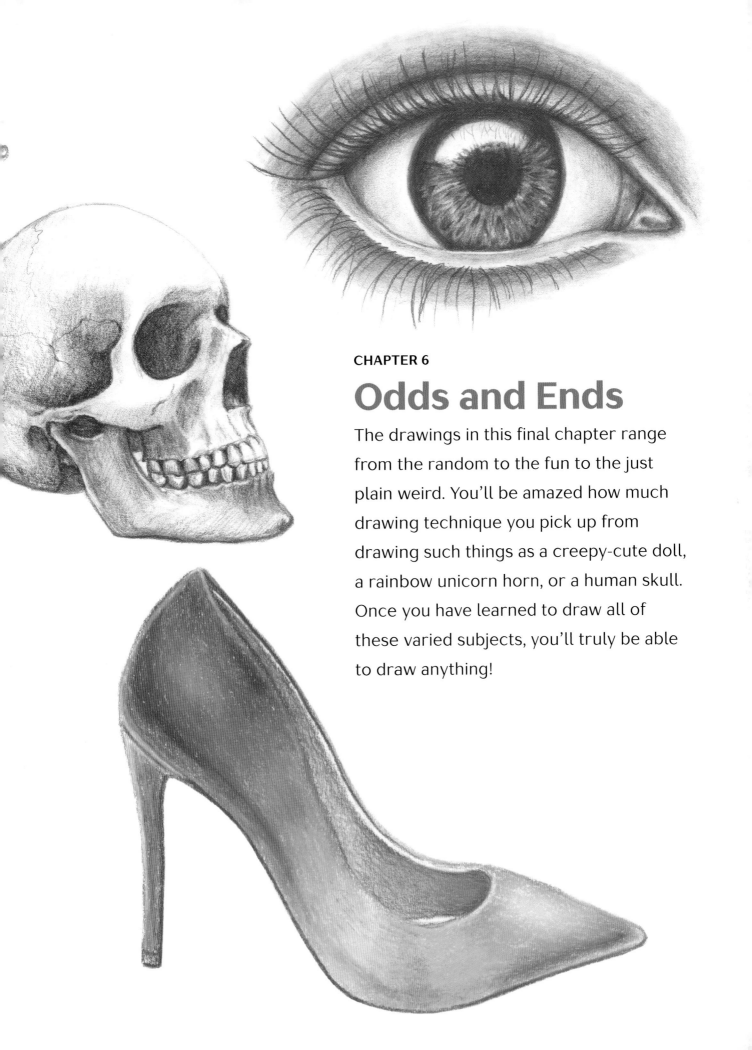

CHAPTER 6

Odds and Ends

The drawings in this final chapter range from the random to the fun to the just plain weird. You'll be amazed how much drawing technique you pick up from drawing such things as a creepy-cute doll, a rainbow unicorn horn, or a human skull. Once you have learned to draw all of these varied subjects, you'll truly be able to draw anything!

Anchors Aweigh

This is a great project for practicing how to draw metal. Focus on the placement of shading and highlights with subtle blending to create a realistic, solid-looking object.

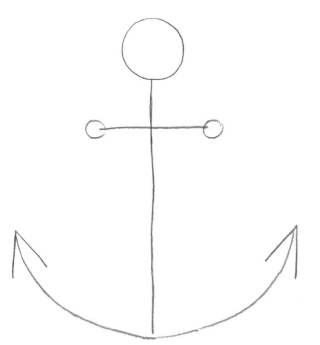

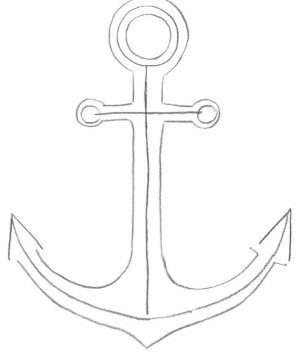

THE BASIC SHAPE

1 Draw a circle and a combination of curved and straight lines to create a basic skeleton.

2 Use the basic stick structure as a guide to add "thickness" to the anchor.

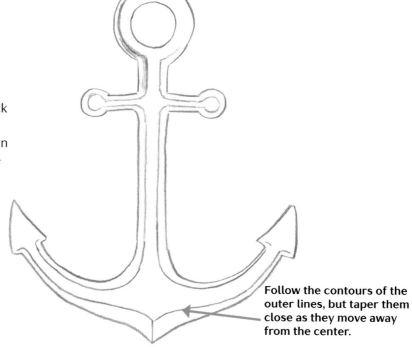

3 Erase the original stick skeleton line. Follow the outer contour drawn in Step 2 to add detail to the inside of the anchor.

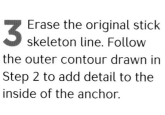

Follow the contours of the outer lines, but taper them close as they move away from the center.

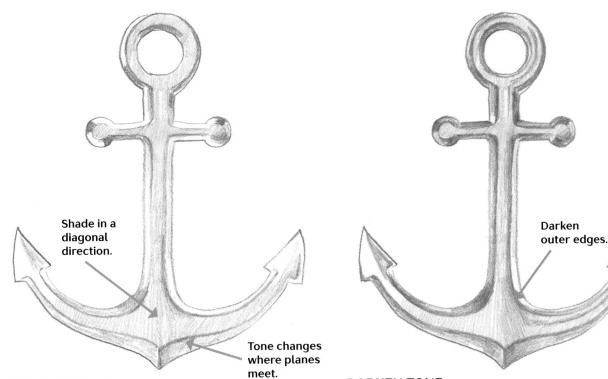

Shade in a diagonal direction.

Tone changes where planes meet.

START SHADING

4 Add the first layer of shading and tone to the edges of each plane.

Darken outer edges.

DARKEN TONE

5 Darken the tone near the outer edges to create more of a dimensional surface. Other areas will appear lighter because of this.

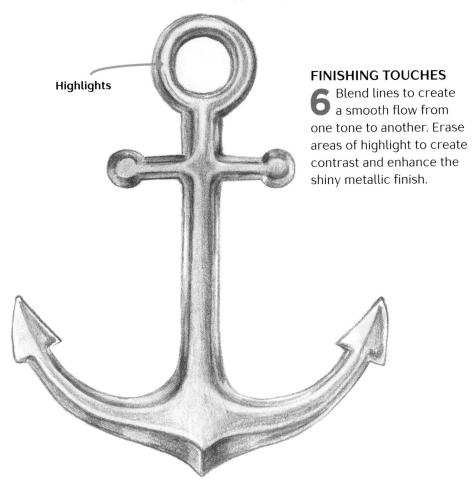

Highlights

FINISHING TOUCHES

6 Blend lines to create a smooth flow from one tone to another. Erase areas of highlight to create contrast and enhance the shiny metallic finish.

Human Eye

Most artists are fascinated with drawing eyes, and for good reason! No other small subject contains so much beautiful detail. After you have mastered the basics, try drawing it in color.

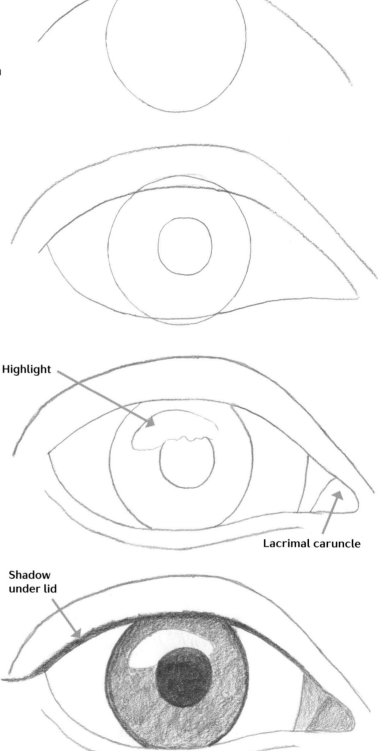

THE BASIC SKETCH

1 Start with a circle for the iris with an arch cutting through the very top.

2 Draw a circle in the center of the iris for the pupil. Draw a line following the top contour for the lid and another line that cuts through the very base of the iris.

3 Draw a kidney-shaped highlight in the eye, a curved line for the lower lid, and curved lines to indicate the meaty part close to the nose (lacrimal caruncle).

Highlight

Lacrimal caruncle

Shadow under lid

SHADING

4 Begin to add tone. The iris should have a light layer of tone while the pupil should be darker. Darken the upper lid and the lacrimal caruncle.

MORE SHADING

5 Add spokes and dark lines radiating from the pupil. Darken the edge around the iris and add a very light layer of tone to the lid, the sclera (white part), and the lacrimal caruncle.

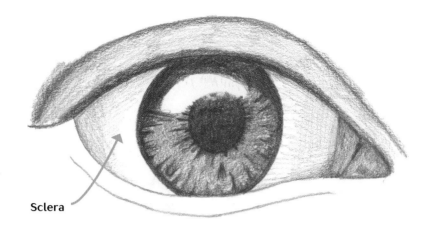

Sclera

6 Add more lines around the pupil and darken the upper lid, the area under the lower lid, the area of sclera under the top lid, and the lacrimal caruncle.

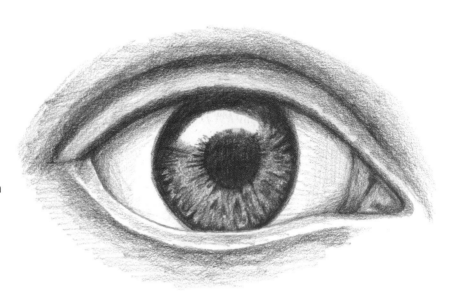

Lashes are darker where they meet the eyelids.

Lashes curve and fan out.

BLEND AND ERASE

7 Blend the tones together. Erase areas of highlight, including the area around the iris and some small slivers within the iris. Draw a light layer of lashes. Add a reflection of the lashes in the eye highlight.

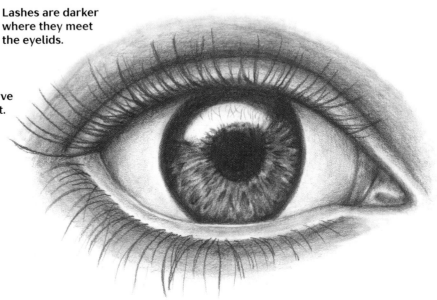

Tied with a Bow

This beautiful bow will give you plenty of practice with shading fabric folds. It starts with a simple X and builds up step by step to make it easy.

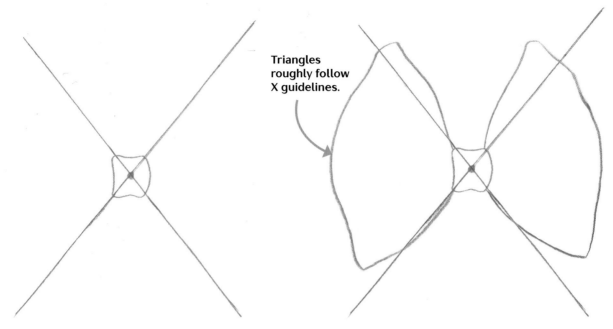

Triangles roughly follow X guidelines.

X GUIDELINES

1 Start with an X shape with a rounded square in the center as a guide.

THE BASIC SHAPE

2 Use the X guide to form rounded triangles, one for each side of the bow.

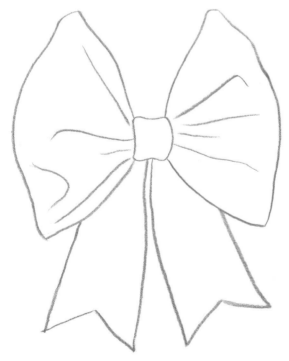

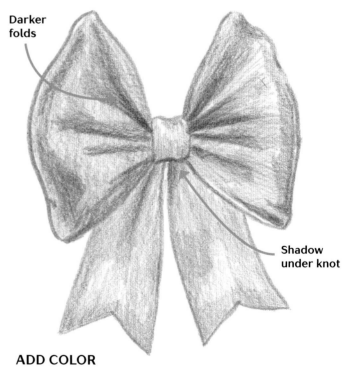

Darker folds

Shadow under knot

3 Erase the X guidelines and add lines to indicate folds in the ribbon. Add lines beneath the bow to show ribbons hanging down.

ADD COLOR

4 Lay down a light layer of one color, pressing harder in areas that will be the folds of the ribbon. More colors will be added in later layers.

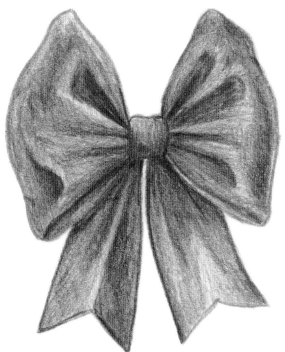

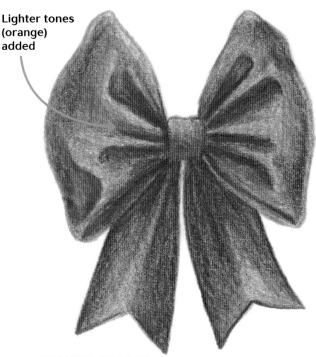

Lighter tones (orange) added

DEEPEN TONES

5 Using the same color, press harder on the bow to intensify the tone, and even harder on the folds.

CHANGE COLORS

6 Using a slightly lighter shade of the same color, add a rim of this new color to the areas touching the current darkest shades. Press more lightly with it over the entire bow.

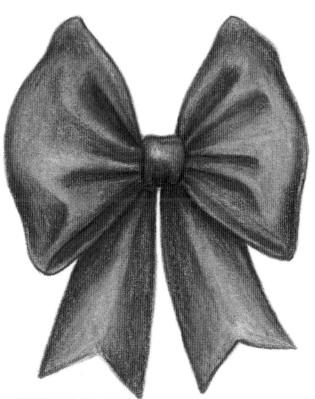

ERASE TO BLEND

7 Use a plastic eraser to remove some tone from the lightest spots. The eraser can also be used to blend the colors together so they appear smoother.

Beautiful Braid

Pay attention to the cross contours of the braid sections when drawing this pretty pigtail. It's wonderful practice for drawing any hairstyle you might like.

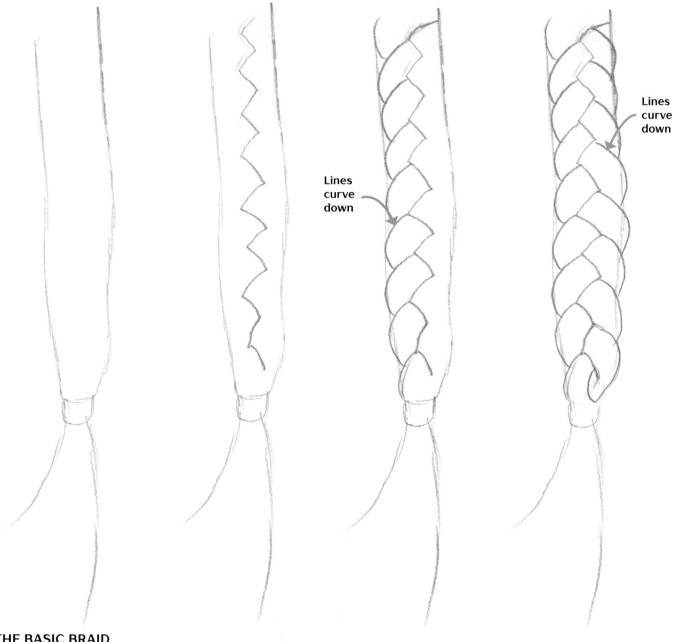

Lines curve down

Lines curve down

THE BASIC BRAID

1 Start with a light outline for the braid.

2 Draw a zigzag line down the center of the braid. This will be the area where the hair overlaps.

3 At the leftmost point of each zigzag line, draw a curved line. I started at the bottom zigzag and worked my way up, stopping when my curve touched the previous line.

4 Do the same for the right side. The zigzag lines have become the braid. Erase the straight lines on the outside of the braid.

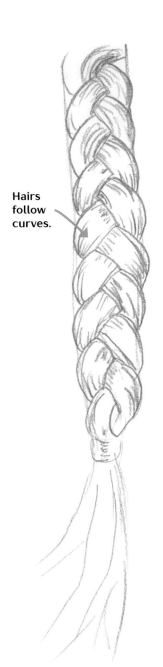

Hairs follow curves.

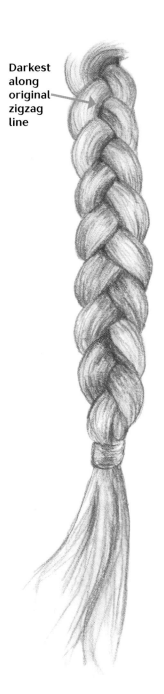

Darkest along original zigzag line

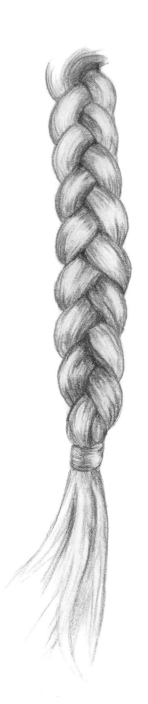

ADD HAIRS

5 Start to draw individual hairs that follow the direction of the curves of each section.

SHADING

6 Draw more hairs and darken the areas where the original zigzag line was placed to show overlap and depth. Blend tones.

7 Erase the center of each braid curve to create highlights and add some lines for hairs under the knot.

Broken Doll

A porcelain doll with a cracked face is the stuff of nightmares and classic horror. Have fun with this creepy cute subject or leave off the cracks for a more innocent look.

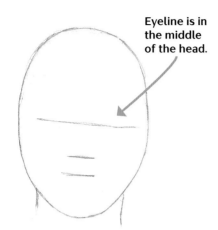

Eyeline is in the middle of the head.

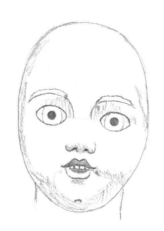

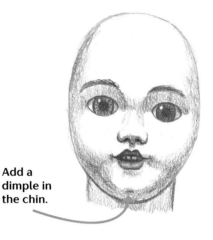

Add a dimple in the chin.

THE BASIC HEAD

1 Start with an oval-shaped head with two lines for the neck and feature guides for the eyes, nose, and mouth.

FACIAL FEATURES

2 Add rounded eye shapes, a nose, a mouth, and lines for the brows. Draw and fill in the pupils. Shade the upper lip, the area under the brows, and near the neck.

DEEPEN SHADOWS

3 Deepen the shadows around the face and fill in the iris, brows, and lips. Leave a white highlight in the eye and lightly shade the sides of the nose.

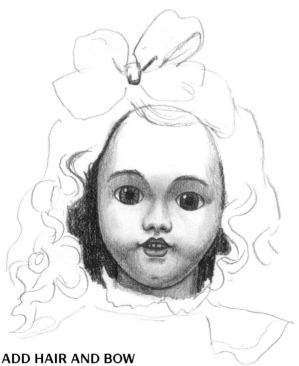

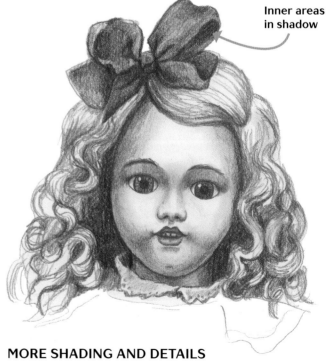

Inner areas in shadow

ADD HAIR AND BOW

4 Add some loose, curvy lines for hair and darken the areas around the face to add contrast. Draw a bow on top of the head.

MORE SHADING AND DETAILS

5 Add more lines and shadow to the hair and bow. Add a collar. Blend the face and hair for a smooth appearance. Add tone to the bow.

Add eyelashes.

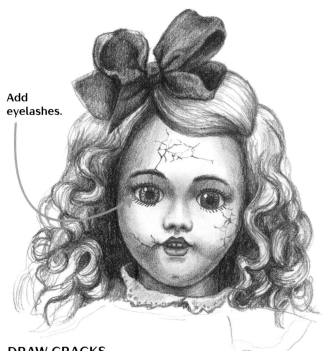

Drawing Cracks

To create a realistic crack in a doll's face or any other surface, draw a series of lines that look like the letter "Y," then darken the areas at the center of each "Y" that form a triangle. Use thin and thick lines that are slightly jagged for a natural look.

DRAW CRACKS

6 Add cracks at various locations using thin and thick lines.

DEEPEN THE VALUES

7 Add more tone to the larger portions of the cracks and define the hair further. Erase areas on the bow to create highlights.

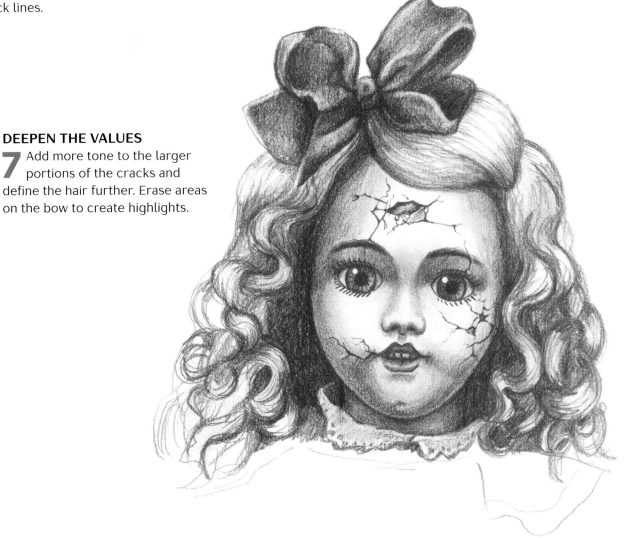

High-Heeled Shoe

When you draw shoes and other clothes you can make them as wild as you like. This psychedelic pump provides a great exercise in blending various colors of colored pencils.

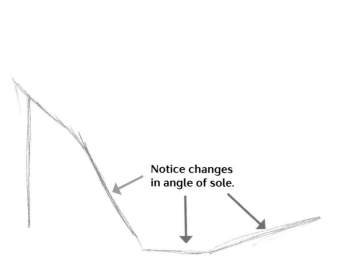

Notice changes in angle of sole.

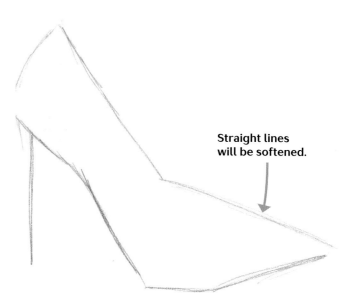

Straight lines will be softened.

THE BASIC SHOE

1 Start lines to indicate the shoe sole and heel.

2 Close the shoe with light lines. Draw lightly because these will be reworked or erased eventually.

Quick Tip
If you are planning to add color to a drawing, keep the pencil lines light so they don't mix with the color.

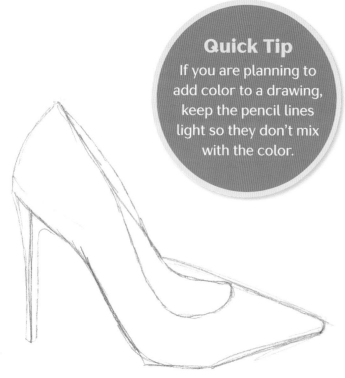

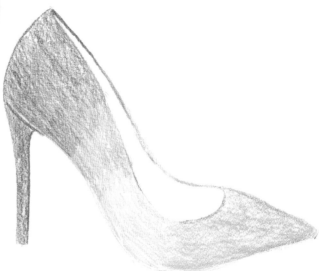

3 Add the heel and the opening for the foot. Round the toe slightly.

ADD COLOR AND SHADING

4 Erase the guidelines that are no longer needed. Erase some of the dark lines so they do not interfere with the color. Start to add a light layer of color(s) of your choice.

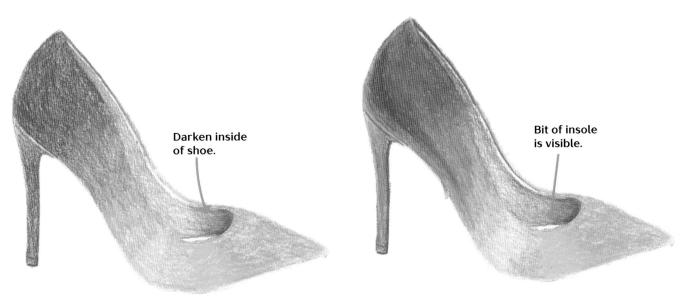

Darken inside of shoe.

Bit of insole is visible.

BLEND COLORS

5 Deepen the colors and create a gradual blend from one to another if more than one color is chosen.

6 Use a combination of pencil pressure and white pencil to achieve a subtle blend from one tone to another.

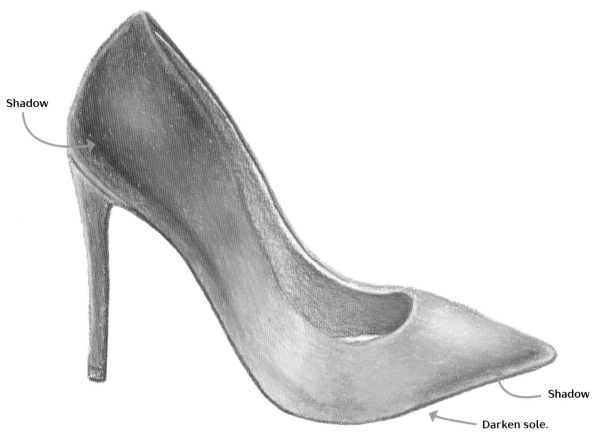

Shadow

Shadow

Darken sole.

FINISHING TOUCHES

7 Add the sole and use a darker tone of each color for shadow areas. Erase lightest areas for highlights. The eraser may also be used to blend tones.

Luscious Lips

This close-up of a familiar subject highlights various textures. You'll pick up plenty of tips to use in your portrait practice.

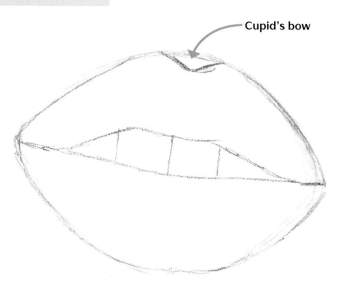

Cupid's bow

THE BASIC LIPS

1 Lightly draw a modified football shape.

2 Add a curve near the top to indicate the cupid's bow. Separate the lips into top and bottom using lines. Draw light lines to indicate teeth.

Quick Tip
Most people's lower lip is slightly larger than the upper lip.

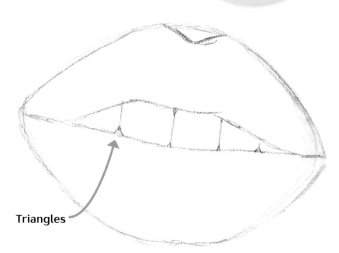

Triangles

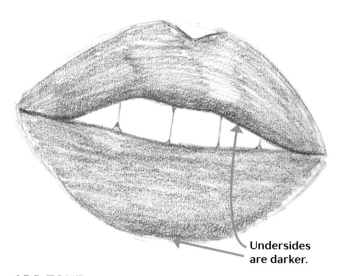

Undersides are darker.

ADD TONE

3 Add tiny triangles to the top and bottom of each tooth line. This will help indicate roundness.

4 Add a quick layer of tone to both lips. The underside of each lip can be slightly darker.

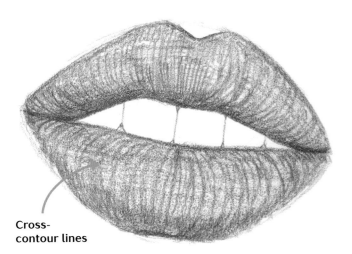

Cross-
contour lines

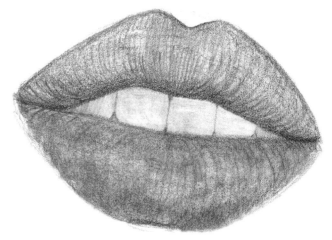

CROSS CONTOURS

5 Draw lines that follow the curves of the lips (cross contours).

BLENDING

6 Smooth tones together using a blending tool or finger, being cautious to not overblend and make a single gray tone.

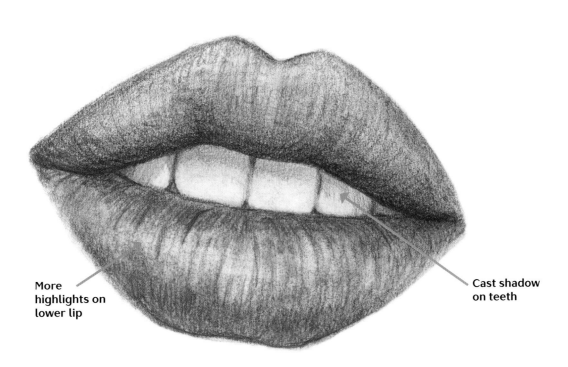

More
highlights on
lower lip

Cast shadow
on teeth

DARKEN AND HIGHLIGHT

7 Darken the tone on the underside of each lip. Use a kneaded eraser to lighten the bottom half of the tooth lines and each tooth. Lighten some vertical lines on the lips. Darken areas between tops of teeth.

Ship's Wheel

Use a compass, a circle template, or a couple of jar lids to draw the concentric circles of this wooden ship steering wheel. Use what you learn here to draw other subjects in wood.

Quick Tip
You can use a ruler to space the lines evenly or just eyeball it.

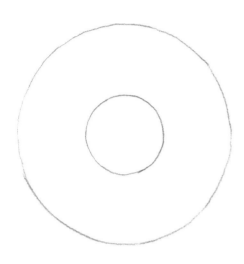

THE BASIC SKETCH

1 Draw or trace a large circle with a small circle in the center.

2 Draw lines that radiate from the center circle, spacing them equally.

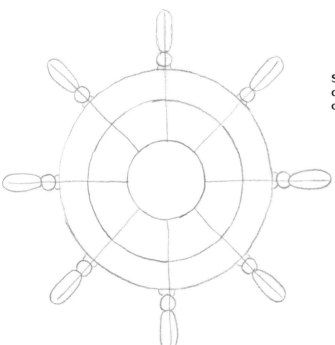

3 Add an inner circle to the original large circle. Draw oval and circle shapes at the ends of each line drawn in Step 2.

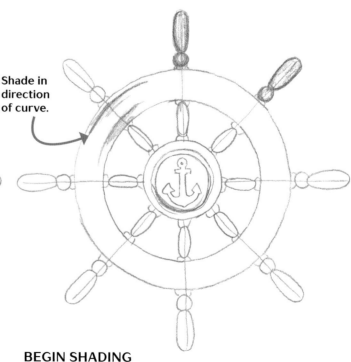

Shade in direction of curve.

BEGIN SHADING

4 Add spindles to the inner circle using ovals and small curves. Begin to add tone.

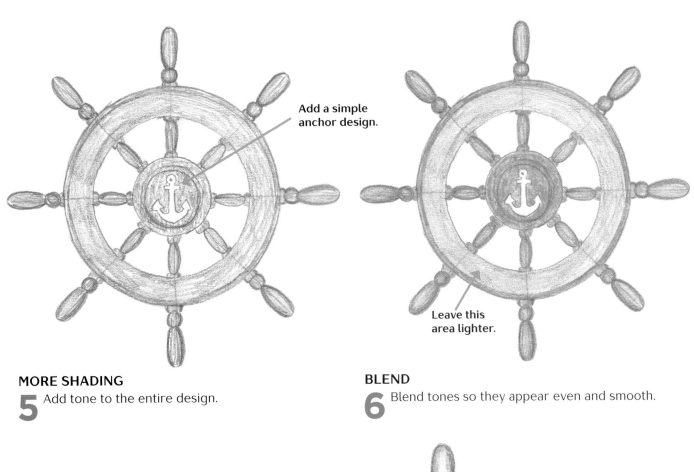

Add a simple anchor design.

Leave this area lighter.

MORE SHADING

5 Add tone to the entire design.

BLEND

6 Blend tones so they appear even and smooth.

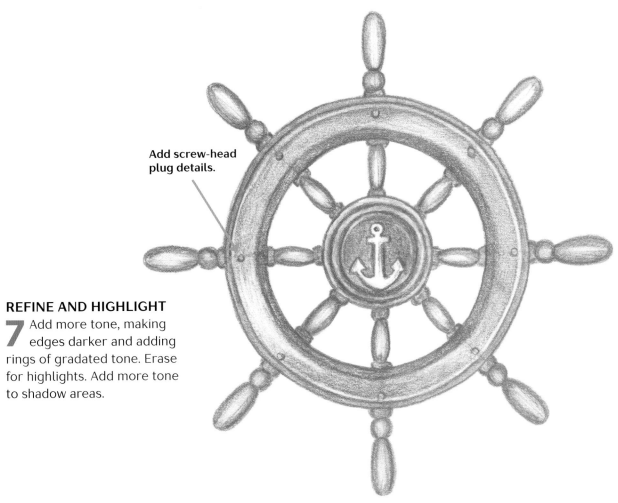

Add screw-head plug details.

REFINE AND HIGHLIGHT

7 Add more tone, making edges darker and adding rings of gradated tone. Erase for highlights. Add more tone to shadow areas.

The Skull

Drawing people can be intimidating, but this subject won't judge your drawing. And it will help you when you do draw live models. The careful placement of shapes in your early sketch will ensure a successful finished drawing.

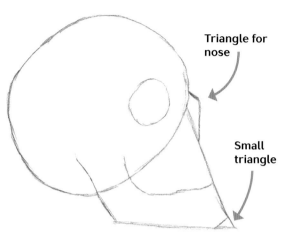

Triangle for nose

Small triangle

SIMPLE SHAPES

1 Start with an oval and two diagonal lines. Close the base of the diagonals with a horizontal line.

ADD DETAILS AND REFINE

2 Add a circle shape for the eye socket and a triangle shape for the nose area. Add curves for the jaw.

3 Erase the small triangle at the chin. Define the bones near the side of head/eye as well as the nose area. Add lines to indicate where teeth will go.

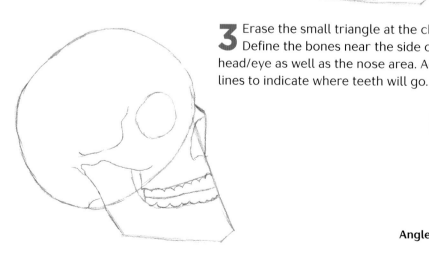

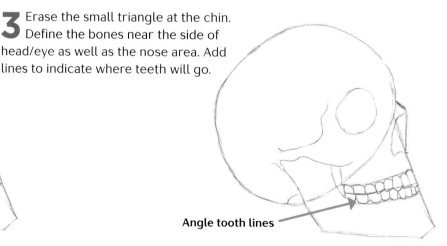

Angle tooth lines

4 Draw curves at the tops of tooth lines.

5 Add lines to separate individual teeth. Make sure these lines are not perfectly vertical.

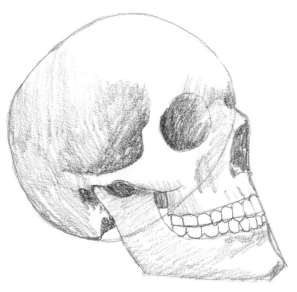

BEGIN SHADING

6 Start to block in shaded areas. Inside the eye socket and nose will be the darkest at this point.

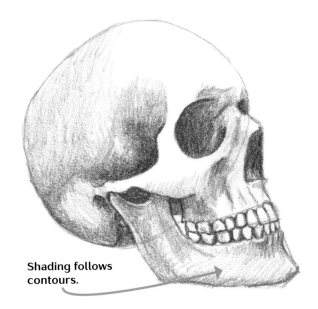

Shading follows contours.

7 Make dark areas even darker, following the cross contours of the form with each mark. Add more tone at the base of the skull and between teeth.

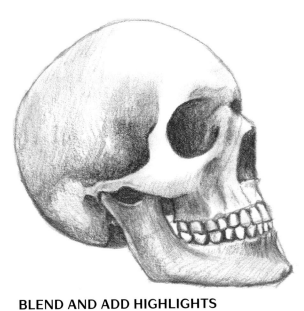

BLEND AND ADD HIGHLIGHTS

8 Blend tones.

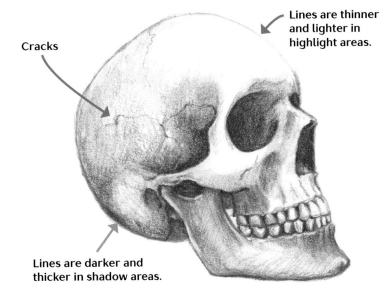

Lines are thinner and lighter in highlight areas.

Cracks

Lines are darker and thicker in shadow areas.

9 Add more tone and erase areas for highlights. Add thin, jagged lines for cracks.

Thick and Thin Lines

Drawing a combination of thin and thick lines will make your art look less flat and will add depth and interest. Thicker lines are usually drawn in darker, shadowed areas, while thinner, lighter lines are usually made in the areas on an object where the light touches the most. Notice how in the skull drawing, the line of the forehead, which is in highlight, is lighter and thinner, while the line along the bottom of the jaw, which is in shadow, is drawn darker and thicker.

This is a subtle technique that will take your drawings to the next level!

Unicorn Horn

Unicorns and rainbows just go together. Try the multicolored version shown here or a more subdued single color. I'll show you how to add sparkle for an even more magical effect.

THE PENCIL SKETCH

1 Lightly draw a long horn shape that tapers at the top.

2 Draw curved sections inside the guideline at a diagonal. The largest section should be at the bottom while the remainder gradually get smaller toward the top.

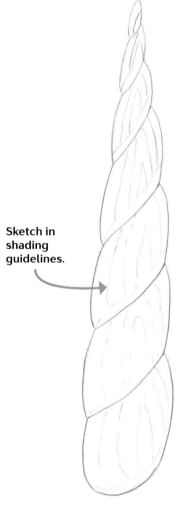

Sketch in shading guidelines.

3 Erase the original guideline. Add light guidelines inside each section to indicate where the various shades will go. The outside edges will be the lightest while the inner oval on each section will be the darkest.

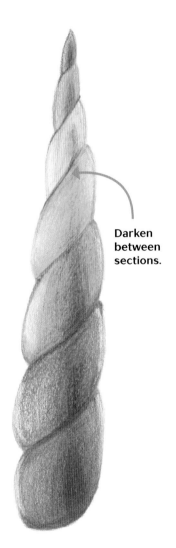

Sparkles

To create a sparkle effect that really shines, draw a shape similar to the one seen here on the edge of the horn and erase inside to the best of your ability. Fill in with white. Rim the edges with a deeper version of the color behind it or light blue and white if nothing is behind it.

Colors are darkest in the center.

Darken between sections.

Sparkles!

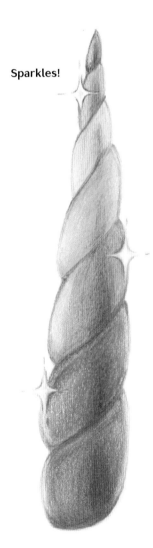

ADD COLOR

4 Use varying pencil pressures to block in the sections of horn. Complete each section of horn with the color of your choice.

BLEND AND DARKEN

5 Blend the tones using light pencil strokes to smooth out the color. Darken the shaded areas using darker shades of the same color on each section.

HIGHLIGHTS AND SPARKLES

6 Erase a stripe on the lightest areas of each section and add assorted size sparkles.

Water Droplets

Drawing a water droplet is different from drawing a solid sphere because the water droplet is flattened. Light also penetrates the droplet, making it lighter overall.

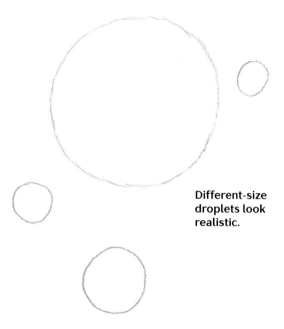

Different-size droplets look realistic.

BASIC SHAPES

1 Start with a few circles of varying size.

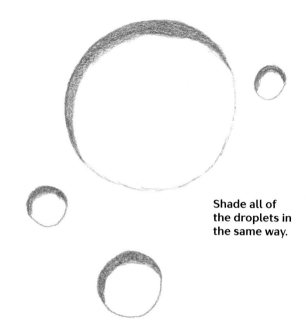

Shade all of the droplets in the same way.

SHADE THE DROPLETS

2 Add tone in a crescent shape to the same side of each circle.

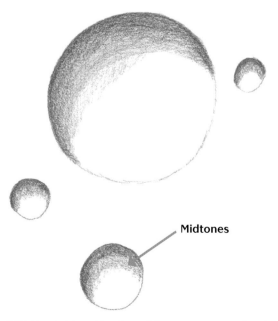

Midtones

3 Next, blend in the midtones next to the darkest tones laid down in Step 2.

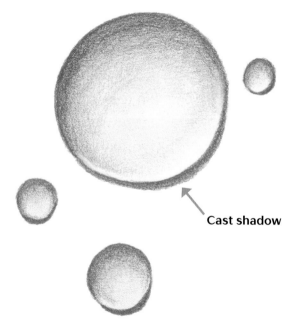

Cast shadow

4 Add the lightest tones until they merge with the unshaded area at the bottom right of each circle. Blend with a blending tool. Add shadows surrounding the outer rim of the lightest part of each circle.

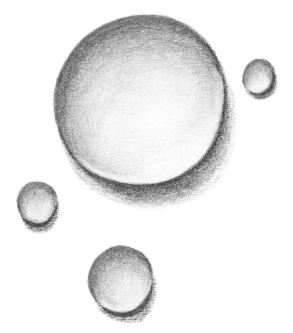

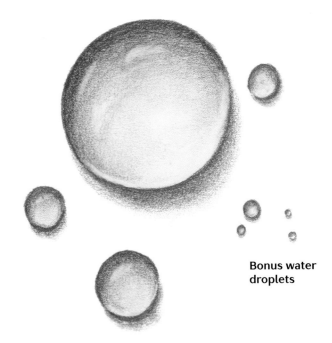

Bonus water droplets

ADD SHADOWS AND HIGHLIGHTS

5 Add lighter tone underneath the shadows drawn in Step 5.

6 Erase areas near the upper left of each circle for reflections and highlights. Add smaller water droplets as desired.

Keep Drawing!

I hope that you have enjoyed recreating the drawings in this book and have improved your drawing skills along the way. Don't stop now! Take the techniques you have learned and apply them to any subjects that catch your interest. If you find yourself lacking inspiration, do an image search online, look through books and magazines, or go out into the world and take photos or draw directly from observation.

Index

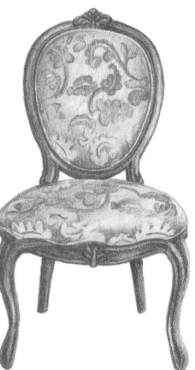